For Emily LaBarge

Affinities

Affinities

On Art and Fascination

BRIAN DILLON

 New York Review Books New York

This is a New York Review Book

published by The New York Review of Books

207 East 32nd Street, New York, NY 10016

www.nyrb.com

Library of Congress Cataloging-in-Publication Data
Names: Dillon, Brian, 1969– author.
Title: Affinities / by Brian Dillon.
Description: New York: New York Review Books, [2023]
Identifiers: LCCN 2022021682 (print) | LCCN 2022021683 (ebook) |
ISBN 9781681377261 (paperback) | ISBN 9781681377278 (ebook)
Subjects: LCSH: Artists—Psychology. | Communication in art.
Classification: LCC NX165 .D55 2023 (print) | LCC NX165 (ebook) |
DDC 701/.15—dc23/eng/20220718
LC record available at https://lccn.loc.gov/2022021682
LC ebook record available at https://lccn.loc.gov/2022021683

ISBN978-1-68137-726-1
Available as an electronic book; ISBN 978-168137-727-8

Printed in the United States of America on acid-free paper.

10 9 8 7 6 5 4 3 2 1

"These appearances catch at my throat; they are the free gifts, the bright coppers at the roots of trees."
—ANNIE DILLARD, "Seeing" (1974)

"One comes away remembering certain small things, haunted by oddities."
—JOAN DIDION, "New Museum in Mexico" (1965)

Contents

Essay on Affinity I

I FOUND MYSELF frequently using the word *affinity*, and wondered what I meant by it. An attraction, for sure—to certain works of art or literature, to fragments or details, moods or atmospheres inside of them. To a sentence, for instance, or an essay, but just as easily to an impression diffusing in the mind that could not be traced back to source. A fascination with this or that artist, writer, musician, filmmaker, designer. With a body or a body of work. *Fascination*— already finding words with which *affinity* has affinities—as something like but unlike critical interest, which has its own excitements but remains too often at the level of knowledge, analysis, conclusions, at worst the total boredom of having opinions. But also: the way things, images and ideas sidled up to each other, seemed to seduce one another, in ways I could not (or did not want to) explain. So that when I wrote *affinity* in a piece of critical prose, perhaps I was trying to point elsewhere, to a realm of the unthought, unthinkable, something unkillable by attitudes or arguments. Not a question of beauty or quality or taste, other eternal aesthetic values. Something fleeting in fact—affinities don't all, or always, last. In the end, and for reasons above as well as others to come, something a little bit *stupid*.

I'd been writing about images for about twenty years, finding affinities rather than deploying any kind of expertise, because I'm

no art historian. Still, it had felt like an education, a second training in the image, after my first in the word. For a long time I had been saying or writing *affinity*, but also dreaming, never exactly conceiving, a way of thinking about art, about objects and images, that belonged to artists, including the contemporary artists whose studios I might visit and find myself staring at pictures (not their own) they had stuck to the wall, books and artefacts on their shelves. I had thought in passing about how these, or the smartphone photographs and notes-app reading lists the artist sent me afterwards—how they sat alongside each other in more or less oblique relations and then, when I came to write up my encounter with the work, would not easily translate into the language of influence, subject matter, research. (Would not do so, that is, if the art was of any worth; sometimes everything explained itself too well.) How to describe, as a writer, the relation it seemed the artists had with their chosen and not chosen—what is the word? Talismans? Tastes? Sympathies? Familiars? Superstitions? *Affinities*.

During the first pandemic lockdown of 2020, I imagined I might spend time in shut-in contemplation of many images and artworks (in books and catalogues or online) I had either written about already or long hoped to write about. Sometimes I drifted about staring at my bookshelves or handling the piles of books that gather around any writing project, no matter how small. What was I looking for? Free-floating reflection, liberated from the need for argument or judgement (or deadlines), somehow therefore more intimate, more attuned to its object. I thought I might stare at certain pictures—mostly photographs—and they would go to work on me, leach into soul or sensibility. I fancied I could memorize these images like poems. (As if I had ever in my life successfully

memorized a poem, no matter how I loved it.) An idiotic project: naive, impossible, disingenuous in disavowal of knowledge, judgement, the privilege of planning such a monkish task before page or screen, while the world went to hell. But *idiotic* too in the original sense of an uncultured, uncivil, private urge. Was it quite so stupid to want to dodge at this moment the public and professional, try to refind a mode of dumb fascination? Could you make out of this a habit—or even a book?

The volume you hold in your hands is not that book—the book of pure uncritical escape, which proved implausible—but a collection of writings about art and artefacts that have hung around in my "image repertoire" (Roland Barthes's phrase) for years. And some that have only lately entered the canon or collection of images that will not leave me alone. All of them have recently—what is the word? *Impinged.* They seem to enact something when placed together in the imaginary space that a book makes. A book of evidence that I'd been an idiot all along, always looking with a slightly stupefied gaze. Not the intense and protracted gaze of a writer and project devoted to a single rapture: T. J. Clark, for instance, in *The Sight of Death*, looking long at two paintings by Poussin. Or Wayne Koestenbaum's *The Anatomy of Harpo Marx*, in which he excitedly delineates every moment the wordless benign trickster is on screen. Because when it comes to writing about art and images and objects I have mostly spent time and attention in short spans: days, weeks or if I'm lucky months devoted to the artefact or the corpus in question. (Of course some of them return, time and again.) Relishing the chance to concentrate, but also loving the constraint of deadline and word count: something will have to come from this more or less extended disposition or humour into which I have got with the thing itself.

What would it be like to put some of these fits of affinity alongside each other, and allow myself to discover new examples to insert among the more familiar? And still unsolved: what did I mean by *affinity*? It seemed impossible to address the question on its own, as if it were an abstraction in aesthetic theory: answers would have to emerge while the particular affinities (the things to which I was attached) were going to work on each other. It was not as if I didn't know that others had been here before me, that a lineage of sorts existed among poets, critics and philosophers who knew affinity by one name or another. It was possible I simply intended what Charles Baudelaire or Walter Benjamin meant by *correspondence*, or what art historians and theorists (Georges Didi-Huberman, Alexander Nagel, Christopher Wood) had rescued from *anachronism*. These writers and their ideas hovered, but it seemed that *affinity* landed a little way off. In what follows the essays on specific artists or images alternate with unmethodical passages on affinity itself, its meaning and meandering. In the life of any writer about art or (weak word) culture who is not deliberately partisan about this or that artist or group of artists, who has not turned aesthetic or political preferences into a self-conscious programme, who doesn't have the liberty of only ever writing about what they choose—in such a case affinities can remain unthought, until you place them together like this and are forced to see where they connect, or do not.

A surprising number of the essays seem to be about images that stage in their content or form some act of blurring and becoming— as in the dance of Loie Fuller or the monstrous transformations of faces and bodies in the works of collagists and *monteurs* like Hannah Höch, Dora Maar and John Stezaker. Becoming otherwise, in disguises and personae assumed by Claude Cahun and Francesca Wood-

man. Ambiguous, entrancing performance, as in the visual insistence and erosion of Edie Sedgwick in Andy Warhol's *Outer and Inner Space*. A remarkable amount of mutable *matter*—remarkable because, if asked what I value most in art, in photography especially, I might not have said: a state of bodily between-ness verging on dissolution, aspiring to reconvene otherwise, in alternative forms. Sometimes it's a question of visual texture: the frequent lack of focus (admired and dismissed in her lifetime) in the work of Julia Margaret Cameron; a woman's blurred face emerging from a crowd in a photograph by William Klein; the sheen of black makeup around a mouth blubbering away in the dark in Samuel Beckett's *Not I*. Elsewhere, instances of animal or plant life whose borders or structure seem imprecise: the aquatic specimens of Jean Painlevé, the preserved pears in a film by Tacita Dean. And images overcome by darkness or light, as in Kikuji Kawada's photographs in Hiroshima, or Rinko Kawauchi's radiant documentation of daily life.

Almost all of these affinities are about photography or film, and even when not—Hooke's experiments with the microscope, De Quincey's fixation on stellar nebulae—there is usually some connection to optical technologies, some new way of seeing or framing the world. When I started writing about art, I gravitated towards the photograph—then also film and video—because it was something I already knew from reading Benjamin, Sontag and Barthes. (Which means that I also had to push those writers aside, which I have never fully succeeded in doing.) Eventually, editors at magazines and journals trusted me also to write about painting, sculpture and the whole field of modern and contemporary art, untethered from medium. Still, I have kept coming back to photographs, and especially to those aspects of them that won't exactly resolve, and

continue to seem excessive, obscure, even idiotic. The challenge, always: to try and render the obtuseness of the image with some but not too much acuity.

As for the order of the pieces, it seemed if I was to remain true to my subject I could not consciously add another layer of affinity to what already existed. A pattern based on newly perceived correspondences was out of the question, but so also an entirely random array, which seemed to put too much faith in accident. I thought about the arbitrariness of alphabetical arrangement, and Barthes's abecedarian structuring of *A Lover's Discourse*: "Hence we have avoided the wiles of pure chance, which might indeed have produced logical sequences." But logic was not entirely at odds with affinity. In the end I realized chronology was random enough for my needs, and so the sequence for the most part follows the first appearance of an image or a body of images—or another significant date in an artist's life or career. Contemporaneous artefacts sometimes rhyme but frequently do not, and there are I hope enough leaps across decades, or even centuries, to obviate too strong a sense of "story" (still less the history of photography, or other forms). This episodic essay on affinity runs through the book like a loose seam, less an argument than a mood or a hunch, which the reader may encounter as it comes, or ignore. Such is the risk of affinity.

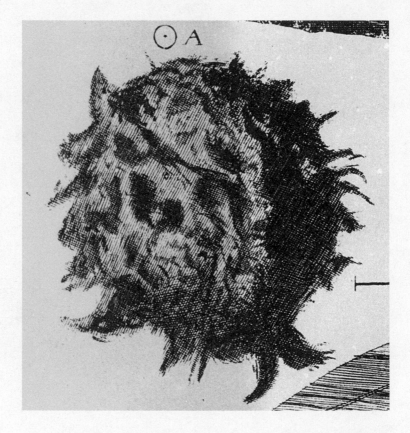

What Pitiful Bungling Scribbles and Scrawls

ROBERT HOOKE'S *MICROGRAPHIA* was the first book published in English to describe and depict (in engravings) a set of observations made with the microscope. Among the better-known illustrations in the first edition of 1665 are those showing a fly's many-faceted eye, the starry shapes of ice crystals and a prodigious bristling fold-out flea. Before training his apparatus on such complex curiosities, Hooke demonstrates its magnifying power with some minute but mundane sights. The point of a small sharp needle is exposed as gnarled and pitted, the svelte edge of a razor is covered in scratches and striations. The scientist turns next to "a *point* commonly so called, that is, the mark of a *full stop*, or period." Whether printed or made with a pen, the tiny point, circle or dot of the period turns out to be disfigured, ragged, deformed. Under the lens, this microdot looks as though it's been made with a burnt stick on an uneven floor. Imagine, Hooke writes, if he had found room in his engravings for a single "O," greatly magnified: "you should have seen that the *letters* were not more distinct than the *points* of Distinction, nor a *drawn circle* more exactly *so* than we have now shown a *point* to be a *point*." Stared at as closely and keenly as possible, even the most elegant, precise or selfsame forms are revealed as monsters.

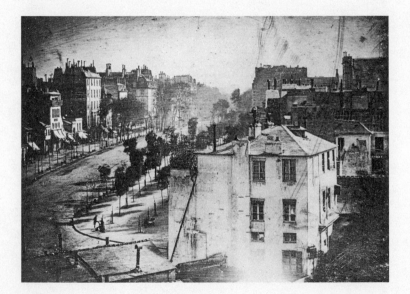

Third Person

Uncertain origins—in the vexed history of early photography, Louis Daguerre's *Vue du boulevard du Temple* (c. 1838) is often said to be the first photograph depicting a real live person. Two versions survive, after the fragile fashion of daguerreotypes; both were taken from a window of his studio in the rue des Marais—the first at eight in the morning, the other at noon. The earlier image is far better known. A thicket of tiles and chimneys, rows of mature and sapling trees, bright cobbles not yet sluiced with water. An exposure time of four minutes has ensured, as in most street photographs of the decade following, that the scene has been emptied of whatever human and equine traffic teemed there. Almost. Towards the bottom left corner, a svelte male figure lifts one bent leg, thrusts a hand into his pocket or onto his hip. The animated blur in front of him, we may assume, is shining the shoes of this early-rising flâneur.

In the uncommonly bright and warm spring of 2020, when London, like most cities worldwide, was deep in its first pandemic lockdown, I found myself thinking sometimes about *Vue du boulevard du Temple* and its two small figures, hardly there at all. (It's been suggested there are others to the right of them, in a dark mass surrounding a young tree, and even that there's a child in one of the open windows—but none of this is very convincing.) I live on the edge of the City of London, and during those long strange weeks

my partner and I would go walking among the abandoned office buildings, the vacant pubs and restaurants of the financial district. Londoners had not yet vanished: there were still enough people around to avoid each other, taking advantage of the absence of cars to stroll into the middle of the street at the first sight of a fellow pedestrian. We all kept our distance, and I began to wonder about a category of city person who seemed suddenly more visible than before. The solitary distant walker, far enough away to be anonymous, unthreatening, *uninteresting*.

There is a series of small works, collectively titled *Crossing Over*, by the artist John Stezaker that consists of fragments excised from larger (but likely not very large) vintage photographs, each fragment containing a tiny figure or figures isolated from the absent whole. These people are crossing streets, wandering in parks, sitting on benches or on beaches, tramping away down country lanes, hiding under Edwardian parasols. In the book that Stezaker has made of the series, each little inhabited square sits at the centre of a white page, snowy allegory of their isolation. Of course, in the original photographs, which have the look of postcards, they may not have been isolated at all: the city or landscape might be heaving. It's as if the artist has turned each photograph he touches into a version of *Vue du boulevard du Temple*. Like Daguerre's inaugural image, Stezaker's project asks: what do we—we who are also, after all, distant walkers and distant viewers—owe to these figures on the edge of visibility? By the time this question had properly formed in my head, there were more of us in the streets of the City of London again, and we had all got used to being slightly closer to each other, masked this time and possibly more wary.

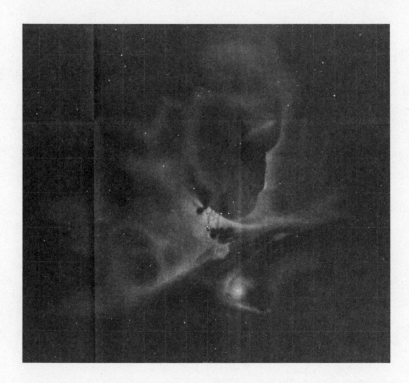

Resolving

WISPS, CONVOLUTIONS, branches, appendages, strata. A few of the phenomena recorded by the polymath John Herschel in the course of astronomical observations he made in South Africa in the 1830s. Herschel's telescope swept the heavens nightly, but sometimes he would interrupt his work to train the instrument directly at certain stellar nebulae. Of these, he made initial drawings, "working skeletons," that later informed more realistic (if that is the word) illustrations. "Frequently, while working at the telescope on these skeletons, a sensation of despair would arise of ever being able to transfer to paper, with even tolerable correctness, their smaller details." In the language of optics as well as astronomy, the nebulae would not *resolve* under Herschel's gaze.

The image in question is Herschel's, from observations he made in the decade before travelling to the Cape of Good Hope. But I found it first among the collected works of Thomas De Quincey, who seems to have misunderstood its provenance, and puts it to grandly visionary use. I've never owned a reproduction of this image except in a photocopy made when I was a student, so for the past twenty-five years it has mostly been a picture of the mind, slightly misremembered. (Occasionally I've gone looking for it online, but the results have been more pitiful than the photocopy.) More than once I've forgotten this crucial fact about the image: in the pages

of De Quincey, we are looking at it (as you are now) upside down, in order to see what he has seen. "The inversion being made, the following is the dreadful creature that will then reveal itself."

De Quincey's description of the "creature" is long, detailed and digressive; its wordiness is part of the wonder of what he sees and how:

> You see a head thrown back, and raising its face, (or eyes, if eyes it had,) in the very anguish of hatred, to some unknown heavens. What should be its skull wears what might be an Assyrian tiara, only ending behind in a floating train. This head rests upon a beautifully developed neck and throat. All power being given to the awful enemy, he is beautiful where he pleases, in order to point and envenom his ghostly ugliness. The mouth, in that stage of the apocalypse which Sir John Herschel was able to arrest in his eighteen-inch mirror, is amply developed. Brutalities unspeakable sit upon the upper lip, which is confluent with a snout; for separate nostrils there are none. Were it not for this one defect of nostrils; and, even in spite of this defect, (since, in so mysterious a mixture of the angelic and the brutal, we may suppose the sense of odour to work by some compensatory organ,) one is reminded by the phantom's attitude of a passage, ever memorable, in Milton: that passage, I mean, where Death first becomes aware, soon after the original trespass, of his own future empire over man.

What is De Quincey looking at? His essay is titled "System of the Heavens as Revealed by Lord Rosse's Telescopes," and was written in 1846. It is a review of a book by the popular astronomy writer J. P. Nichol, a friend of De Quincey's from his precarious days living

in Glasgow. Among Nichol's achievements as an author was his popularizing the (mistaken) nebular hypothesis, which held that stars were formed by the condensing or resolution of a nebular substance, a kind of gas or mist. In some cases—the Orion Nebula, for instance—you could see this interstellar medium with the naked eye; but mostly it was glimpsed through the telescope: a vague, luminous mass surrounding certain stars. By the middle of the nineteenth century, the telescope itself had started to make this stuff disappear: the visual confusion of the nebula now resolved into precise points of heavenly light. (In Ireland, the Earl of Rosse had built a telescope fifty-six feet long, with a mirror six feet in diameter, known as the Leviathan of Parsonstown. It was said the Bishop of Ely had walked the length of the instrument's interior, with his umbrella up.) But Nichol resisted the new evidence, and in his *Thoughts on Some Important Points relating to the System of the World* he admitted only that the nebular hypothesis had encountered some difficulties, not that it had been disproved.

Still, Nichol was not so attached to an obsolescing theory that he did not baulk at De Quincey's use of his text and its illustration. He later advised the oracular author not to reproduce the image in his collected works, because this vision of the nebula and its origins had been superseded. Nichol may also have been abashed by the exaggerations in his old friend's account of the nebula, especially his highflown description and Miltonic personification. When a later edition of the essay was noticed in the *Westminster Review*, the reviewer lamented that the passage seemed "more worthy of one whom the moon has smitten, than of one who gazes calmly at the stars." Worse, De Quincey had misattributed the image; he thought he was looking at an illustration based on Lord Rosse's recent observations, and not

one of Herschel's from twenty years earlier. It is not clear he even grasped the mistake he had made, even when he went back to the essay later, and consulted Nichol.

For De Quincey, his "errors" do not matter. Nichol, he notes, has "apparently misunderstood the case as though it required a *real* phenomenon for its basis." De Quincey by contrast is engaged in a type of poetic astronomy. (There is something similar, though on a vaster scale, in Edgar Allan Poe's essay "Eureka," published two years later.) The descriptive passage is a dream vision in the mode he had already perfected in his *Confessions of an English Opium-Eater*. In that book, under the influence of the drug but also of certain Romantic spasms of the unconscious, De Quincey dreamed of endless labyrinths in the style of Piranesi. He had Orientalist nightmares about the size and populousness of China, imagined the obscene and murderous kisses of a crocodile, experienced strange distortions of time and space by which he was flung back ceaselessly into his own past. The devilish or deathly being trapped in the Orion Nebula—he too seems tormented by such images, or such knowledge. "There is no such thing as forgetting possible to the mind," De Quincey wrote elsewhere.

Essay on Affinity II

I HAD BEEN USING (overusing) the word *affinity* and quite forgotten the places where I'd read it in recent years. It is in the nature of affinity—as distinct from influence—to give us these moments of forgetting, which we then mistake for our own originality.

I traced the word back, or happened on it again by accident. In the opening paragraph of Maggie Nelson's *Bluets*:

> Suppose I were to begin by saying that I had fallen in love with a colour. Suppose I were to speak this as though it were a confession; suppose I shredded my napkin as I spoke. *It began slowly. An appreciation, an affinity. Then, on day, it became more serious. Then* (looking into an empty teacup, its bottom stained with thin brown excrement coiled into the shape of a sea horse) *it became somehow* personal.

So an affinity is somehow unserious. Equivalent to, or maybe slightly stronger than, a pathetic *appreciation*. Which in its turn is a disreputable sort of semi-critical text, wherein the author hymns, lauds, exalts, commends. A type of criticism without criticism, a high-school examiner's way of speaking—*Appreciate this poem*.

What if you got trapped at the frivolous stage of affinity? Or taking (too) seriously the possibly sentimental gesture of mere

appreciation? I have always thought it was worth paying attention to actions or qualities routinely dismissed as *mere* when they appear in writing about art, literature, the world. *Mere description*, for instance, is in reality the most vexing thing to attempt when faced with any form of art, let alone aspect of reality. Or so it has seemed to me. Always and already *personal*, too. I wonder about Nelson's equating of appreciation and affinity: the second seems both more intimate and more tentative. More ambiguous too, allowing for the possibility that its attachment might fade—affinity *flirts*. And its seeming infatuation may turn out to be nothing at all, or a confusion, or all-out aversion. *Attraction of opposites*: this cliché has a peculiar history—chemical, psychological, aesthetic.

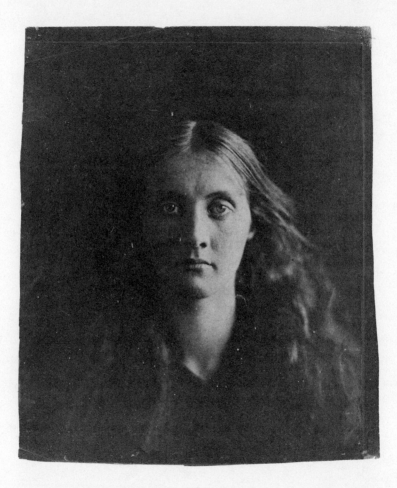

Vaguenesses

THE PHOTOGRAPH WAS TAKEN in 1867, four years after Julia Margaret Cameron acquired her first camera. A young woman stares from the dirty shadows of a wholly indistinct background. She addresses the viewer head-on. Half her face is brightly lit, most likely by a window to her left, and overexposed at nose and temple; the other half is all mottled shadow, apart from the white of her right eye and a highlight from the window. Her face is mostly in focus: hooded eyes, long nose, bow-shaped mouth, and the sort of strong chin and jaw that for some reason mark her out as mid-Victorian. Her hair is Victorian too: flat and parted in the middle—it looks like the photographer has focused here—and falling into an unruly fog about her shoulders, where it is hard to tell what is hair, what fabric, and what a more ghostly artefact of the photographic process. Actually, the whole picture is fraught with reminders of its mechanical and chemical origin: there are scratches and smears, ectoplasmic grey forms that loom above the subject's head. And a pure white snow of dust or chemicals flecks the lower half of the image.

The young woman in this photograph is Cameron's niece Julia Jackson, who was twenty-one when it was taken. She is unusual among the photographer's female sitters in that she gets to be just herself—the women and girls around Cameron are mostly suborned for allegorical ends, dressed and posed as mythic or literary figures,

while great men of the age (Alfred Lord Tennyson, Charles Darwin, Sir John Herschel) loom out of the dark, signifying only themselves. Julia Jackson looks at us straight, without the theatrical paraphernalia of costume, bodily attitude or poetic picture title. Which is not to say she is unposed or the composition unconsidered; the window light divides her neatly in two, her dress and the backdrop have been carefully chosen so as to fade to black, or near black. Still, there is something austere and open about the way she looks at us—we might even be tempted to say this is what makes the photograph look so modern.

Cameron photographed her niece more than fifty times, and almost always close-up, isolated in the dark. In an oval portrait also made in 1867, she turns her head toward the light so that her profile is outlined in white against a dark and blurred ground. This time, her lean, sinewy neck emerges from a modest but intricate white lace collar. She looks to the window and lowers her gaze a little, her face and expression are oddly familiar—Who does she look like? There is nothing obviously worked up, winsome or atmospherically excessive about Cameron's pictures of Julia Jackson, who by 1867, photographed among the drooping flowers of a dark hedge, had married Herbert Duckworth. (He died three years later.) Her face has thinned, her mouth turned down, and her hair is gathered under a white bonnet, which she wears far back on her head. A fluted or pleated white collar circles her throat, above the pure black— uncharacteristically for Cameron, hardly a flaw interrupts this expanse—of her dress. Her face is slightly out of focus compared to the collar, she has raised her head a little and she regards the photographer steadily but a touch quizzically.

Above all, in her aunt's photographs of her, Julia Jackson appears

to think. She looks familiar because she looks like her daughter Virginia Woolf, especially in profile. (After Herbert Duckworth died, his widow married Leslie Stephen.) Woolf wrote more than once about the eccentric great-aunt who had photographed her mother, many notables of mid-century and a cast of friends, acquaintances, and servants who were instructed to impersonate the Virgin Mary, Sappho, Beatrice Cenci, and numerous other figures from history and fable. Cameron appears in Woolf's only play, *Freshwater* (1935): she's an eccentric matriarch, well off and well connected, without a thought in her head for the demands of Victorian social convention. In 1926 the Hogarth Press published a selection of Cameron's photographs, and Woolf wrote a short biographical essay by way of an introduction. The essay is filled, like most accounts of the photographer's life and career, with peculiar moments of zeal or indifference on Cameron's part. She walks her houseguests to the railway station with a cup of tea in her hand. She flounces about in fabrics from India, where she was born, and if anybody compliments her on this exotic attire, she hands bits of clothing over at once, even tearing a scarf in two so that a visitor might go away with one half.

Woolf and her great-aunt were in most respects completely different artists. Cameron was a woman of considerable means who hit upon her medium in middle age, and became a tireless and even vulgar champion of her own work, whose merits she partly misunderstood. There are considerable elements of sentimentality and clumsy meaning-mongering in her work, and yet the photographs seem to point well beyond their allegorical and monumental intentions to a more modern way of seeing. In terms of their visual texture, Cameron's photographs are best known for her having subtracted from them—whether by design or accident—the sort of precision

that most artistic photographers strove for in the nineteenth century, and still strive for in some contexts. That is to say, her photographs are frequently blurred, though these blurs are not all of the same origin or type: some have to do with the shallow depth of field her lenses gave her, others with unpredictable movements from her sitters, and some are most likely results of bad habits in the darkroom. In her lifetime, the lack of distinction in Cameron's art was taken either as evidence of an eye for the picturesque or a sign that she simply did not know what she was doing. The jury of the Dublin Exhibition in 1865 opined: "There is no experienced judge who would not prefer these productions, with their manifest imperfections, to many of the best-manipulated photographic portraits which are to be seen." But A. H. Wall, in a review of her first exhibition at the South Kensington Museum in the same year, regretted the "palpable distortion arising from a misuse of the lens."

It is possible now to see the relative absence of focus in her photographs as a deliberate effort to capture something evanescent but particular. Cameron's venerable and accomplished male sitters and the long-suffering servants who stood in for figures out of the Bible, Shakespeare, and classical myth all had a quality of inwardness and reflection that was shared by her niece Julia. We shouldn't forget that Woolf, too, had a taste for historical burlesque—what else is her novel *Orlando*?—but what the two women shared was an artistic struggle to render as closely as possible certain fluxual states or (to use Woolf's phrase) moments of being that threatened to turn into abstract blurs. Despite herself, in some ways, Cameron really was a modernist photographer, maybe even the first to have mounted such a concerted attack, from right inside the plush precincts of high Victorian culture, on the values of clarity and realism.

Except of course we overstate things if we think of photography as a stable, truth-seeking medium in this or any other period. Better perhaps to think of Cameron as an artist who knew, at some level at least, that photography promised as much of mood, atmosphere, and character as it did a precise recording of the nature of things and bodies—but also knew that such vaguenesses could be rendered only by running against the current of most contemporary photographers, who aimed at precision and a certain realism even when their subjects were obviously staged.

Julia Margaret Cameron was born in Calcutta in 1815. Her mother was the daughter of one of Marie Antoinette's pages, and her father, James Pattle, a gentleman of riotous reputation who eventually drank himself to death. In her short preface on her great-aunt, Woolf recounts a tale about her grandfather's demise, or rather its aftermath. His corpse being preserved in rum for the passage home to England, "the cask was stood outside the widow's bedroom door." She was woken in the night by a terrific explosion, and rushing from her room discovered that the lid had blown off and her husband was sitting bolt upright, "menacing her in death as he had menaced her in life." Mrs. Pattle was said to have gone off her head, and died raving, but not before she had tried to send her pickled husband home and been thwarted by the wreck of the ship that carried his cask.

The details of Cameron's life are less picturesque, but Woolf notes that her great-aunt seems to have inherited "a strain of that indomitable vitality" that her father exhibited even in death. She was one of seven daughters; the others were renowned for their beauty—

Thackeray wrote a mawkish *Punch* article about one of them—but Cameron was short and squat and made up for her lack of grace with enthusiasm and eccentricity. (Such at least, as Janet Malcolm has pointed out in an essay on Cameron, is the cliché that inevitably attaches to a woman artist of that period.) She was educated in France, returned to India in 1834, and in 1837, on a trip to South Africa, met her husband, Charles Hay Cameron: a jurist in India and later owner of coffee plantations in Ceylon. They were married in 1838. While at Cape Town, Julia Margaret Cameron had met and befriended the astronomer John Herschel, who had an observatory nearby. He introduced her to photography in 1842, just a few years after the official announcement of the invention of the medium. (Official, that is, in France, where the discoveries of Daguerre were presented to a joint meeting of the Académie des Beaux-Arts and the Académie des Sciences on 7 January 1839. A handful of others, including Daguerre's French associate Nicéphore Niépce and William Henry Fox Talbot in England, had successfully made and fixed photographic images already.) But it would be a full twenty years before Cameron began to take her own pictures.

The Camerons moved to England in 1842, and lived in turn at Tunbridge Wells, East Sheen, and Putney. In India, where Charles was involved in drawing up new laws, they had been at the centre of colonial society. Now they were attached to a more artistic and literary milieu, thanks to Julia's sister Sarah and her husband, Thoby Prinsep, newly established at Little Holland House in Kensington. Here Cameron met Ruskin, Holman Hunt, Thackeray, Tennyson, and George Eliot—most of them would become her sitters. In 1860 Charles and Julia moved again, to the Isle of Wight, where they set up home at Freshwater. It was here, before long, that Cameron's

photographic career began. In 1863 her daughter and son-in-law gave her a camera, and wrote: "It may amuse you, Mother, to try to photograph during your solitude at Freshwater." For a long time— Woolf assumes as much, for instance—this was thought to be Cameron's first practical experience of photography, but it seems Herschel had not only described or shown the new invention to her twenty years before, but had continued to send her examples of his own photographs, and in framing and displaying the work of her friend and mentor she must have given some thought to aesthetics as well as technology.

Cameron used the wet-collodion process: the most common at the time. Collodion was the syrup result of dissolving guncotton— one of the new high explosives devised in the middle of the century —in ether and alcohol. It was combined with potassium iodide and poured, in the darkroom, onto a polished glass plate, which then had to be sensitized in a bath of silver nitrate before being exposed (still wet) in the camera. Once exposed, the plate was returned to the darkroom to be developed in pyrogallic acid, then washed and fixed with sodium hyposulphate ("hypo") or cyanide. The negative was then varnished, and positive prints were made by placing it on albumen paper and exposing the whole to sunlight. There were numerous opportunities for error during these procedures, and Cameron seems to have fallen foul of all of them. In time she embraced her mistakes as the markers of her photographic style, and so did a wide public.

Within a year of acquiring her first camera, after much trial and error and staining of clothes and hands with chemicals, she had produced the photograph she called her "first perfect success": a head-and-shoulders portrait of a young girl called Annie Philpot.

In several ways it is unlike the works for which she became celebrated and sometimes mocked, and it points the way, whether Cameron knew this or not, to a strain in her work of intense focus on expression, especially about the eyes. Little Annie, who is eight and has lost her mother and is staying with her guardians on the Isle of Wight, wears a thick dark buttoned-up wool coat, one of whose buttons might be the only thing properly in focus in the whole picture. The light falls from the top left onto her slightly matted hair. (Cameron had repurposed a chicken shed at Freshwater to become her glasshouse studio, and you can tell there is some daylight behind the girl too.) Annie is in half-profile, and looks away to the left: the eye closest to us is a grey blur, the other a little sharper.

The effect of this wayward focus on the face—it comes back time and again in Cameron's portraits—is that we seem to apprehend the duration of the child's gaze. In a literal way that is exactly what we are looking at, because exposure times of several minutes meant her sitters, especially the children, were likely to shift their gaze and so appear, dreamily, not to have focused properly either. But the most striking thing about the portrait of Annie is just how informal it feels for an image produced under exacting, uncomfortable conditions. The child could have been cropped out of a street scene of the mid-twentieth century, such is the delicate contingency Cameron has captured. Cameron later wrote of the photograph of Annie: "I was in a transport of delight. I ran all over the house to search for gifts for the child. I felt as if she entirely had made the picture." (Look closely at an original print or a good reproduction and you may think the child has been crying; in fact the "tears" are evidence of Cameron's mishandling of her chemicals, and similar streaks appear on the pale cheeks of many of her subjects.)

Annie Philpot is unusual in having been photographed with no attendant adults and no meaningful scenography. Elsewhere Cameron shows children held fast in the arms of various women, the triangular arrangement of Madonna and child serving to organize the allegorical embodiments of such virtues as Faith, Meekness, Temperance, Gentleness, Goodness, and Long-suffering. In 1865 she photographed her two-year-old great-grandson Archie, half-dressed and asleep on velvet cushions. The scene recalls contemporaneous photographs of deceased children, which were often taken when no pictorial record existed of the living child—it's one of those Victorian mourning practices whose morbidity or "creepiness" is easily and commonly exaggerated today. Still, there is something unsettling about the slumberous infants in Cameron's work, plonked among cut flowers or deposited on beds of straw, out of focus and out for the count while robed women hover solicitously above them. Cameron constructed complex poses among her less famous and more symbolic sitters, but sometimes it seems the children would not cooperate, or there were none available, so at times she inserts them into the composition via the clumsiest kind of photomontage, simply appending one print to another. In *Daughters of Jerusalem* (1865) the three women of the title loom above an out-of-focus floral arrangement, and below that, tipped in from a separate session, lies the infant, dead to the world like a specimen in a shallow vitrine.

The obviousness of Cameron's combination prints does not exactly set her aside from her photographic contemporaries. It was common, for example, to add a separate print of the sky to landscape

photographs, because it was impossible to expose for both: skies would typically turn white. What looks artificial to us today did not necessarily look that way to the Victorian eye. The artifice, however, that many critics could not accept during Cameron's lifetime, or for many decades after her death, accompanied her taste for elaborate tableaux. For most of the history of photography, critics—but notably not the general public—have found the staged photograph to be untrue not only to life but to the medium itself. In 1873, by which time Cameron had been famous for close on a decade, the *British Journal of Photography* claimed of her: "For the so-called art photographs it is impossible to find any terms of praise. They are weak and thin: the fancy in them is of the most mechanical; and the compositions show claptrap and pose plastique of the most wooden type."

Here is the kind of thing this critic must have had in mind. In 1864 Cameron made two pictures titled *The Five Wise Virgins* and *The Five Foolish Virgins*. As expected, the young women in the first photograph are holding lamps as they crowd into the frame, dressed in robes that look suspiciously like blankets. The girl in the middle is wearing something darker; she stares dolefully away to the right. Three of the others are in profile but the one on the far right, whose dress has taken up a little too much of the image—Cameron has also managed to cut off the top of her head—stares at us with an uncertain look, as if she might ask what she's meant to do now with the candleholder in her hand. Did Cameron intend this look that threatens to break the spell, reminding us of the fussing and hypo-stained figure behind the camera? Was she content to have the same girl blur the representation of the foolish quintet by moving? Or to have the roof of her glasshouse so obviously visible above their

heads? It is hard to say, though a critic from the *Photographic Journal*, seeing the two pictures in Dublin in 1865, was sure something was wrong: "It is difficult to distinguish which are the 'Wise' and which are the 'Foolish,' the same models being employed for, and looking equally foolish in, both pictures."

Once more though, something escapes the limitations—theatrical this time instead of technical—of Cameron's overambitious art. What fascinates, a century and a half later, is the range of expression on the young women's faces, the inwardness that persists in spite of the crude getup and absurd scenography into which they've been cajoled. Whether bored, benign, melancholy, or (as in the case of that girl on the right) confused, they seem emotionally to have exceeded the brief of Cameron's biblical fancy. So that stared at long enough (just as Cameron's camera looked at them for five minutes at a time to get these pictures) these servant girls and assorted orphans whom Cameron took into her household start to resemble the monumental male geniuses represented in the bulk of her most famous portraits.

Those portraits are by turns sublime and absurd, evidence alike of Cameron's hagiographic attitude to the great men of her acquaintance and of her uncanny ability to cast them as pure forms or emanations of light. Two years after taking her first photograph, Cameron began using a camera that held larger plates and allowed her to get closer to her subjects. The result was a strain of intense and close-up portraits in which the sitter seems to come out of the dark at us, his or (less usually) her head floating against the black ground. The best example is the series of studies she made of Herschel, with his halo of white hair looking increasingly spectacular, for all the world (she and he must have known) like a nebula

glimpsed with a telescope. Here she emphatically knew what she was doing: to achieve this effect Cameron had shut out most of the light, swathed the old man in black velvet, and ruffled his hair at the last minute. The tricks did not always work. Her portrait of Charles Darwin, for example, looks much like any other, apart from the depth of darkness against which he is photographed—it's a portrait entirely without psychology. Whereas Cameron's pictures of Tennyson, which initially seem weak because he does not look quite the same person from one to the other, are in fact ideal representations of the most celebrated writer of his era: a laureate on the run from fame, trying his hardest, it seems in these photographs, to disappear.

As with her homemade tableaux, it is not always possible to take these portraits as seriously as Cameron did. The comical side of her "great man" pictures is surely in the beards: those huge silvery masses that fall teeming over the frock coats of prophetic figures such as the largely forgotten literary figure Henry Taylor or Cameron's husband, Charles, who is the most visionary (and properly biblical looking) of the lot, with his great mane of white hair and the beard rippling away like a waterfall. Cameron could not help adding him to her allegorical array—he made an exquisite old Lear allotting his kingdom, topped with a tiara and clutching an ornate walking stick, his daughters flitting about his velvet robes.

Cameron's photographic career, at least in its popular and curiously original phase, was really rather short. She and Charles moved to Ceylon in 1875. Charles had long since retired and become both an invalid and recluse; now his coffee plantations were in trouble but

he also longed to be back in a climate and culture he loved. She seems to have given up on allegorical arrangements and concentrated instead on straight portraits and group shots. Except that they are still unconventional in their highly selective focus and the extraordinary gazes that meet us in these pictures as in her earlier work. *A Group of Kalutara Peasants* (1878) is a whirl of unfocused vegetation in the background—the nature of the blur this time suggests it was to do with a peculiarity of the lens—while in the foreground three figures lean against a tree. Cameron's original caption read: "A group of Kalutara peasants, the girl being 12 years of age and the man saying he is her father and stating himself to be 100 years of age." The latter is a shrunken figure whose eyes are so pale you would think they're afflicted with cataracts were it not for the sharp black dots of his pupils, perfectly in focus.

When Virginia Woolf put together the book of her great-aunt's photographs, they had languished out of fashion since her death. Cameron had been famous for a while, celebrated by the popular press, and frequently denigrated by specialist journals for the perceived technical failings in her prints. She had been partly rehabilitated in the preceding decades by the attention of the American photographer, publisher, and gallery owner Alfred Stieglitz, who saw in her resistance to visual exactness a precursor to the blurred and often near-abstract pictorialism of the turn of the century. Cameron entered the canon of photography slowly, helped in part by the influential critic Helmut Gernsheim, who wrote a book about her in 1948. But her current status—major museum shows began in the 1980s—surely owes a good deal to the renewed respectability of "staged" photography, whether in the layered self-presentations of Cindy Sherman or the complex scenarios constructed by Jeff Wall.

The blurring of distinctions between art photography and performance in the 1980s and '90s meant Cameron started to seem less of a Victorian curio, more an artist with a keen eye for the invention of scenes, narratives, and personae. And the fault line in her work between all those darkling male geniuses and obscure women arrayed and arranged to mean a great deal—this has made her all the more intriguing to curators, critics, and contemporary audiences.

Woolf's essay tells us that on her safe arrival in Ceylon in 1875 Cameron was so overcome with gratitude that she began raising money to present the ship's captain with a harmonium. The house where she and Charles settled was surrounded by trees, and rabbits, squirrels, mynah birds, and a tame stag wandered in and out. Cameron kept up her sociable habits, and covered the walls of her home with her photographs, making all her visitors sit for their portraits still. She had four years at Kalutara, and then: "The birds were fluttering in and out of the open door; the photographs were tumbling over the tables; and, lying before a large open window Mrs. Cameron saw the stars shining, breathed the one word 'Beautiful,' and so died."

A table of alchemical symbols arranged in a grid, with the following legend below:

∿ Esprits acides.	▽ Terre absorbante.
Acide du sel marin.	SM Substances metalliques.
Acide nitreux.	☿ Mercure.
Acide vitriolique.	Regule d'Antimoine.
Sel alcali fixe.	☽ Argent.
Sel alcali volatil.	
♀ Cuivre.	♄ Soufre mineral. [Principe.
♂ Fer.	Principe huileux ou Soufre
♄ Plomb.	Esprit de vinaigre.
♃ Etain.	▽ Eau.
Zinc.	⊖ Sel. [denta
PC Pierre Calaminaire.	Esprit de vin et Esprits ar
☉ Or.	

Essay on Affinity III

EARLY IN *ON BEING BLUE*, William H. Gass embarks on an etymological adventure around the word and the colour. "Blue: bright with certain affinities for *bael* (fire, pyre), with certain affinities for bold. Odd, well a bald brant is a blue goose." With its bubbles and baubles of alliteration, Gass's writing is here also "bright with certain affinities"; he wants subject and style to be allied and affianced. What an idea, *bright with affinities*, as if affinity were a luminance or coruscation, a fizzing halo of possibilities. Which is, according to Gass, just what happens to words: "So a random set of meanings has softly gathered around the word the way lint collects. The mind does that. A single word, a single thought, a single thing, as Plato taught. We cover our concepts like fish, with clouds of net." Note the cheap rhyme of "thought" and "taught": Gass's prose performing again the labour (or the accident) of affinity, finding charms and allurements at every step, in every sentence.

Affinity: the usual caveats and clauses apply when we go in search of origins and attachments. Chasing etymologies is a sentimental habit of the critic and essayist, and one I cannot give up. Roland Barthes, who blesses such adventures, describes his own addiction thus: "His discourse is full of words he cuts off, so to speak, at the root. Yet in etymology it is not the truth or the origin of the word which pleases him but rather the *effect of overdetermination* which

it authorizes." The point is to come back with surprises, not having divined the source but various peculiar tributaries, some of which seem to flow in the wrong direction. To find affinities, as Gass puts it—which makes my excursion around the word itself especially awkward and self-conscious.

But look at these treasures. The OED points first to affinity as a type of relation—but how intimate? From the fourteenth century at least, the word meant family connections other than those of consanguinity: contracted by marriage, as in the case of the married couple itself, but drawing in others. Families too might be affined or affianced. As a volume of Anglican canon law has it in the early eighteenth century: "Affinity is a Civil Bond of Persons, that are ally'd unto each other by Marriage or Espousals." Over more or less the same span, *affinity* means precisely a relation of blood. In Susanna Centlivre's 1712 comedy *The Perplex'd Lovers*: "Cousins may couple for all their Affinity." The modern meanings seed and ramify from here, though retaining some vagueness or even contradiction—is affinity a formality or a feeling, a physical state or a psychic one? The last is a specifically Catholic notion: a condition of affinity exists between godparents and a child baptized or confirmed. (There's an affinity too between the godparents themselves.) A ceremonial as well as spiritual connection, a state of mutual dependence. The musical instruments of a group or orchestra have affinities. The arts have affinities, if only metaphorical: poetry paints the world, while painting describes or narrates it. *Affinity* has here begun to signify likeness or proximity as well as alliance.

Similarity, resemblance, common ground: these senses proliferate from the sixteenth century onwards. Affinity might be a material, organic connection, as in this sentence from Thomas Elyot's *Castel*

of Helthe, in 1541: "By reason of the affinitie which it hath with mylke, whay is convertible in to bloude and fleshe." Just as likely, an intellectual or aesthetic association; here is Herbert Read in *The Meaning of Art* (1931), discussing Cézanne and Picasso: "These artists have a greater affinity with the anonymous artists of the Gothic period than with any artists of the intervening period." In 2004, the author of a short anonymous (it sounds like Peter Schjeldahl) review in *The New Yorker* described the artist Rachel Harrison as "a frisky, enigmatic bricoleuse with affinities to Jessica Stockholder and Franz West." Among languages there are also affinities, chiefly structural; in 1659, in *An Exposition of the Creed*, the English theologian John Pearson noted: "We know the affinity of the Punick tongue with the Hebrew." *Affinity* as liking or attraction arrived late, deriving from physical and spiritual states rather than judgement, intention, attitude or desire—though it comes to encompass all of these, in complex and sometimes contradictory ways. Charles Estienne, in a sixteenth-century study of agricultural methods, on the best technique for pacifying bees: "he shall smoake all with Oxe dung burnt; for this dung, by a certain affinitie, is gratefull and well liked of Bees."

So far so familiar, when it comes to the multiple and married meanings of the word. What I did not expect: that among this litany of relations would be at least two items or entries that point up the sundry or manifold. I had not known that *affinity* once meant (and so might mean again) a gathering of like or like-minded people. Until the middle of the seventeenth century, the word could name not just the relationship but the relations: *affinity* meant family. And from this deployment of the term, it was possible also to speak of a group, a gang, a camp as a kind of affinity. I love this unforeseen inflection: *affinity* as retinue or entourage, as diverse but determined

clique or claque. Perhaps it is not easy to distinguish such an affinity from a mob, herd or crowd—but I want to assert its difference, I want to travel with an affinity that is discreet, diverse, loosely convened but moving with purpose. I want each book I write to be an affinity of sorts, and within it each essay or fragment in turn an affinity of ideas, images, moods and citations. It is not enough to want this—you have to perform it, and one of the perils of writing is that I may only describe my affinity, and fail to embody it.

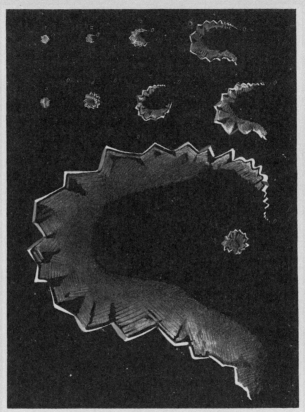

PLATE XXV.

Figs. 1–4. Early stages of sinistral Teichopsia (see p. 256) beginning close to the sight-
point, as seen in the dark. The letter O marks the sight-point in every
figure.

Figs. 5–8. A similar series of the early stages of sinistral Teichopsia beginning a few
degrees below and to the left of the sight-point.

Fig. 9. Sinistral Teichopsia fully developed. δ. Beginning of a secondary attack, which
never attains full development unless it arise on the opposite side.

A Bright Stellate Object, a Small Angled Sphere

I WAS FIFTEEN YEARS OLD when it first appeared. I'd cycled to school as usual, survived a flummoxing maths lesson without shame, settled into the day's second period and opened my science textbook, when I found I could not see straight. I blinked hard at the page. Something remained in the way. I tried to get the object in focus, the better to banish it, but it would not resolve. The thing was not exactly *there*, no blurred patch or dark hole in space, instead pure absence, as if one side of reality had simply dropped away. I remember thinking that whatever this was, it would be hard to put into words. I looked up from the book and there the nothing was still, obscuring several classmates, half the blackboard and an array of chemistry equipment on the teacher's desk. Surely I was going blind.

I must have seemed in some distress because this teacher, a sour and sometimes violent man, quickly sent me home. (It occurs to me only now, thirty-seven years later, to ask: why would you let out into the streets a teenager in your care, who suddenly could not see?) I cycled four miles through the South Dublin suburbs in a state of extreme anxiety, more for my sight than my safety. For a while in my teens I was a reckless and inattentive cyclist, and had ridden

twice into static cars on my way home from school—but I was sure now that habit and what remained of my vision would get me home. When I was a few minutes from the house, an old man with a walking stick started to cross the road ahead of me, vanishing into the void in my field of vision, emerging again on the footpath opposite, just in time.

The pain set in while I was still cycling, and as I was heaving the bike into our garden shed my head throbbed violently. I had never felt the like in my life. In the kitchen I tried explaining to my mother that I had a headache, but I had forgotten the word—instead I told her I had a grenade, a really bad grenade. It must have been she who first used the word *migraine*. The pain was now so fierce I could hardly speak, but my vision had begun to clear as I went up to bed. It was now late morning. My mother closed the curtains, and I spent the afternoon curled there, actually whimpering. Some pains, so we say, come in waves; this one seemed to arrive like a tide, saturating mind and body. I kept thinking the day must be done, but I'd look at my alarm clock and find only a few minutes had passed since I last checked the time.

Around six in the evening I got up and vomited, went back to bed, found the headache had faded, and went downstairs for dinner, feeling as if I'd been sluiced or drenched (imagine a sheep dragged from its chemical dip) and I'd risen lighter, cooler, made of air. My father was home from work, my brothers from school; I think we all knew that if it was a migraine, this was something a person might be prone to. But the subject was soon dropped, and I sat that evening in front of the television (not, I learned later, a very good idea during or after a migraine) silently amazed at what had happened.

Years later, when this sort of episode returned, I could spend days

afterwards feeling stupefied and weary, also fretful in case it happened again before very long. But aged fifteen I quickly forgot about the pain and fear, and there were no physical aftereffects the following day. I was left only with a sense that for the hour or so that I could not see properly, something inside me had been switched to another channel, been partially detuned or afflicted with interference—*snow*, as we used to say when it happened on the TV screen. I felt, in other words, a little less human, oddly electronic. The feeling, it seems, is not unique. In the medical archive of the Wellcome Collection in London, there is an anonymous drawing from 1985 (the year of my first attack), a self-portrait in which the patient's face is obscured by the "Migraine Computer": something like an arcade game of the period, with joystick and screen, on which a jagged form seems to pulse and glow.

Here is another picture, if that is the right word for an image that depicts or describes the interruption of vision. The illustration is mostly a field of black—richly printed, in its first published version, by G. West & Company—on which appears a series of white forms, built up in zigzag or herringbone strokes, like fine Elizabethan brickwork. The largest forms pointed or appointed in colour. Subsequent reproductions, especially in black and white, tend to miss the jewellery quality of what is laid out on the inky velvet ground. A trove, a cache, the spoils of a dream heist: quite unreal, instead conjured, abstracted, fantasized. There are ten of them, these—what? Entities? Artefacts? Apparitions? Eight arrayed in the upper quarter of the image, in two rows. Left to right each row records the birth and

growth of the thing, from a spark that's hardly there at all, contending with the dark, to a small *c*, then its uppercase sibling *C*, and finally a shape like the claw of a crab or lobster, snapping away at the righthand edge of the image. Image of what, exactly?

The form, at first zygotic, as if something is really coming to life, also reminds me of diagrams we were made to draw at school of a river's meanders, slowly orphaned from the main stream and turned into oxbow lakes. Hard to look at the shapes in this darkling image without falling (or is it ascending?) into metaphor. I'm not the first to say immediately what they remind me of, to say what they are not. Below the eight smaller figures—which are numbered in tiny white superscript, as though footnoting features in a landscape—sits the largest of the ten, like a mountain range at dawn, its peaks catching the light while lowlands remain in shadow. An unassailable redoubt, a fortification made by the earth itself. And over on the right: a settlement of sorts? A burial mound or ring fort? The final form, which suggests the whole thing may be starting to sink away, like an archaeological remnant.

Enough metaphorical diversion: *concentrate*. What you are seeing is a *scintillating scotoma*, one of many manifestations of migraine aura: a bout of physical, mental or emotional disturbance that precedes the arrival of pain but may follow, too, the end of the headache itself. To scintillate is to sparkle, to give off sparks. At the time this image was made, *scintillating scotoma* was not yet the name for the phenomenon it shows, although the form and its vibrations or coruscations were well known, if not understood. The image derives from a paper published in 1870 in the *Philosophical Transactions of the Royal Society*. It was written by the English physician Hubert Airy, and "communicated" to the Society by the author's father,

Sir George Airy, who held the post of Astronomer Royal from 1835 to 1881. The article is titled "On a Distinct Form of Transient Hemiopsia," and in it Airy *fils*, who has been both observer and patient, notes "the outward spread of the cloud, its arched shape, its serrated outline, with smaller teeth at one end than at the other, its remarkable tremor, greater where the teeth are greater, its 'boiling,' its tinge of scarlet, and its sequel of partial aphasia and loss of memory."

These are all, Airy writes, "new features," unrecorded by any previous researcher in the field. He had himself already attempted, two years before, to capture the visible aspect of aura, if not its more elusive emotional and intellectual symptoms: "A bright stellate object, a small angled sphere, suddenly appears in one side of the combined field." He had first experienced it in 1854, as a student of eighteen:

> In its height it seemed like a fortified town with bastions all around it, these bastions being coloured most gorgeously. If I could put my pen into the space where there was this dimness, I could not see it at all, I could not even distinguish the colour of the ink at the end. All the interior of the fortification, so to speak, was boiling and rolling about in a most wonderful manner as if it was some thick liquid all alive.

The kernel grows, ramifies like a crystal, feathering like frost on a windowpane. These mixed metaphors are mine, but Airy, whose very name seems suited to describing evanescence, has already supplied his own imagery. It is like looking through watered silk, he tells us. The points of the scotoma resemble the erect tails (or does he mean fins?) of sharks, or sharp waves on windblown water. They

are like abstract details in a mosaic or a Turkish carpet. Airy's most striking comparison, however, is this: "It may be likened to the effect produced by the rapid gyration of small water beetles as they are seen swarming in a cluster on the surface of the water in sunshine." Years ago, in high summer, walking in woods by a shallow canal or "leat"—the place had once been a gunpowder factory—I spotted just such a cloud of insects teeming on the surface, and I stopped and stared long enough to get my phone out and make a video of this congregation of excitable creatures, which are so slight they might themselves be made of water, air or light. Their crepitations on the surface of the water are so subtle that it hardly moves, and you can see the pinpricks of their feet in the meniscus, holding it down like the tufting of a mattress. They don't look much like a scintillating scotoma until a shadow falls on the water—the shadow of my phone, for example—and the startled water beetles skate about in panic, drawing ripples and wakes that do indeed, Hubert Airy is right, call to mind the restless geometry of the scotoma.

The visual effects—*special effects*, we might say—of migraine had been well known to early medicine. Among the Greeks, Hippocrates writes of one sufferer who in advance of pain and nausea "seemed to see something shining before him like a light." Optical oversensitivity is typical, says Aretaeus of Cappadocia: "For they flee the light; the darkness soothes their disease." The illness known in English as *megrim* was not always associated with seeing things (or not seeing things); historians of medicine have gone looking for unsuspected migraine in descriptions of strange, jagged visions. Blaise Pascal sometimes saw a cavity or precipice gaping away to his left, and in his manuscripts would insert peculiar zigzag patterns reminiscent of migrainous designs of eye or mind. And here much

later is Hilary Mantel, in her memoir *Giving Up the Ghost* (2003), describing her own symptoms: "Small objects will vanish from my field of vision, and there will be floating lacunae in the world, each shaped rather like a donut with a dazzle of light where the hole should be. Sometimes there are flashes of gold against the wall, darting chevrons, like the wings of small quick angels."

Transient teichopsia, Airy called his own spiky visions. *Teichos* means wall, denoting a resemblance to the angled walls of a fortified town. Architectural visions, in other words: Airy's father, who drew his own interpretations, said they were like "the ornaments of a Norman church." The younger Airy was struck by the prevalence of this affliction among learned men, especially scientists, more especially astronomers. Perhaps their eyes were taxed by reading or by the rigours of minute and distant observation. Whatever the cause, according to Hubert Airy such patients' professional skills meant they were well equipped to describe their symptoms: "The votaries of Natural Philosophy are especially qualified by their habits of accurate observation to contemplate attentively any strange apparition, without or within."

One final image or metaphor from Airy's repertoire. The zigzag figure, he writes, is "a veritable 'Photograph' of a morbid process going on in the brain." Scare quotes aside, and the weakening effect of "veritable," this is still an extraordinary statement. It has required some considerable labour and skill to bring Airy's "Diagram of Transient Teichopsia" before the members of the Royal Society and the readers of their journal. First the art of Airy's original, and second the efforts of G. West & Company to convey accurately the colours and shading of Airy's illustration. But what they had communicated, Airy now tells us, was itself a representation of some process unseen,

which makes of the patient, natural philosopher or not, a kind of camera, but a camera that can see what is not there.

I was not, it transpired, very prone to migraine, at least not in my teens: one or two more attacks before I left school, and then nothing. At college, a couple of false alarms when the aura arrived while I was reading at the library, but no headache or nausea followed. Eventually, when sympathizing with friends or colleagues, I talked about migraine as something I'd fleetingly suffered when I was young. And then, around forty, a sudden reprise, this time obviously linked to sleeplessness, fatigue or exercise. And now, also, with more pronounced auras: a sense of intellectual and creative confusion or abeyance, wildly varying levels of pain and a long, anxious, sometimes even tearful *prodrome* (as I learned it was called) lasting days. In the autumn of 2018, a year or so into an academic post for which I was insanely unsuited, and which I worried would stop me writing for good, I spent a week in a cycle of near-blindness and incredible pain, unable to look at a page or screen, or even out of the window, in case it started up again—which it did anyway, in spite of precautions. In my perplexity I took so many painkillers that when I closed my eyes I seemed to be speeding through a sort of tunnel lined with ornate, spangled fabrics. A hypnagogic horror show—also very kitsch, very "psychedelic."

Recently, I've narrowed my incidence of migraine down to a single, avoidable circumstance: during early-morning runs, I should not complete more than three or four circuits of the large complex of flats where I live without a rest. Otherwise, within an hour or so,

just as I'm settling in to the day's reading or writing, the page will start to blur, a certain unreality arriving at the same time, and I'll turn my head away from my notebook or laptop and catch the first germinating twitch or flash of the scotoma. Hubert Airy's architectural fantasia being birthed, persisting *in nucleo* for a while, hard to place in the field of vision, as if the eye had been caught by sunlight on a faraway window, a boat at sea, a car speeding out of view in the distance. Sometimes, because usually these days the pain, if it comes, is not so severe, or may be kept at bay with immediate Tylenol, I will calmly close my eyes and watch the bright fortification being built, filling a portion of my sight on one side or the other, slowly floating towards me. And at such moments I always think of George and Hubert Airy, with their more or less elaborate sketches, detailed letters describing the latest manifestations, expanding vocabulary for what they are seeing. And once or twice I've caught myself trying to hold onto and list—forgetting words is a common symptom— some terms for the bristling shapes I'm seeing. *Rampart, bulwark, parapet, buttress, outwork, projection, breastwork, redoubt, barbican.*

Essay on Affinity IV

A RELATION OF BLOOD OR MARRIAGE, a kind of love or attraction, a species of similitude, alike entities as they move en masse: all of these meanings of *affinity*, more or less vernacular in nature, are present in the scientific use of the term. Uses, rather: as the philosopher Isabelle Stengers (my principal guide to the history in question) has written, *affinity* belongs to no specific discipline. During its long journey through the sciences, the word has denoted resemblances in structure, property or composition between animals, plants and minerals. But it is in chemistry that *affinity* has had the most precise and profound meaning. The concept, according to Stengers, "has had a genuine history marked by a succession of sudden developments, in which the relationship between chemistry and physics came into play at certain crucial points."

Understood in the most fundamental terms, *affinity* can be traced to the origins of metaphysics and natural philosophy in the thinking of the pre-Socratics. The atomic theory of Democritus; the fiery universe of Heraclitus, in which opposites combust and combine: these are precursors of the theory of affinity. In the verse fragments of Empedocles the four elements (earth, air, fire, water) comport themselves in ever-changing relations brokered by the powers or principles of love and hate—or synthesis and sundering. As Stengers has it, the alchemists of the Middle Ages, with their ambitiously

refined understanding of different modes of action and transformation, are inheritors of the mutable cosmos of the pre-Socratics. Alchemists such as the thirteenth and fourteenth-century writer known as "Pseudo-Geber"—his work for a time being attributed to an earlier Islamic author—produced litanies of possible mutations of matter, including sublimation, distillation, dissolution, fixation, ceration (softening, becoming like wax) and coagulation.

In his writings on metallurgy, Pseudo-Geber also devised lists or tables of relations between elements—hierarchies of affinity. In the case of mercury, for example, the list of substances with which it will most readily react, in descending order: *gold>tin>lead>silver>copper>iron*. In ascending order of propensity to react with sulphur, he lists the same elements in another order: *gold<tin<silver<lead<copper<iron*. Such hierarchies would later become essential to modern chemistry: in the work of scientists such as Étienne-François Geoffroy in the eighteenth century, writes Stengers, "the construction of ever more comprehensive, ever more precise tables, became one of the classic tasks of chemists across Europe."

What did the adepts of affinity imagine they were measuring? It was not the attraction of like to like; in fact, Stengers says, the modern concept of affinity was a rejection of the idea that substances act upon each other because of some resemblance or similitude. In the affinity tables, "the order of the series is determined by the capacity of the reagents to displace and replace another reagent in the series associated with the substance in question." In this version of the concept, affinity involves attraction and susceptibility, but also a usurping violence. It sounds like a matter of force or mechanics, but the doctrine of affinity was formulated against the quantitative world of force described by Isaac Newton. However rigorous the

efforts of chemists to tabulate affinities, they still seem to be studying something quite mysterious—a sensitivity that belongs to matter itself.

A kind of intention even? Chemical affinity began to be described as *elective*. It was not only a question of specific relations between elements, but also of exclusivity: for one substance to "choose" another meant the rejection and ejection of alternatives from the realm of the reaction. Although the whole theory of chemical affinity had begun to recede by the end of the eighteenth century, it's this concept of election that Goethe lights on and elaborates in his *Elective Affinities* (1809) to describe the atomic dance of human sexual and romantic relations. The chemical sense of *affinity* had begun as a metaphor drawn from connections through blood and marriage. Neither of course is the "real" meaning of the term. Chemistry speaks of love, and a literature that wants to reflect on love and desire (at a strangely nonhuman level) adopts the language of chemistry and the architecture of the affinity table. In 1858, the English polymath William Whewell—he was the coiner of, among other terms, *scientist*, *physicist* and *linguist*—wrote in his *History of Scientific Ideas*: "We are here to imagine not mechanical action, not violent impulse, not antipathy, but love, at least if love be the desire of unity."

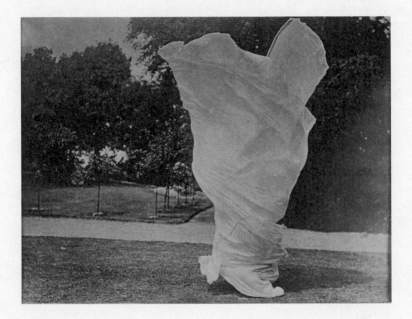

Beautiful Scenic Effects Are Produced

IN THE AUTUMN OF 1892, Marie Louise Fuller left New York, where she enjoyed modest success in vaudeville, and travelled to Paris intent on reinvention as a dancer. Loie, as she'd lately begun to style herself, had secured an interview with Édouard Marchand, director of the Folies Bergère; she planned to perform for him a "Serpentine Dance" she'd devised the year before. But stepping from her carriage on the rue Richer she was startled by a poster advertising the theatre's current attraction: a young woman wreathed in silk and billed as the "Serpentine Dancer." Her name was Maybelle Stewart, and it seems she was too well acquainted with Fuller's recent appearances in New York. "Here was the cataclysm, my utter annihilation," Fuller wrote later. Trembling, she went in to watch the usurper's matinee performance. "The longer I danced the calmer I became." Stewart, it turned out, was terrible. "I could gladly have kissed her for her...inefficiency." When the theatre emptied, Fuller put on her own curious billowing costume and auditioned for Marchand. By the end of the day, the hapless Stewart had been dismissed.

Fuller went on to dance three hundred consecutive nights at the Folies Bergère. Parisian intellectuals were in the midst of a craze for

the music hall, and she recalled in her memoir, *Fifteen Years of a Dancer's Life* (1913), that writers and artists threatened to crowd out regulars. What exactly had they come to see? Fuller's act involved seeming acres of white silk, her gown extending into vast wings that the dancer manipulated with concealed wands made of aluminium or bamboo. (We know this kind of detail in part because Fuller secured several patents for her costumes and stage machinery—with the serpentine dress, according to the text of US Patent No. 518,374, "beautiful scenic effects are produced.") The Serpentine Dance, by which she created the swirl around her almost stationary figure, was just one of a dozen variants on the principle of a body consumed by movement. Also by light and colour: while at the Folies Bergère she perfected her "Fire Dance" with the aid of a glass trap in the stage and a red lamp trained upward on her seething form.

You can get some sense of the sheer strangeness of these performances—less, however, of the immersive atmosphere she conjured around them—by looking at several films by Léon Gaumont, Georges Méliès, and the Lumière brothers. It's not clear if Lo Lo (as the French knew her) actually appears in any of these; the dancers seem to be imitators, or perhaps members of Fuller's expanding troupe. The scenes in which they're inserted are occasionally absurd: the Serpentine Dancer rises from the earth like an apparition, or is clumsily match-cut into existence from a fluttering bat clearly made of paper. But suddenly there is the dance itself: a succession of surging forms, equivocating violently between figuration and abstraction. Facing the camera and rippling the costume just a touch, she draws a snaking vertical line with the vast cuffs of her dress. seen in profile, she seems to swim in a silk ocean. Now, large discs of fabric spin either side of her like industrial saw blades. At her most extreme,

she disappears inside a cylindrical tower of cloth, like some pupal thing immured in its cocoon.

How had Fuller become this prodigious creature, this explosion of protean matter on a Paris stage? Born in Illinois in 1862, she was a lifelong hypochondriac, claiming to have caught a cold at the moment of her birth that she never shook off. Little Louie gave her first performance, impromptu, at Sunday school and later delivered temperance lectures complete with lurid-coloured slides depicting ruined livers. In her teens she began to act, found a part in Buffalo Bill's Wild West Show, then moved to New York. Fuller was a canny fantasist who told diverging tales regarding the origins of her singular dancing style. Among these is an anecdote that has her costumed in a shirt far too large, and hoisting it up as she drifted about the stage while playing a character who'd been hypnotized. The sight, she claimed, had a mesmeric effect on a New York audience, who cried: "It's a butterfly!... It's an orchid!"

Interviewed by the magazine *Éclair* in 1914, Fuller recalled: "I wanted to create a new form in art, an art completely irrelevant to the usual theories." At a time when advanced types of dance pushed the body itself into abstraction (forcing it, as the critic Frank Kermode later said, to "objectify a pattern of sentience"), she became famous, at least on the face of it, for incarnating other sorts of being—including inanimate, almost immaterial things. The serpent and butterfly were just the start; she might equally imitate a peacock, a lily, a cloud, or some pale bird of the polar seas. With their awkward atactic movements, modern dancers were sometimes compared to the thrashing and flexing hysterics famously photographed by Jean-Martin Charcot. But Fuller looks more like one of those animals whose movements were photographed and analysed by Étienne-Jules

Marey in the closing years of the nineteenth century: a bird multi-plied in flight, a wasp with gilded wingtips, a ray propelling itself by elegant, sinister undulation.

There is no evidence that Fuller was aware of the chronophotog-raphy of Marey or Eadweard Muybridge. Her technical interests were considerable, but they were directed at effects rather than essences. Her extraordinary fame at the turn of the century—there were Fuller-themed soaps, perfumes, skirts and ties, even cocktails *à la Loïe*—was built as much on her innovations in stage lighting as in choreography and costumes. From the outset the Serpentine Dancer had been bathed in coloured light: Fuller experimented constantly to find the right technology, from Edison's electric lamps to potentially lethal phosphorus. (A phosphorescent dress once exploded at her Latin Quarter laboratory, singeing the eyebrows off Fuller and her dancers.) Her most compelling scientific interest arose from a friendship with Marie Curie, from whom she tried to borrow a quantity of radium to light her stage. Curie assured her it was impossible, and crazy, so Fuller compromised with a dance in hom-age to the mysterious element, and in 1911 delivered a lecture on radium in London, hymning its magical potential to "photograph our imagination."

Fuller was a kind of special effect. She aspired to the inhumanity of radiant matter, to a mutation supervised by machines. Her act, Stéphane Mallarmé wrote, was "an intoxication of art, and, at the same time, an industrial accomplishment." The more skilled she became at designing costumes that were hardly costumes—more like atmospheres or ectoplasmic effusions—and the more complex or spectacular the lighting thrown upon these costumes, the less there seemed to be of Fuller herself. Her disappearance into the

dance is the more impressive because physically she was far from the narrow, angular ideal already current by the 1890s. At the Moulin Rouge, the morbidly graceful Jane Avril, who had in fact been one of Charcot's patients, embodied this slim, neurasthenic modern type—one critic wrote that her movement was a kind of handwriting in space. Fuller tended instead to the solidity of a point or period, amid the freehand lines and volumes sketched by her gowns. But her art lay partly in erasing this cumbersome body. As Mallarmé put it in his 1893 essay "Considerations on the Art of Ballet and Loie Fuller," she would turn herself into "a central nothingness, all volition, for everything obeys a fleeting impulse to disappear in whirls."

The essay, written after seeing Fuller at the Folies Bergère that same year, is the best-known literary response to her art. But Mallarmé was hardly alone, for she seems to have seized the imaginations of writers and critics, and if she did not exactly define the aesthetics of Symbolism in that decade, she was surely a test case for how far new ideas about poetic incarnation and abstraction could be pushed in the realm of actual bodies. Critics may at first have been impressed by Fuller's mimetic abilities, but they quickly saw past the serpent and butterfly to the fundamentals of movement. "Detail is secondary," wrote the art critic Roger Marx. The Belgian Symbolist Georges Rodenbach spoke of a "body delighted by being unlocatable." She turns up much later in poems by W. B. Yeats: he seems to refer to her Fire Dance in "Sailing to Byzantium"—"Dying into a dance, / An agony of flame"—and mistakes the Japanese dancers in her troupe for Chinese in "Nineteen Hundred and Nineteen" (1921). Kermode, in his 1961 essay "Poet and Dancer before Diaghilev," argues convincingly that Fuller had pointed many Anglophone writers, as well as French, towards a newly impersonal art: "She is

abstract, clear of the human mess, dead and yet perfect being... out of time."

Though she was the subject of many paintings and sculptures, and became a common subject for art nouveau ornament, Fuller appears to have presented more of a problem to artists than she did to writers thrilled by her vanishing act. Depictions tend to oscillate between allowing her a body and taking it all away, stopping just shy of abstraction. In posters by Jules Chéret and Jean de Paléologue that advertise her appearances at the Folies Bergère, the artists have predictably given her a trim naked outline, teasingly visible among the eddies of colour and light, which in photographs or films of her (and of her dancers) tend to drown the body in waves of pure form. Henri de Toulouse-Lautrec caught this moment of immersion very well in a lithograph from 1893. With her head flung back and a pair of tiny feet hovering inches above the earth, the dancer gives herself up to the bizarre shape—a fungus, a phantom, a monstrous stain or slick—that she has summoned on stage. In a 1902 painting by Koloman Moser, she is no more than a tiny blob floating atop a spreading form like the frill of a mushroom, flanked by vertical streams of red and blue light.

I first heard of Fuller, first had a glimpse of all this monstrous movement, at the Centre Georges Pompidou around 2011. A little lost amid a catchall display of works from the Modernist era, a small video monitor was showing one minute of hand-coloured film footage of the Serpentine Dance, performed by Fuller—so I thought. Later, finding similar sequences on YouTube, I realised it was not Fuller at all, but a member of her troupe. In the Pompidou's online listing for this work, which was acquired from the Institut Lumière the year before I saw it, there's the proof: *"d'après la danse de Loïe*

Fuller," created between 1897 and 1899. On the bare boards of an elevated stage (it must have been outdoors in that period, to ensure enough light) the unnamed dancer inscribes her unreadable alphabet, in pink and orange and pale blue.

A still photograph of her, in black and white: it really is her this time, but she is more apt than ever to disappear inside the rigours and extravagance of her work. In the collection of the Metropolitan Museum of Art, there are thirteen photographs of Fuller, taken around 1900 by an English photographer by the pleasing name of Samuel Joshua Beckett. Fuller is posed in a park or manicured grounds—she disports herself on the lawn, with trees and footpath in the background. What forms, what designs, does she act out? In two of the pictures Fuller trails her acreage of white drapery behind her as she advances into the foreground, with arms and wooden or metal wands outstretched. In another image she flings herself away from us while looking at the camera over her shoulder—and grinning. She looks like a primitive aircraft coming apart, a soft disintegrated Blériot. And in one picture she is quite gone; the fabric truly engulfs her like flames, like petals, like a wild idea into which the real Lo Lo has at last been subsumed.

Despite all these versions of her, Fuller's visual legacy is hard to reconstruct. As a dancer, her reputation was quickly eclipsed by those of Isadora Duncan and Vaslav Nijinsky. Cinema, which has partly preserved her for us, also did a better job than she could of staging the pageant of pure movement. Her innovations in stage lighting were important, but were further developed without her name attached. Still, it's impossible to look at Beckett's photographs —her frothing, roiling fabrics and miraculous metamorphoses suddenly stilled in the sunshine—and not imagine a submerged sort of

Fullerism at work over the past century. It survives every time film, for example, is seduced by matter in motion. In the several astonishing seconds it takes Oberon's starry cape to appear on-screen in Max Reinhardt's *A Midsummer Night's Dream* (1935); or the gleaming extruded swathes of colour in Alain Resnais's film about plastics manufacture, *Le chant du Styrène* (1958). Her costumes, predictably, were among the Modernist motifs invoked by Lady Gaga. But it is Fuller's vanishing into atmosphere and effect that now seems most contemporary—she might be a precursor to all artists in thrall to projected light and colour.

She died in 1928, having performed for the last time the year before, in London. Late in life, she was surrounded by her troupe, known as the Fullerets, and looked after by her partner, the heiress Gaby Bloch. Isadora Duncan recalled visiting Fuller in Berlin and finding the inveterate hypochondriac fretted over by many beautiful young women. In 1924 the Louvre put on an exhibition about her. It seems the performances she devised became more stark and austere in her last decade. The Fullerets mimicked a silver sea to the strains of Claude Debussy's *La mer* (1905). There was a dance that consisted of no more than a row of silver tassels held by her girls and lit by a single horizontal shaft; she had a photograph of the surface of the moon blown up and projected onto her costume. She became a pure white screen. She succumbed to pneumonia aged sixty-five, but the rumour in Paris was that she burned to death, and that her last words had been: "The light! The light!"

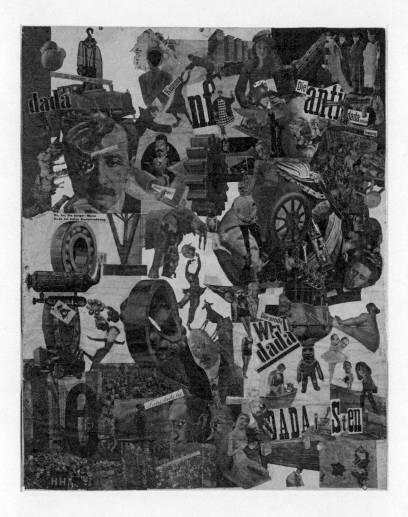

Dada Serious

THE FIRST INTERNATIONAL DADA FAIR took place in Berlin in the summer of 1920, and included works by George Grosz, John Heartfield, Max Ernst and Francis Picabia. Photographs from the opening show the gallery teeming with paintings, posters and scurrilous assemblages. Hanging from the ceiling is *Prussian Archangel* by Heartfield and Rudolf Schlichter: a pig-faced dummy in military uniform. Suited and spatted, the Dadaists comport themselves with dandyish indifference to their own anti-art inventions. There are only two women present, and one of them is the bobbed and diminutive Hannah Höch, who leans on a cane borrowed from Grosz while she looks over the shoulder of her lover, Raoul Hausmann. To the right of the couple is a pasted slogan: "Art is dead. Long live the machine art of Tatlin." And to the left a large squarish composition in which one can just about discern faces, text and fragments of machinery.

Höch's photomontage *Cut with the Kitchen Knife Dada through the Last Weimar Beer-Belly Cultural Epoch of Germany* (1919) was featured in the exhibition. Judging by reviews of the time, it was one of the hits of the fair, perhaps because it's so richly legible in terms of contemporary cultural politics. Ranged in the top-right corner are the forces of "anti-Dada": stern representatives of the late empire, the army, and the new Weimar government. Below, in the Dada

corner, are massed artists, communists, and other radicals. Hausmann is being extruded, shat out really, by a machine to which is affixed the head of Karl Marx. There are less crudely anatomical machines scattered about the metre-wide collage, and female film stars such as Pola Negri battle with moustached emissaries of the old German order. In the bottom-right corner, Höch has glued a small map showing the European countries in which women could then vote.

Cut with the Kitchen Knife is Höch's best-known work, though it is something of an anomaly, not least in its scale. She claimed to have hit on the technique of photomontage while on a Baltic holiday with the married Hausmann in 1918; having come across mocked-up photos of German soldiers, in which the young men's heads were superimposed on pictures of musketeers, they realized the power of cut-and-paste to "alienate" images. This origin tale is slightly misleading, however, because since 1916 Höch had been working for the Berlin publisher Ullstein, producing embroidery and lace designs for such periodicals as *Die Dame* and *Die praktische Berlinerin*. She was likely already familiar with the kinds of collage that an expanding print media practised with photographs. Höch worked on these handicraft magazines for a decade, and even wrote a manifesto of sorts for modern embroidery, in which she enjoined Weimar-era women to "develop a feeling for abstract forms."

Höch, in other words, was an unlikely addition to the boisterous lineup of Berlin Dada, and efforts to edge her out of the frame began almost immediately. Whether because of her conventional training in the applied arts, her involvement in commercial illustration, or the mere fact of her being a woman, Grosz and Heartfield took against her work, and tried to exclude it from the fair. She was only

reinstated when Hausmann, a key figure in the group, threatened to withdraw. Most of what she exhibited in 1920 has been lost: more photomontages and a few of her trademark "Dada dolls." A photograph of Höch cradling one of these curious figures also shows her sporting an astonishing sci-fi getup, but she did not relish the exhibitionist element in Dada. It is said she was embarrassed by the bohemian antics of her male confederates, though she did appear in a supporting role (armed with a saucepan and a toy gun) in at least one clamorous performance.

The montages that Höch made in the years following the fair divide equally between explicitly political comment (more or less in line with Communist colleagues like Heartfield) and a visual celebration of the 1920s New Woman, though the latter leans in turn towards more formal, eventually abstract, experiments. In *Heads of State* (1920), she took a recent newspaper photograph of German president Friedrich Ebert and his defence minister, Gustav Noske, pictured in their swimsuits at a Baltic resort, and set their paunchy figures atop an iron-on embroidery pattern of a woman with a parasol, surrounded by flowers and butterflies. In *Dada-Ernst*—which might mean "Dada-serious," or may be a reference to fellow collagist Max Ernst—she juxtaposed sentimental images of nineteenth-century femininity with photographs of athletic young women whose limbs, freed at last from the constraints of the old century, are equated with the soaring forms of skyscrapers. There are bare legs everywhere in Höch's art from this point on: flexing and leaping, frequently amputated from any actual body, the motif expresses at once the graphic energy of the New Woman and a kind of Surrealist grotesque—the abscised limb with a life of its own.

By the end of the 1920s, Höch had lost touch with most of the

Berlin Dada group, though she remained well connected among the European avant-garde: her friends and occasional collaborators included Tristan Tzara, László Moholy-Nagy, and Kurt Schwitters. (Along with Hans Arp, Schwitters, she later recalled, was among the very few male artists she knew who were willing to take a woman seriously as a colleague.) She had split from Hausmann in 1922, and at the end of the decade, having moved to the Netherlands, she began a relationship with the Dutch writer Til Brugman.

For almost ten years after the Dada fair, Höch declined to exhibit her photomontages, preferring to concentrate on painting. But she had not stopped cutting and pasting, and this period produced two of her most compelling and self-contained projects. The first, *From an Ethnographic Museum*, is a group of seventeen works made in the late 1920s, featuring images of non-European sculpture sutured to photographic fragments of human bodies and faces. Höch had frequented ethnographic museums in Leiden and Berlin, but it can't be said for certain that she developed much of a critical perspective toward relics from Germany's lost colonies or the ways they were now exhibited. She seems more interested in form than politics, experimenting with increasingly grotesque agglomerations of heads and body parts, and setting her inventions against slabs of livid colour.

At the same time, she had embarked on a more private project, completed in 1934. Höch's *Album* is a scrapbook of a little over one hundred pages into which she pasted 421 images cut from magazines and newspapers. It is not an exercise in photomontage; almost all the images are intact, and the book's visual intensity is mostly a matter of how they collide and rhyme across double-page spreads. She borrows liberally from fashion photography, movie-star por-

traits, architectural studies, and natural-history close-ups. The legs of dancers and naked gymnasts resemble nests of scaffolding and the spindly forms of Karl Blossfeldt's plant photographs; dogs and kittens stare soulfully like Hollywood starlets and pompous statesmen. It's been argued that *Album* was a repository for motifs to be employed later in her photomontages, but the effect is actually of a fully achieved work, in which the forms and images of mass media meld and interlace into an exotic whole.

Little of Höch's post-Dada work was exhibited at the time. Though her collages were not included in the *Entartete Kunst* ("degenerate art") exhibition of 1937, she had been an early victim of the Nazis' assault on "degenerate art." An exhibition of her paintings and photomontages was planned at the Bauhaus in Dessau in May 1932, but cancelled when the Nazi-dominated local council closed the school. Höch had been marked out with many of her Dada contemporaries as a "cultural Bolshevik." In a postwar interview she commented on the retrospective evidence of the 1920 fair: "Those few slogans were indeed evidence enough, in the Nazi era, to have us all tried and condemned as Communists." While many avant-gardists fled Germany, Höch went into internal exile: she bought a house on the outskirts of Berlin, hoping her neighbours would not guess at her past and denounce her, and she lived out the war with her own work and those of several Dada exiles hidden away in a cabinet.

It's customary to see in Höch's postwar art a blithe turn toward an almost decorative abstraction, all vestiges of her radical past fallen away in favour of dizzying arrangements of colour. There is a little truth in this: her palette was now drawn from colour advertisements, and especially from magazines such as *Life*. But the accusation misses the astonishing complexity of pieces like *Industrial Landscape* (1967),

in which photographs of a crowded swimming pool and the Swiss resort of Lugano are filleted and repurposed to such an extent that they resemble teeming factories and smokestacks. Perhaps only Ernst (whom it seems she never met) achieved quite this level of skill with the scalpel. Besides, there are many instances where motifs from her early work—notably fragments of the female body—reappear with new force and meaning: the grinning mouth of Marilyn Monroe, for example, hovering beside a fish's eye in her *Little Sun* (1969).

Höch died in 1978, her place in twentieth-century art history almost but not quite assured. Postwar histories of Dadaism had tended to patronize at best; she does not appear at all in Robert Motherwell's 1951 anthology *Dada Painters and Poets*, and Hans Richter, in 1965, called her "a good girl" with a "slightly nun-like grace." But gradually she snuck into the canon—she was part of the major "Dada and Surrealism and Their Heritage" exhibition at the Museum of Modern Art in 1968—and scholars and curators have since belatedly recognized that she was both a key Dadaist and considerably more: a true pioneer of photomontage and a complex, funny critic of mainstream and art-world misogyny alike. Her innovative presence has survived in the work of later *monteurs*: in the laconic and unsettling incisions practised by John Stezaker, in the pointed assault on images of women and commodities in the work of Linder Sterling. Her keenest insight is to have already seen, a century ago, that the profusion of images given us by the mass media might constitute "a new and fantastic field for a creative human being."

Discordia Concors

IN THE YEARS IMMEDIATELY FOLLOWING World War I, with
research in Italy and the US behind him, and now established as a
professor in Hamburg, Aby Warburg suffered a mental breakdown.
He fell into a profound depression and turned on his colleagues; in
a 1912 essay on frescoes in the Palazzo Schifanoia, Ferrara, he accused
fellow art historians of behaving with a "border-police bias" towards
his interdisciplinary approach. At a private mental asylum in Kreuz-
lingen, he was treated by the noted psychiatrists Ludwig Binswanger
and Emil Kraepelin, who diagnosed a manic-depressive illness.
Among Warburg's stranger symptoms was a habit he had developed,
a kind of "cult" according to observers, of talking to the insects that
flew into his room at night. He would speak to them for hours,
recounting to moths and butterflies—according to Binswanger's
clinical report, he called them his "soul animals"—the onset of his
agony, describing the shape of his suffering.

What an apt and moving image that is for the inner life of War-
burg, who thought so intensely about the relationship between
static, beautiful forms and the forces that set them in real or imag-
inary motion. His main interest, and whole modus as an art histo-
rian, was a kind of fluttering movement, a silent-screen flicker that
gave back life to historical images. *The Mnemosyne Atlas*, which
Warburg began to elaborate a few years after his recovery from the

breakdown, is his most achieved (if also definitively unfinished) expression of that agitated mode of thought. Originally conceived as an illustrated book—a *Bilderatlas* ("image atlas") such as scientific publishers had perfected in the nineteenth century—it could only really exist as a mobile star chart of motifs and pictures, a depthless teeming sea of images, a centuries-long film unspooled onto walls and panels in the rooms where it lived at the Warburg Institute in Hamburg, before being dispersed into the archive of the Institute's new home in London after 1933.

There are many varieties of movement, stately or speeding, visible in the pictures that Warburg affixed to those panels. Here is Albrecht Dürer's rendering, from around 1518, of the great triumphal carriage of the Holy Roman emperor Maximilian I, pulled by six pairs of horses and attended by a winged Victory. Elsewhere, bodies ascend or fall: Peter Paul Rubens's *The Great Last Judgement* (1614–17), Filippino Lippi's *Martyrdom of St. Philip* (1502), the plummet of Phaeton—who tried in vain to drive the chariot of the sun—drawn three times by Michelangelo in 1533. And a series of diagrams of the solar system, focusing on Mars and its "children," is juxtaposed with a sleek onrush of Zeppelin airships: all heavenly bodies in motion. But Warburg's keener interest, before and during the period of his making the *Mnemosyne Atlas*, is in the way that seemingly immobile bodies and faces in fact express or (better) incarnate movement, spiritual as well as physical. Under his gaze, the history of art reveals itself to have been a sort of cinema all along.

The insight is already there in some notes Warburg made in 1890. About the faces in Renaissance art, he writes: "The question was no longer 'What does this expression mean?' but 'Where is it going to?'" Sandro Botticelli is a key artist in this regard: in his *Primavera*

(c. 1480), the figure of Spring is flanked on the left by the Three Graces and, on the right, by the nymph Chloris, who is fleeing from, and turns her head back towards, Zephyrus: the West Wind. Extract the figure of Chloris, blow her up to see more closely her stricken face, as Warburg does in the *Mnemosyne Atlas*, and you have a figure only half human, whose movement may be bodily, or it may be emotional. Her ambiguity is all of the point: she's at once fraught and frozen, an image that scintillates instead of merely signifying. And it's in the picture of a frightened or suffering face and body that Warburg discerns, time and again, a movement that connects the innovations of the Renaissance with nineteenth-century photographic portraits and the melodramatic expressions of early silent-movie stars.

The panels Warburg devoted to the Roman sculpture *Laocoön and his Sons* are his most ambitious explorations of art and movement. The statuary group, excavated in 1506 on the Esquiline Hill and immediately exhibited in the Vatican, shows the Trojan priest and his children attacked by serpents that have been sent by the gods Athena and Poseidon. Warburg was not the first to see in the sculpture's writhing stone an image that encapsulated solid stasis and wild movement. In his essay "On Laocoön" (1798), Goethe compared the work to "a frozen lightning bolt" or "a wave petrified at the very instant it is about to break upon the shore." He had even imagined it as the occasion for a sort of proto-cinematic experiment with his own vision: "To seize well the attention of the Laocoön, let us place ourselves before the group with our eyes shut and at the necessary distance; let us open and shut them alternately and we shall see all the marble in motion."

Goethe saw some shivering, terrible truth in the Laocoön that an earlier writer, Johann Joachim Winckelmann, had weirdly denied: in

Reflections on the Imitation of Greek Works in Painting and Sculpture (1755), the art historian wrote of the main figure's suffering: "This pain, however, expresses itself with no sign of rage in his face or in his entire bearing." In the *Mnemosyne Atlas*, Laocoön is all pain, all of the time. Pathos is at the heart of Warburg's vision of art as stasis and movement, and he surrounds images of the Laocoön group with related and alternative images of faces in agony and dolour. There is the head of a bearded man, attributed to Pisanello and dated to around 1435, long before the discovery of the Roman sculptures. With his mouth open and eyes thrown back, the figure rhymes with the head of Adam in a fifteenth-century fresco by Lippi. Together, such faces and bodies compose a mobile frieze of frozen expressions.

In that sense, the *Mnemosyne Atlas* is part of a long history of efforts to tabulate the varieties of human emotional expression. Charles Le Brun's *Conférence sur l'expression générale et particulière des passions*, published eight years after the painter's death in 1698, is an atlas or dictionary of facial affects: tranquillity, admiration, the violence of astonishment. In 1872, Charles Darwin published *The Expression of the Emotions in Man and Animals*, which reproduced photographs of smiling and grimacing subjects taken by the French neurologist Guillaume-Benjamin-Amand Duchenne de Boulogne. Warburg's constellations of bodies and faces in motion have been compared to the photographic studies of so-called hysterics that Jean-Martin Charcot produced under Duchenne de Boulogne's influence. But the truth is that the *Mnemosyne Atlas* diagnoses something far more fleeting and enigmatic. There is pain and suffering in these pictures, but also a sense of pure possibility, as though the space between images, or between panels, contained only wind, or the beating of wings.

L'HIPPOCAMPE FEMELLE

Preposterous Anthropomorphism

AKERA BULLATA is a species of hermaphroditic sea snail or slug, discovered on coasts from Norway to the Mediterranean. It grows up to six centimetres long, has a brown or white shell, and a speckled body that ranges in colour from grey to orange. In sheltered bays, these molluscs settle into fine, soft mud or muddy sand, where they mate in undulant chains, half a dozen at once. Disturbed from their orgies, the snails swim away using two broad fins or parabodia, which billow around them like skirts or cloaks. In Jean Painlevé's 1978 documentary film *Acera, or the Witches' Dance*, the creatures cavort like weird sisters, they twist like slo-mo dervishes, striving upwards in the water and getting nowhere. Towards the end of his tranced study of their life cycle and movements, Painlevé cuts to a split-second shot of Loie Fuller—discerning an affinity with the Edwardian dancer's imitation of insects, flowers and aquatic animals.

Starting in the mid-1920s, and working as writer, producer, director, editor and narrator, Painlevé made over two hundred films. Most of them are science documentaries—of a sort. In his basement studio in Montparnasse, he deployed microscopes, aquariums, powerful lights and high-speed photography to capture an amazing array of mostly water-bound beings. There are sea urchins with their

spines and hydraulic suckers, a spirograph worm that flings out its delicate fan in another homage to Fuller, a shrimp cleaning itself methodically like a cat with sixteen legs. After the Second World War, Painlevé made a film about vampire bats—a bat and its guinea-pig victim stare each other in the face for ages before the decisive bite—and turned it into an allegory of Nazi terror. In the 1980s he was still working, filming city pigeons and employing schoolchildren to imitate their head-nodding gait.

The endearing strangeness of Painlevé's output is such that at times he looks like an avant-garde artist and at others he seems simply a pioneering documentarist of the natural world: the missing link between the early high-speed and microscopic experiments of Étienne-Jules Marey and Lucien Bull, and the popular adventures of Jacques Cousteau and David Attenborough. In another light, Painlevé is a photographic modernist, attending to tiny spines on the rostrum of a shrimp with the abstracting eye that Karl Blossfeldt brought to fiddlehead ferns or László Moholy-Nagy to the geometry of a city street. He was at once a sedulous describer of minute and alien naturalia, a well-connected amateur of the avant-garde and a kind of visionary chancer—he contrived a range of brass-and-Bakelite jewellery to cash in on the success of his film about seahorses.

Painlevé was born in 1902, the son of mathematician Paul Painlevé, who served twice as French prime minister. Jean studied medicine, but quit when he witnessed the maltreatment of a hydrocephalic patient. He switched to marine biology, and while working at the research centre at Roscoff, Brittany, met Geneviève Hamon, who became his companion and collaborator. Through her he met Alexander Calder, Jacques Prévert and the photographer Eli Lotar. He became friends with filmmakers Sergei Eisenstein, Luis Buñuel and

Jean Vigo. (In *L'Atalante*, directed by Vigo, the severed and preserved hands kept by the old sailor Père Jules were sourced and supplied by Painlevé.) Among composers, he knew the Futurist Luigi Russolo, Edgar Varèse, and later Pierre Henry, whose music he used to score *The Love Life of the Octopus* (1967). The pile-up of names is important, because Painlevé seems to have learned from all of them. His films are obsessively focused on minute anatomy, but aesthetically they invoke everything from Calder's delicately orbiting abstractions to the "organized noise" of musique concrète. (Calder is the subject of a colour film from 1955, in which he's seen unpacking a miniature circus he built in the late 1920s, and putting to work animals and acrobats made of wire and string.)

Most often, however, Painlevé has been associated with Surrealism, or at least its dissident varieties. He collaborated with the poet and playwright Yvan Goll on the first and only issue of the journal *Surréalisme*, which appeared in October 1924. Painlevé had taken a personal dislike to André Breton, and had more in common with Georges Bataille, who reproduced photographs from Painlevé's film of crabs and shrimps in his own journal *Documents*. Beside a text by Jacques Baron that makes an expected connection with Nerval's pet lobster—"a gentle animal, affable and clean"—appear the appalling close-up heads of the crustaceans. Bataille also reproduced the photograph *Lobster Claw*, in which the appendage looms out of darkness and looks like a monstrous face. (After the war Painlevé spotted a resemblance and retitled the picture: *Lobster Claw or de Gaulle*.) The danger that we are seeing too much in such images is never far away, and Painlevé runs towards it: "The most preposterous anthropomorphism reigns in this field."

His scientific and artistic ambitions are likely most involuted in

L'Hippocampe, filmed in 1934 in Arcachon Bay and in Painlevé's studio. Everything about the seahorse and its milieu is a reminder of something else—the creature's real medium is metaphor. (Painlevé even gives us seahorses swimming in front of footage of a horse race.) According to the director's own amused voice-over, a young seahorse resembles a King Charles spaniel. Fully grown, it's a puffed up and pompous individual, fretfully anthropoid, given to pouting and anxious darting of the eyes. Like the sea snail, this animal is ambiguously sexed: the female inserts her eggs in the male's belly, and he squirts out their offspring in gassy contractions. The young attach themselves to a forest of artfully placed weeds: a green world underwater that looks in certain shots like the mise-en-scène of Max Reinhardt's *A Midsummer Night's Dream*.

Eisenstein famously admired the "plasmatic" quality of the protean, boneless characters in early Disney films. He had probably picked up the word and idea from his viewing of Painlevé's first film, on the eggs of the stickleback. In the end, beyond whimsical anthropomorphism and Surrealised science, it is this quality that marks all of Painlevé's work. Figure, substance and form are ever ready materially and visually to translate (as Shakespeare's Peter Quince puts it) into something quite else; on the way they will appear alluringly or hideously unformed. Consider Painlevé's study of the octopus: a partially amphibious animal that can force itself through the smallest apertures, whose colour and texture change constantly, like forest light. Painlevé pushed this interest in labile things to its extreme in his 1978 film *Phase Transition in Liquid Crystals*. In response to changes in light and temperature, the magnified crystals throb and scintillate—in seconds they turn from bushfires to glaciers, blood cells to nebulae. It's Painlevé's most ravishing later work:

a colour-mad counterpart to Resnais's *Le Chant du Styrène* and product of an artist and educator whose interests overspilled the aquarium to touch design, dance (Balanchine was inspired by his lobsters), mainstream television and experimental film. Even Jean-Luc Godard looked at him with wonder: "There would never have been a New Wave without Painlevé and his unsinkable camera."

Essay on Affinity V

GOETHE'S *ELECTIVE AFFINITIES*, as its translator R. J. Hollingdale points out, is an example of a narrative form that has no close equivalent in English, either language or literature. The German *novelle* is longer than a short story and shorter than a typical novel (if there is such a thing). But *novella* does not quite suit either, because the *novelle* is not defined by extent alone. Rather, by certain strictures of art: emphasis on the mechanics of plot, a distance from realism or naturalism that extends to the minimal naming of characters, an order or symmetry of action and detail by which everything seems to connect to everything else. *Elective Affinities*, like Goethe's earlier novel *The Sorrows of Young Werther*, is concerned with the fatal excesses of romantic (or is it aesthetic?) love and sexual attraction. But the principals in the later work seem hardly human—they incarnate relations that are really chemical or elemental.

Charlotte and Eduard are an aristocratic couple, both married before, who spend their days, at the start of the novel (let us call it that), in high-flown conversation and planning the redesign of their estate. When they are joined by Ottilie, a niece of Charlotte's, and Captain Otto, a friend of Eduard's, an experiment of sorts is set in motion, concerning the attractions and repulsions of these four bodies. It's a process both entirely predictable to the reader and completely self-conscious for the four characters, because early on

the Captain has already explained the theory of chemical affinity which they will simply (not so simply) enact:

> Those natures which, when they meet, quickly lay hold on and mutually affect one another we call affined. This affinity is sufficiently striking in the case of alkalis and acids which, although they are mutually antithetical, and perhaps precisely because they are so, most decidedly seek and embrace one another, modify one another, and together form a new substance.

Such interactions, says Charlotte, following the Captain's train of thought, "appear to me to possess not so much an affinity of blood as an affinity of mind and soul"—this is how friendships (meaning more than friendship) may arise between human beings. Eduard now interjects: these relations only become interesting when one considers the relative strengths and weaknesses of the bonds involved: "It even used to be a title of honour to chemists to call them artists in divorcing one thing from another."

This is the chemical-emotional perplex into which Charlotte, Eduard and the Captain fling themselves knowingly—Ottilie less so. As predicted, Eduard and Ottilie fall in love: in terms of narrative space and intensity their romance dominates, eclipsing the more pallid and static scenes between Charlotte and the Captain. Around these central reactions, lesser characters move in orbit, for the most part no more than vehicles for commentary on the main characters. Among the more vividly drawn are Charlotte's daughter Luciane and a young and susceptible architect who works on the estate mostly in Eduard's absence. The novel moves, with almost essayistic interludes, towards its inevitably tragic conclusion: Charlotte

becomes pregnant by Eduard; Ottilie accidentally drowns the child; in turn she and Eduard die in despair. Nobody has really had a choice—they have been the fleeting personifications of natural forces beyond their control. As fiction, *Elective Affinities* may sound, or seem to some readers, overly schematic. But its symmetries have an explosive, reactive energy, revealing themselves with a shock each time. The architect paints faces of angels on the ceiling of the estate's chapel—they all look like Ottilie. Eduard looks at some trees on the estate, and realizes he planted them on Ottilie's birthday. Both of them develop headaches in opposite hemispheres: sure sign of affinity. Eduard turns a page and discovers Ottilie's handwriting exactly resembles his own. In the atomic whirl of *Elective Affinities*, romantic fate and wild coincidence amount to the same thing.

Souls and bodies collide in *Elective Affinities*, in accordance with Goethe's understanding of the eighteenth-century doctrine of affinity. Less often remarked is the degree to which this is a story about aesthetics, about appearances. There is the protracted—and, if truth be told, rather tedious—detailing of landscape design and chapel architecture on the estate of Charlotte and Eduard. But also: a peculiar concern with painting and with pictures in general, or rather with their restaging or replication in real life—an eccentric practice of the era that seems to draw on dance and drama, while also presaging photography and cinema.

Goethe had first encountered the minor art form of *Attitüden* in 1787, near Naples, when he saw the young Lady Emma Hamilton, with her hair let down and with the aid of a few scarves, performing the poses of certain classical statues and attitudes associated with different human emotions—all of these in swift succession. In *Elective Affinities*, Goethe has his characters arrange themselves in more

elaborate *tableaux vivants*. Luciane encourages all in replicating paintings by Van Dyck, Poussin and Gerard ter Borch, as well as lesser Dutch scenes of inns and markets. Later, the young architect casts Ottilie as the Virgin Mary in a living Nativity crib. These images-in-action suggest another way of seeing the novel's adulterous choreography: a static but quivering source of energy and potential. In his celebrated essay on *Elective Affinities*, Walter Benjamin wrote about the entropy that overtakes marriage in the novel: "In its dissolution, everything human turns into appearance, and the mythic alone remains as essence."

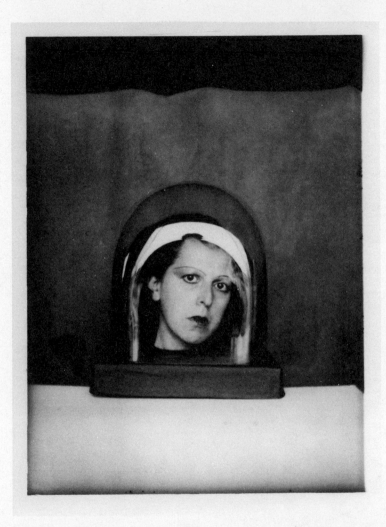

L'autre Moi

IN THE EARLY 1920S, before she left her native Nantes to live in Paris, the artist and writer Claude Cahun was photographed at least twice in the guise of a dandy. (I almost wrote "a male dandy," but with Cahun things are not so simple.) In one photo, she stands against a pale interior wall, to which has been pinned a square of black-bordered silk. Inside this frame Cahun, then in her late twenties, adopts the contrapposto stance of classical statuary: hips tilted, one leg relaxed and turned outward a little. She is wearing a dark jacket, wide trousers of velvet or corduroy, matching white cravat, and pocket handkerchief. Her left hand is a tight fist against her thigh, but her right rests loosely on her hip, and she is holding a cigarette between her ring and little fingers. In the digital semaphore of smoking, you would have to say this grip denotes the furthest extreme of affectation.

In other respects Cahun's dandyism is austere, reduced to its simple essentials. This look is nothing like, for example, the exquisite getup of the Comte de Montesquiou—the original of Proust's Charlus—a quarter century earlier: in photographs and paintings his collars, lapels, and cane (not to mention a moustache waxed to vicious points) compose an elegantly barbed image. He positively bristles with tasteful disdain. Cahun's dandy—as in all her work, she is playing a kind of fictional character—has more in common

with the plain monochrome style of the Regency wit George "Beau" Brummell, or with Baudelaire's idea that dandyism involves a drastic reduction of bodily action, decoration, and affect. At his most achieved remove from ordinary life, the dandy, says Baudelaire, recalls nothing so much as a corpse. In Cahun's photographs—they are not only Cahun's, as we'll see—the dandy is a modernist, committed to a clean and cool functionalism. The figure Cahun most resembles is the Russian poet Vladimir Mayakovsky, photographed in 1924 by Aleksandr Rodchenko: Mayakovsky the bruiser aesthete, with his hobnailed boots, three-piece suit, and shaved head.

We have not even looked at Cahun above the neck yet—in a second close-up shot from the same session she stares at us even more intently. She cropped her hair a few years earlier, but seems to have shaved it off around 1920, to reveal a skull that is squarish when seen straight on, and elongated in profile. In the dandy portraits you get a sense of how striking she looked, but not the full effect that she would knowingly deploy in later pictures. Instead, the peculiarity of her appearance is concentrated mostly about the eyes: their almost nonexistent brows, the affronting gaze with which she fixes the camera, the inwardness and remove that are nonetheless readable there. She looks like David Bowie in *The Man Who Fell to Earth*, at the moment the melancholy extraterrestrial Thomas Jerome Newton reveals his true appearance: hairless and white, with animal eyes. Cahun knew just how curious she looked, and here as in numerous other photographs she has exaggerated her freakishness, pushed it so far that she looks alien or sick, never mind androgynous.

The scope and strangeness of Cahun's imagery, which was hardly known in her lifetime, is not reducible to any one of the categories she has been coaxed into by art historians in recent decades. Although

she is best known as a photographer whose subject was mostly herself, the pictures were all made in collaboration with her lover, Marcel Moore, who was also Cahun's stepsister. (Moore, said Cahun, was "l'autre moi"—her other self.) More vexingly, Cahun did not think she was a photographer at all, or even primarily a visual artist. She was first of all a writer, aligning herself with the Surrealists, who partly accepted her, but publishing such disparate things—political pamphlets, cultural reviews, prose poems, an "anti-memoir," articles in the growing field of sexology—that her reputation would not settle, and she was almost forgotten by her contemporaries after she and Moore left Paris for Jersey in 1937. Since her rediscovery about thirty years ago, Cahun has been compared to feminist artists of the 1970s and '80s, and this makes sense even if her experiments with gender identity seem far more private, even esoteric, than the activist art of that era. It makes more sense to think of her as a pioneering queer artist—though again her style and interests are so idiosyncratic that the work will not map easily onto the art and culture of today. But she is now well established in histories of Surrealism, photography, and art by women. Thirty years ago, it was still often assumed, by critics who'd come across the pictures in passing, that Cahun was a man.

Claude Cahun was born Lucy Renée Mathilde Schwob in 1894, into a prominent Jewish family in Nantes. Her father, Maurice, was editor of *Le Phare de la Loire*, a regional newspaper that had been in the family since 1876. His wife, Mary-Antoinette Courbebaisse, suffered from mental illness, and so from the age of four Lucy was raised by her grandmother. At school she was subject to anti-Semitic

bullying, especially around the time of the rehabilitation of Alfred Dreyfus. Hoping to protect her, Maurice Schwob sent Lucy to boarding school in England when she was thirteen. When she returned in her mid-teens she became anorexic, and expressed suicidal urges; her father worried that she had inherited her mother's illness. Lucy herself identified with an uncle, the Symbolist writer Marcel Schwob, who died when she was eleven years old. Among many other writers, he had known Wilde, Proust, Gide, and Apollinaire. Lucy immersed herself in the Symbolist and Decadent literature of the last decades of the old century and the start of the new.

Shortly after her return from England, Lucy met Suzanne Malherbe, who was two years her senior, and the pair quickly became inseparable, somewhat to the consternation of Maurice Schwob, who may already have been planning to divorce his wife and marry Suzanne's widowed mother. Lucy was not exactly a prodigy, at any rate not in the way of her exact contemporary Jacques Henri Lartigue, who began photographing when he was six years old. (There are some striking similarities between the androgynous Surrealist and the blithe chronicler of the French Riviera; each took advantage of inherited money to contrive an almost entirely private practice of photography, while hoping to be known for something else: writing in Cahun's case and painting in Lartigue's.) Cahun and Moore seem to have begun making photographs around 1913. It's striking how many of their early pictures conjure a childhood they had not shared. There is Cahun in a sailor suit, such as then worn by young boys, sitting at a table with a box camera beside her and contemplating a huge bound volume of the fashion magazine *L'Image de la femme*. When Cahun was twenty-one, Moore photographed her as a young girl in bed, looking straight up from a pillow, sheet tucked

to her chin and hair snaked about her head as if she's floating underwater. And later, in Paris, they would concoct one of the oddest of their works out of the child's attraction to confined spaces. Made in 1932, this picture shows a large wardrobe or armoire, with doors either side, four wide and shallow drawers in the middle and above them three shelves. Cahun has squeezed herself into the bottom shelf, and she's dressed as a little girl: bare legs, white ankle socks, a ribbon in her blonde curls. She seems to be fast asleep—one arm hangs limp in front of the drawers below. Has this child drifted off in the middle of a game, while waiting for the playmates who have failed to find her? Or has she been hidden away here, unconscious or worse? It's a properly disturbing image, not least because of Cahun's sharp and definitely adult face, with eyes enigmatically shut.

If her father had been worried by Lucy's relationship with Suzanne Malherbe before he remarried, he seems to have quickly accepted that his daughter would never marry, and perhaps he even approved: there was no danger of her passing on the madness in the maternal line. Nonetheless, Cahun's ambiguous relationship with her father may be gleaned from a photograph she and Moore made in 1920, when they were still living in Nantes. It features Cahun in profile, all nose and chin below her closely cropped hair; the picture is clearly modelled on, and seems to mock, a portrait of Maurice Schwob soberly dressed in the same fashion, in profile against a dark background. There's a much starker version, too, for which Cahun has shaved off what remains of her blonde hair. One can hardly overestimate the visual effect of Cahun's bald-headed look. Photographed against a granite wall around the same time, she might easily pass for a skinhead of the 1970s—except, of course, that skinhead girls never looked like this.

"Androgynous" doesn't quite describe Cahun's physical presence. She began making photographs at a time when homosexuality was being studied, defended, and even celebrated by relatively mainstream writers. Havelock Ellis and John Addington Symonds's *Sexual Inversion* was published in German in 1896, and in English the following year. It described homosexuality—a word Ellis considered "a barbarous hybrid"—in objective, nonjudgemental terms with which many readers could identify: both men and women, even though the book's focus was on men. Cahun, who would later translate an essay of Ellis's on "woman in society," was quite familiar with then current theories of homosexuality. She would later use the somewhat dated label "Uranian" to describe her relationship with Moore. (The term was widely used in Europe, and in England had been applied to such writers as Oscar Wilde, John Addington Symonds, and Walter Pater.) She must also have known that Ellis had advanced a theory of transvestism, or what he called "eonism." Thinking only of male cross-dressers, he thought the desire at its root was an excessive admiration for, or identification with, the opposite sex. It was common also in this period to talk of homosexuals as examples of a "third sex," which however fanciful and (to put it in contemporary terms) essentialist, seems an apt idea to apply to Cahun's self-presentation in her photographs. For sure, she sometimes plays around with blatant clichés and stereotypes of either gender: dressed as a sailor, or a Hollywood starlet draped in leopard skin. Far more often she is ambiguous or somehow not sexed at all—lying in a rock pool, snaked around with seaweed, Cahun might be a sea nymph or sprite of either sex. Her infrequent nudes are not erotic but sculptural, the artist appearing as a bronzed and gleaming ornament to a quilted, silky backdrop.

But again it's the shaven-headed portraits that are the most com-
pellingly neuter—another word Cahun liked to use about herself.
She rarely gave titles to her works: these were mostly added decades
later by curators or archivists and take the same form, as in *Self-por-
trait (as a dandy)* or *Self-portrait (in cupboard)*. But a photograph
from 1928 is pointedly named *Que me veux-tu?*—What do you want
from me? It's a composite of two pictures of Cahun with her head
completely shaved, brought together to suggest that the identical
heads are conjoined at the neck. The more dominant Cahun is look-
ing diagonally away from the camera; the other Cahun faces away
from us and looks as though she's in the shadow of the first, whom
she regards warily over her shoulder. Cahun used the technique
elsewhere, in a double portrait of Henri Michaux, and perhaps she
knew the multiple self-portrait that Marcel Duchamp produced in
1917 of five Duchamps sitting around a table, each puffing on a pipe.
But *Que me veux-tu?* seems of another order. The art historian Dawn
Adès has argued that the photographs are not self-portraits at all:
first, because they were taken by Moore and not Cahun, and second
because there is no fixed self to be frozen by the camera. The double
portrait goes further, however, than simply pointing to the veiled
and multiple nature of Cahun's Uranian identity. It turns her into
an avowed freak, a two-headed monster whose gaze avoids the
viewer and is turned upon itself: Narcissus squared.

Lucy Schwob and Suzanne Malherbe changed their names in 1921—
Cahun had experimented with other names, including the surname
Douglas, after Lord Alfred—and so arrived in Paris fully remade,

and took an apartment on the rue Notre-Dame-des-Champs in Montparnasse. There are few photographs of them together, but it is nonetheless not hard to gauge the effect the couple had among even high bohemians of the age—they became friends with Sylvia Beach and Adrienne Monnier, and Gertrude Stein in *The Autobiography of Alice B. Toklas* mentions having met Cahun. The dramatic self-fashioning that one sees in the photographs was carried on into real life—Moore was an accomplished illustrator and costume designer—and they might turn up in the cafés of the Left Bank wearing stark makeup, Expressionist suits, monocles and cropped hair dyed pink or gold. When they met André Breton a decade into their time in Paris, he declared that Cahun was "one of the most curious spirits of our time." But he made a point of leaving a café as soon as she and Moore had made their startling entrance: the third-sex double act was too much for the notoriously prudish superintendent of Surrealism.

Cahun studied literature and philosophy at the Sorbonne, and began writing for philosophical reviews and cultural magazines. In 1925 she completed her first book, *Héroïnes*, a collection of feminist monologues by famous women and girls, many drawn from fairy tales and the Bible: Eve, Penelope, Helen, Sappho, Mary, Judith, Salome, Delilah, Cinderella, and Beauty from the tale of *La Belle et la bête*. In "Too Credulous Eve," Eve sits in the Garden of Eden waiting for Adam to return from work, and pores over advertisements for pills that will improve his sexual performance. In "Salome the Sceptic," Salome dances only because she is paid, and not because she wants anything from Herod. And in "Beauty (or the Taste for the Monster)," Beauty, or Belle, is disappointed when the monster she has learned to love turns into a mere prince. *Héroïnes* was never

published—the plan had been that Moore would supply illustrations, some of which survive—but a few of the essays made it into the periodicals *Mercure de France* and the *Journal littéraire*. Cahun carried on writing throughout the 1920s and eventually published, in an edition of five hundred, a selection of her writings as *Aveux non avenus*, which is usually translated as *Disavowals*. The book included essayistic fragments, private letters, and apparently sincere declarations regarding the author's outsider status and tastes: "I'm obsessed with the exception. I see it as bigger than nature. It's all I see. The rule interests me only for its leftovers with which I make my swill. In this way, I deliberately downgrade myself. Too bad for me...."

In the same period, she played the part of Elle in a stage version of the story of Bluebeard: there is another double exposure of her chalk-white face, darkly circled eyes and thick blonde plait wrapped laterally about her head like a stone arch. There is a 1929 portrait of Cahun as Satan in a twelfth-century mystery play; she looks at the camera balefully from beneath double-decker eyebrows, pencilled twice in straight lines to her temples. She is wearing a sort of jewelled helmet, with its Perspex visor pushed back. Her ruined-angel's wings seem to be swathed in cellophane, so that she might as easily have come from a sci-fi film of the era, such as *Metropolis* or *Things to Come*, as a revived medieval play. Actually, the gleaming cellophane links her to one of the great dandy-modernist photographs of the period: Cecil Beaton's 1927 portrait of the blonde aesthete and artist-writer manqué Stephen Tennant in leather coat against a silver backdrop. The following year, Cahun and Moore photographed each other before a mirror. Moore looks dressed for the beach, in soft cloche and a maritime top. But Cahun is something else: she

had dyed her short hair gold, and her skin seems to have the same lustre, while her chequered shirt turns her into a sort of sleek and moderne Pierrot.

Such photographs are not yet Surrealist. She exhibited only once in a Surrealist exhibition, and then her contribution was a small sculptural object featuring a tennis ball with painted eye and pubic hair. But as a photographer Cahun belongs in the category, and not merely the Surrealist milieu, thanks to the many images she made in which the distinction between human subject—naturally, herself—and inanimate object becomes moot. She had a plaster cast made of one of her hands, and then photographed the real hands entwined with the fake—a tiny porcelain doll's hand is stuck on the end of one of her fingers. Among her most famous pictures is *Je tends les bras* (I extend my arms, 1931/32), in which a pair of arms— they are probably Cahun's—reaches out from a granite gatepost, one arm thrust through a hole in the stone. In 1925 she made *Studies for a keepsake*, a series of photographs of her own head under a bell jar. It's an idea that occurred to a number of notable photographers, independently from Cahun and perhaps from each other: Lee Miller made her *Tania Ramm and Bell Jar, Variant on Hommage à D.A.F. de Sade* in 1930, and Angus McBean a "Surrealised" portrait of the actress Beatrice Lillie in 1940. In Cahun's versions, she appears glamorous and dreamy, her heavily made-up face gazing out amid bright reflections in the glass. She is emphatically alive but quite detached. In 1936 she travelled to London for the International Surrealist Exhibition at the New Burlington Galleries—there is a snapshot of her looking oddly conventional alongside Breton and crew—and had herself photographed among crystal heads and stone masks at the British Museum. She had become a curiosity at last.

In the last decade of her life, Cahun had herself photographed frequently by the seashore, near her Jersey home. Some aspects of her theatrical persona are hardly changed: she poses and preens in a costume apparently made of cellophane wrapped around a swimsuit, and she waves a spiral cane of glass or Perspex, like a long stick of barley sugar. She is obviously older, and has reverted to wavy blonde hair, which may well be turning grey. The effect is to make her photographs seem all the more theatrical, now that there is less of a fit between their (still eccentric) subject and the outfits and situations into which she's inserted herself. She poses awkwardly in medieval-style dress by a barn door. She pokes her head through a circular mirror or picture frame, but is wearing a floral housecoat over shapeless tunic. She advances along a jetty wearing a black mask and black jodhpur-like trousers, walking a long-haired cat on a leash; behind her is a modest church and graveyard such as you might find in any sedate English village. Elsewhere, she holds a featureless mask to her face and stands next to this churchyard again, wearing a short fragment of pale silk and a single black leather glove. Such pictures have the joyfully odd air of amateurs playing at being Surrealists for the afternoon. It's not clear if these photographs were ever intended for an audience other than Cahun and Moore.

They had moved to Jersey, where Cahun had spent holidays as a child. In a large granite farmhouse named La Rocquaise, on St. Brelade's Bay in the southwest of the island, Lucy Schwob and Suzanne Malherbe established themselves, reverting straightaway to their given names. They lived quietly for the next three years, and Cahun later wrote of "the illusion of holiday without end, a garden already in flower. It seemed that the only thing left to do was to become familiar with the trees, the birds, the doors, the windows

and pulling from the clothing trunk the appropriate article, short or long, to dive into the sun and the sea." But this paradise did not last. The occupation of Jersey began in July 1940: Cahun was in her bathing suit, watering the garden, when she saw the German bombers fly over, and then noise and smoke in the distance. During that summer, she photographed their cat, Kid, curled inside a sunlit window, with sea and rocks in the distance, and there are silhouettes of German soldiers on the beach. The Nazis would have considered Cahun Jewish even though her mother was not; she refused to follow the occupiers' order for all Jews to register and identify themselves as such.

During the next four years, while the Germans employed prisoners of war to fortify the island, and portions of the Jersey population actively collaborated with the occupying force, Cahun and Moore embarked on a secret campaign of counterpropaganda against the Nazis. They owned three radios, which would eventually be banned, and used them to glean information on the war from BBC broadcasts. Employing Moore's fluent German, they wrote and typed up tracts supposedly composed by a disillusioned German soldier and signed "The Soldier without a Name." They modified newspapers and wrote on scraps of paper or discarded cigarette packets, leaving them to be discovered in public places. Notes were left in cafés and even slipped into soldiers' pockets. They carried on this programme of resistance even when the Germans requisitioned part of their house and stationed their stable grooms there. In 1944 they were arrested and their tracts discovered. Imprisoned separately, they tried to kill themselves with barbiturates, but both survived. In November they were sentenced to death, but reprieved early in the new year. They were released on May 8, the date of liberation.

Cahun died in 1954—her health had been undermined by the months of imprisonment. The previous year she had made her final trip to Paris, hoping to reestablish her relations with the Surrealists. To Breton she wrote: "For four years we undertook militant Surrealist actions." In their last years on Jersey, she and Moore continued to make photographs. Much of their work had been lost when the Germans moved into La Rocquaise, and more (including photomontages and the original plates of *Disavowals*) taken away as evidence when they were arrested: it was all burned after the war along with the prison archive. But the spirit in which Cahun and Moore rebuilt their lives and their art may be seen in a photograph taken soon after their liberation. Cahun stands in a doorway at La Rocquaise, in a trench coat and headscarf, with a Nazi eagle-and-swastika badge clamped viciously between her teeth. Having invented the Soldier without a Name as a guise inside which to attack the Nazis, she maintained the persona after the war. Moore photographed her smoking haughtily while dressed in a quasi-military outfit, and holding the blank mask to her face, vanishing once again into a version of herself that was as much provocation as retreat.

Voracious Oddity

In 1936, at the height of her celebrity as a photographic artist, Dora Maar showed her picture *Portrait of Ubu* in the International Surrealist Exhibition at the New Burlington Galleries in London. Named after the scatalogical, ur-Surrealist play by Alfred Jarry from 1896, the black-and-white photograph shows a ghastly being of indeterminate origin and melancholy aspect. Maar would never say what the clawed, scaly creature was, nor where she had come across it. Her Ubu has elements of Jarry's porcine, louse-like original, and, with its doleful eye and drooping ears, it also resembles an ass or an elephant. Scholars generally agree that the monster is an armadillo foetus, preserved in a specimen jar. It is also an idea, something like *l'informe*, the concept Maar's lover Georges Bataille coined to describe his fellow-Surrealist's admiration for all things larval and grotesquely about-to-be.

Maar's work did not begin or end with Surrealism, nor with queasy repurposing of found images as in *Portrait of Ubu*, which was widely circulated as a postcard. She was born Henriette Theodora Markovitch, in 1907, lived to be eighty-nine, and was several sorts of artist in the decade or less that her photography had free reign. The first evidence of the voraciousness and oddity of Maar's vision is in pictures she took of Mont-Saint-Michel in 1931, for an illustrated book by the art historian Germain Bazin. There are double

exposures of a church and its interior, skewed perspectives with photobombing gargoyles. She treated statues and deserted Paris streets in similar fashion, and, in 1934, travelled to London and Barcelona, where she took rapt, slightly perverse street photographs, fixated on fragments of advertising, amputated mannequins and awkwardly posed children, who would soon reappear in her Surrealist montages. She had a commercial studio—initially with the photographer and film set designer Pierre Kéfer—where she produced work of glossy playfulness: a tiny ship on a sea of hair, to advertise hair oil; a fashion shoot in which the model's head has been obscured by a large, glittering star.

Maar's early photomontages look almost as modish and styled as her fashion work. From a shell resting on sand, a dummy hand protrudes, with delicate fingers and painted nails, just like Maar's own. In a way, the image could be by one of many photographers of the period—Cecil Beaton, say, or Angus McBean—who politely surrealised their pictures, as if the movement were merely a visual style. Except: there is something ominously self-involved about this hybrid thing. The shell and hand recall Bataille's obsessions with crustaceans, molluscs and orphaned or butchered body parts. The hand rhymes with similar ones in the photographs of Claude Cahun, where they sometimes have masturbatory implications. And what are we to make of the storm-lit, gothic sky that looms over this auto-curious object?

The most accomplished examples of Maar's art are the photomontages of 1935 and 1936. There were already many vaults and arches in her Mont-Saint-Michel pictures; now she took the cloistral galleries of the Orangerie at Versailles, upended them so that they looked like sewers, and populated them with cryptic characters

engaged in arcane rituals and dramas. In *29 Rue d'Astorg*—of which Maar made several versions, black-and-white and hand-coloured—a human figure with a curtailed avian head is seated beneath arches that have been subtly warped in the darkroom. An untitled work from the same period repeats the arched or arcade scene, this time with a helmeted figure in classical dress in the distance, and in the foreground one bareheaded advancing towards us with another boy, who is upside down, held in front of him. Another montage shows an Orangerie gallery awash with foamy water, shallow waves lapping at a sleeping (or sick?) figure lying in the bottom right corner. And in *Silence*, a 1907 photograph from Versailles has been inverted and populated with three apparently sleeping figures. Have they been washed up or deposited here? Dreamt into being by this crypt-like, Piranesi-styled space? Inscribed on the image, to resemble graffiti—the word *silence*.

The best known and most disturbing of these montages is titled *Le Simulateur*: the pretender, or the fake. Again we're in an inverted passage of the Orangerie at Versailles, in 1907. In the reproductions I've seen of the original source image, it is much brighter and less starkly contrasted that in Maar's montage. Sunlight pours through an open door and window. Close to the bottom of the picture there is a tiny figure holding, diagonally against the floor, a board or plank; without his presence it would be hard to grasp the scale of the soaring, cathedral-like space. In the distance, two or possibly three slim triangular ladders are propped against the stone wall. Is that a coat, hung from a hook, just inside the sunlit doorway?

There is at least one version of *Le Simulateur* in which some of this detail remains intact: the ladders, the man with the board, the coat, if that's what it is. In reproduction, it's more or less clear that

Maar has inked or painted over the window and door so that they now form blank masonry recesses. Sometimes the picture is exhibited or published the right way up, so that all of this is quite legible. More often, upside down, and frequently with the figure at the bottom (now the top) cropped out of the frame.

But I have been ignoring the most obvious and bewildering presence: the boy at right, in short trousers, his whole body bent backwards at an obscene angle. He derives from a photograph Maar took in Barcelona in 1933: a group, it seems, of child acrobats, with a haycart being unloaded behind them on the street. One of the boys is sitting on the hay-strewn pavement; another, the youngest, comes at the camera while shoving something into his mouth, or maybe chewing on a stalk of hay. Between them, this figure: feet flat against the wall, one hand by his side and the other (behind the small boy) supporting himself while he turns his head, inches from the ground, in our direction. Righted and reversed, this is the peculiar imp or homunculus who regards us in *Le Simulateur*. For extra strangeness, Maar has whited out or scratched out the boy's eyes—in most reproductions, it's hard to tell if these eyes are cast in our direction. What does the simulator (if that is who or what this is) want or intend? Does he suffer? He has been made to perform some disorder, but where it lies is obscure. In himself? In this sinister oubliette? The force, or the horror, of the image lies partly in the fact there are no answers to these questions.

The uncanniness of *Le Simulateur* and related works did not last. In 1935, Maar met Pablo Picasso, and they began a relationship that would last for nine years. Early in their time together, they collaborated on photographs and drawings scratched onto photographic paper. Maar documented the painting of Picasso's *Guernica*, pro-

ducing an essential art-historical resource, as well as evidence of their creative intimacy. (According to the art historian John Richardson, Maar also made some of the vertical brushstrokes on the horse at the centre of the painting.) Picasso encouraged Maar towards painting and away from photography—and then he left her, for Françoise Gilot. Maar had a breakdown, slowly recovered her poise, carried on making art. She was old and infirm and had retired to a house in Provence by the time she went back to photography, adding floral photogram borders to her early portraits of Surrealist friends and peers. Devout, reclusive, and famously jealous of her photographic legacy, she seems to have died fully aware of the dark miracle of her art.

On Not Getting the Credit

THE BEST-KNOWN PHOTOGRAPH OF the designer and architect Eileen Gray was taken in 1926 by Berenice Abbott, whose sitters had included Jean Cocteau, André Gide and James Joyce. Gray was forty-eight, but she looks younger: her hair is cropped and bobbed, and she is wearing one of the tailored masculine suits that she had recently adopted. Apart from certain avant-gardists photographed by August Sander, or the chromium glamour of Cecil Beaton's 1927 portrait of Stephen Tennant, it is hard to imagine anybody looking quite so sleekly tuned to the modern as Gray does here. The perfect profile, the flying-helmet of dark hair, the slightly downcast gaze: it all promises the combination of austerity and affect that one finds in her designs. Roland Barthes once remarked on the air of pure thought emanating from an André Kertész photograph of Piet Mondrian (also taken in 1926), and there is some of that alluring self-involvement about Gray, alongside the thrill of her androgyny.

There are less well known photographs from the session with Abbott: the subject smiling in half-profile, chin almost resting on her clasped hands, which are showing off some huge rings. I've most likely seen all the published shots: at the Centre Pompidou's Gray 2013 exhibition, at the National Museum of Ireland's permanent display in Dublin, in the pages of many books and articles. (Peter Adam's biography, published in 1987, remains the best introduction.)

But despite the photographs and exhibitions and the commercial as well as scholarly rediscovery in recent decades, I cannot quite shake the suspicion that Gray did not exist. In a certain light, she seems quite implausible: a bisexual Irish woman at the heart of European modernism, an Edwardian designer who was making things out of Plexiglas or Perspex in the 1970s, a great architect whose sole completed work of genius, the E-1027 house near Monaco, was routinely attributed to others and remained until recently a half-forgotten ruin. Though her place is now assured in the modernist canon, each new book or show still feels like a rescue bid on an unfairly buried reputation.

She was born Kathleen Eileen Moray, and raised at Brownswood, the family estate near Enniscorthy in County Wexford. In 1893 her mother inherited the Scottish title of Baroness Gray, though she didn's claim it or change her children's name until Eileen was ten. The Honourable Eileen Gray rarely employed her title, and thought such trappings fit only for operettas. It has been suggested that she fled Ireland when the plain, elegant Brownswood House was made over as a Tudor-style confection that she could no longer bear, but this is unlikely. The family kept a house in Kensington, and like many young women of her class in Ireland she had been well used to a life in London when in 1900 she enrolled at the Slade School of Fine Art to study painting.

For the first half at least of her long life, Gray knew everybody. At the Slade she met Wyndham Lewis, and she soon made friends with the potter Bernard Leach, the explorer Henry Savage Landor, and sculptor Kathleen Bruce, later wife of Captain Scott. Bruce found Gray "lovable, though rather remote," and noted that she lived in constant fear of inheriting a strain of family madness. (A

general anxiety does appear to have dogged Gray all her life: as a young woman she copied out, and always kept, a passage from a self-help book on "the removal of shyness.") It was around this time, too, that she counted among her many admirers a pre-Beastly Aleister Crowley, who wrote her love poems and of whom she later said: "I don't know how I put up with this nonsense, but he was very lonely."

Gray gave an interview to London Weekend Television's *Aquarius* programme in 1975, a few years into her very belated renaissance. Half-blind and suffering from Parkinson's, surrounded by aged examples of her early designs, she recalls an afternoon's stroll in Soho in 1905—she was by that stage dividing her time between Paris and London—during which she came across a lacquer workshop on Dean Street. Already intrigued by examples of the art that she had seen in Paris, Gray persuaded the owner to take her on as an apprentice. It's from that moment that we can date her swift maturation as an artist. Back in Paris, where she bought an apartment on the rue Bonaparte, she began to collaborate with Japanese specialist Seizo Sugawara, who had come to the city in 1900 to repair lacquer artefacts on show at the Universal Exhibition.

In Gray's early lacquer objects there are still structural and illustrative traces of the art nouveau that she was eager to leave behind. Though the process of its lacquering was arduous, and the result ravishing, an early panel such as *Le Magicien de la nuit*, from 1913, is not yet exactly of its time or ahead of it. An almost naked central figure bows its head and offers a mother-of-pearl lotus flower to an androgynous person to the left; a third figure on the right pulls a golden robe from the shoulder of the supplicant, or perhaps moves to cover it. The anecdote and the forms are not that far removed

from the compositions of Aubrey Beardsley a couple of decades before. The aesthetic is cooler but still turn-of-the-century in her red lacquer table of 1915, silhouetted with speeding charioteers.

Gray quickly specialized in large room-dividing lacquer screens that became more intricate as her talents and interests tended toward the architectural. These might still be ornately illustrated, as for instance the extraordinary *Le Destin* in 1913, with its svelte mock-classical grotesques. But they soon aspired to and then attained pure abstraction: one of these screens is a wall of twenty-eight hinged black panels that conspire to fling elaborate reflections on the floor. At its most extreme, this tendency produced in 1915—the same year as Malevich's more celebrated painting—a pure black lacquered square to be mounted on a wall like a flat-screen TV.

Gray also absorbed influences beyond her Paris base: she made lacquer trays and a lamp that have obvious graphic antecedents among the Russian Constructivists. What is not so obvious from the work itself is the immediate milieu in which she moved. She had settled in France partly in pursuit of a sexual liberation that did not entail much subsequent frankness about one's liaisons—toward the end of her life she burned most of her personal correspondence. So while we can guess who her lovers were in the early years of her career, there is not a great deal in the way of intimate anecdote. She came to the city with a friend from London, Jessie Gavin, and somewhat scandalized Kathleen Bruce when the two women trawled the bars, Gavin dressed as a man in corduroys and Norfolk jacket and Gray styled, though rather enigmatically, as the lesbian *bohème* of 1920s Paris.

Gray was close, though it is hard to say how close, to the singer Damia, to the artist Romaine Brooks, and to Gaby Bloch, companion-

cum-manager of Loie Fuller. She knew and admired Gertrude Stein, but mostly steered clear of her salon. She mocked a little the coterie around Djuna Barnes, with their white gloves and martinis at the Flore. In fact, she seems to have spent her spare time elegantly bowing out of romantic entanglements and whatever glamorous or gossipy circles were at hand—the real drama was elsewhere, in her work. In 1922 she opened a shop called Galerie Jean Desert, on the rue du Faubourg-Saint-Honoré, to sell her carpets and furniture. (It seems that she never met that other great exiled Irish designer of rugs and chairs, Francis Bacon.) Her rug designs included one that looks like an almost bare blueprint, and another that is merely a large expanse of beige felt, dotted with a grid of small holes. But it was the furniture that really occupied her in the period, and prepared the ground for her move into architecture a few years later.

Until the 1920s, the interiors on which Gray worked, and much of the furniture with which she filled them, retained something of the overstuffed fin de siècle: plush domestic rooms of the sort Walter Benjamin said functioned like the shell of a snail. There is a photograph, taken in the early 1920s, of one of Gray's most important clients, that shows how much this sense of interior design as envelope or carapace had persisted. Juliette Lévy, for whom Gray decorated an apartment on the rue de Lota, reclines on the Pirogue sofa bed (1918–22): a scalloped flute or furrow of lacquer in silver and tortoise-shell effect, inside of which Madame Lévy (photographed for a perfume ad by Baron de Meyer) nestles like an elegant mollusc.

The Lota apartment took four years to complete, and it is a bridge of sorts between Gray the late-Nouveau designer and the architect of E-1027. The project included some of the pieces for which she remains best known and which have been in production since her

rediscovery at the end of the 1960s. Several of these are still manufactured. They include the remarkable Bibendum chair: a sandwich of tubular adipose leather that Gray reputedly based on the walrus folds of the Michelin Man. The museum in Dublin lets you sit on one of these at the end of its display, and it is surprisingly supportive despite its blubbery appearance.

The critics took notice of the Lota designs in 1923, though her name was routinely left out of articles about the apartment—it was not the first or last time male designers would take credit for her work—Gray was invited to exhibit an entire room at the Salon des Artistes Décorateurs. The result was the Monte Carlo room, containing a white version of a multiple-hinged screen, lacquered furniture with "Cubist" details (pretty much anything starkly or complexly geometric might be called Cubist at the time) and a sharply conical ceiling light. It seems to have been this last that most unsettled a writer for the magazine *Art et Décoration*: "Take a look at the strange bedroom of Madame Eileen Gray. It is comical and it is abnormal. But it exudes an atmosphere, and one cannot deny its harmony and its extravagance." Another critic declared the room "the daughter of Caligari in all its horror." But there were unalloyed accolades too: Dutch architects and designers were especially impressed, and Gray came to the attention of Jean Badovici, an architect and editor of *L'Architecture Vivante*, a journal that championed De Stijl and the Bauhaus.

Gray and Badovici first met in 1921, when she was forty-three and he twenty-eight. He was a handsome Hungarian architect, penniless, and "doing all sorts of evening jobs." The nature of their relationship is both obvious and enigmatic. They were lovers, and partners of a sort, though Gray once again bristled at the strictures of a conven-

tional romantic relationship, let alone domesticity. By the mid-1920s, they had begun to collaborate on a series of published dialogues about the new architecture, and then on houses that remained unbuilt but convinced Gray she might be an architect herself. (She had "laughed in his face," she said, when Badovici first encouraged her in that direction.) In 1926 they started work on a vacation house for Badovici, on a plot of seafront land that Gray, who financed the whole endeavour, had bought at Roquebrune-Cap-Martin. Gray came up with a name: E for Eileen, 10 for the J in Jean, 2 for Badovici, and 7 for her own surname.

E-1027 is the fullest, bravest and saddest expression of Gray's art. The structure itself is a feat of compression as well as design: its two floors contain a living room, two small bedrooms, terraces, loggias, bathrooms, and tiny quarters for a maid. Almost all the rooms open out onto the terraces, and a spiral staircase, its form blatantly derived from Vladimir Tatlin's projected *Monument to the Third International* (a model of which had been shown at the Paris Exposition of 1925), rises through the centre of the house to a glass cabin on the flat roof. Strip windows run the length of each floor, with an intricate system of five different types of shutter, some of them opening and sliding on rails, so that the distinction between inside and outside may be seamlessly elided. A staircase descends from the upper terrace to a sunken concrete solarium with built-in recliner, Gray having toyed with and rejected the idea of a pool.

The influence of Le Corbusier on E-1027 is obvious, but Gray was already at odds with his "machines for living." Certainly the house accords with his "Five Points of a New Architecture," published the year Gray began work: the pilotis, the flat roof reached by a staircase, an open plan achieved with fixed and freestanding

walls, the horizontal windows opening the facade to the south. Gray, however, decried what she viewed as the excessive rationality of the new architecture. That much is a cliché among interpreters of her work; how she did it is another matter. As with Le Corbusier's own conception of the modern house, it is largely a question of how she imagined a body moving in space: she rejected his *promenade archi-tecturale* for a more secluded and circuitous procession through the house. Even in the smallest dwelling, she wrote, "each person must feel alone, completely alone. The civilized man needs coherent form. He knows the modesty of certain acts; he needs to isolate himself."

There were clues in the Pompidou show to how exactly she imagined that isolation, mostly in Gray's remarkable attention to every turn and gesture to be enacted by the dweller of E-1027. In the absence of the space itself—there were plans and models, and a film showing the dilapidation of the house—it was the furniture that brought one closest to it. The exhibition included a reconstruction of Gray's living room from photographs and original or related fittings: the blueprint carpet, the Bibendum chair, the Transat armchair that is modelled after transatlantic liner furniture but looks more like a fragment of one of the early aircraft that she loved. It's the more private and interstitial stuff, however, that hints at what E-1027 was like to live in: the glass and tubular steel adjustable table, named for the house itself, which she first conceived so her sister could breakfast in bed; a dressing table that is little more than a sketch in chromed steel with wooden drawers hovering to one side; a slanted writing table whose centre rises to become a lectern. Gray designed E-1027 for a sociable youngish man, but looked at closely it seems best suited to a middle-aged woman whose first priorities were solitude and work.

She did not, by all accounts, spend much time alone there. Badovici was a heavy drinker and a womanizer: factors that may have had less to do with their eventual split than his more general need for company and the intrusion into their life together of the architect they both revered. Le Corbusier had admired Gray's unrealized projects, and now became a regular visitor to E-1027, which he may have coveted with a professional regard that verged on personal spite. Things reached an irreversible pass after Gray moved out of the house in the mid-1930s and Corbu continued to see Badovici there, around the time that the Swiss master developed a passion for wall painting. In 1938 he convinced Badovici to let him paint eight large colourful frescoes on the pristine interior walls of E-1027; there are photographs of Le Corbusier sprawled on the daybed in the living room, looking very pleased with himself and his murals. Neither man had thought to consult Gray, who was furious and spoke from then on of Le Corbusier having vandalized a building he professed to love.

The love did not end there. In 1950 Le Corbusier built a holiday cabin or *cabanon*, supposedly for his wife, Yvonne, near the entrance to Gray's property, and after Badovici's death in 1956 built five studios raised on pilotis directly behind. He had his sights set on E-1027 itself too, of course: he persuaded a friend, Marie-Louise Schelbert, to buy it in 1960, and he remained involved with its upkeep. Le Corbusier even died while swimming in sight of the house, in August 1965. He had at least kept Schelbert from making a bonfire of Gray's furniture, but Eileen got none of it back. The subsequent history of the house is a sorry tale with a protracted happy ending, or near enough. Schelbert died in 1982, leaving the house to her doctor, Peter Kaegi, who sold the remaining furniture, now somewhat

decayed, at Sotheby's. In 1986 Kaegi was murdered in the house by his gardener. After that, squatters moved in. In 1999 E-1027 was finally bought by the Commune of Roquebrune-Cap-Martin, with the help of the French government, and declared a national monument; it was another sixteen years before the house was opened to the public.

Gray, meanwhile, had lived on, been forgotten then rediscovered, and died in 1976. E-1027, if mentioned at all in the architectural literature, was frequently said to have been designed by Badovici, sometimes by Le Corbusier, and on at least one occasion by the French modernist Jean Petit. Gray had in fact carried on building houses, first at Menton, overlooking the Mediterranean. Tempe à Pailla, built for herself, was completed in 1935 and filled once more with her signature pieces as well as metal-framed outdoor furniture that included an S-shaped folding chair, this time explicitly based on lightweight aircraft design. This house was more thoroughly vandalized, by German troops during the war, and she sold it to the painter Graham Sutherland in 1955. There was one more house, called Lou Perou: a renovation, undertaken when she was in her mid-seventies, of an old stone building near Saint-Tropez, which she had bought in 1939. And numerous designs for postwar housing and civic or leisure centres, all of them unbuilt.

One version of Gray's life after the war has it that she simply faded away, overcome by age and illness, forgotten by fashion. And it is partly true: she hung on at Saint-Tropez until isolation and Parkinson's got the better of her and she retired for good to the rue Bonaparte, where scholars and collectors later discovered her, polite but brittle and somewhat surprised that things she had made fifty and sixty years before were being sold at auction for astonishing sums.

But some part of Gray had been waiting for her close-up. She had maintained at her Paris home a sedulous fidelity to the work and the design ethos she had elaborated in middle age. The screens, the chairs, the steel and glass writing table, her thrilling design for something as simple as an aluminium twin socket, her bedroom brightly mirrored and flung with furs—all of it was still there, and over decades she had put together a portfolio to prove that it was all hers. The new era called her work art deco: a term of recent invention that she firmly refused. She had been modern, and was ready to be so again. "I wish I could work faster and never hesitate," she wrote toward the end.

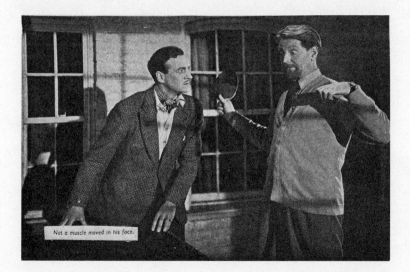

Not a muscle moved in his face.

The Leaves of the Rhododendrons Did Not Stir

A GOD'S-EYE VIEW OF the universe—"Big, isn't it?" a voice-over asks—furnished with drifting nebulae and exploding stars. The screaming hulk of an RAF bomber in its last airborne minutes. The seemingly doomed pilot's final words, quoting Sir Walter Raleigh and Andrew Marvell: "But at my back I always hear / Time's wingèd chariot hurrying near; and yonder all before us lie / Deserts of vast eternity." A pearl-grey heaven made of Plexiglas and light, where the airman is awaited. Hypnagogic abstractions seen from behind a human eyelid, as our hero hovers between life and death.

Michael Powell and Emeric Pressburger's *A Matter of Life and Death* is a frieze or masque of audaciously realistic and fantastical images. Powell later called it "a tilt at the documentary boys." Commissioned in wartime to depict relations between Britain and the United States, *AMOLAD* (as its makers called it) tells the tale of Peter Carter, poet and Master Bomber, who miraculously survives a chuteless plunge from his burning Lancaster. He is cared for by June, an American radio operator he has fallen in love with in what he presumed were his final moments, and he resists a plan to call him to the afterlife, where the heavenly legal system believes he belongs.

The photograph, a production still taken by Eric Gay at Denham

Studios, shows Peter (played by David Niven) on the left, and on the right Frank Reeves (Roger Livesey), a doctor who is trying to treat the airman's "highly organized hallucinations" about his forthcoming trial in heaven. (The world "up there" is in black and white, the warring earth in colour.) Reeves and June (Kim Hunter) have left the patient sleeping and gone to play table tennis on a conspicuously studio-bound terrace, which cinematographer Jack Cardiff has filled slantwise with sunset lighting. Peter wakes to find himself spied on by Conductor 71 (Marius Goring)—a celestial fop, sent up to heaven by the French Revolution, and now dispatched below to fetch the Englishman—and rushes to the terrace: "Doc, he's here! June!" But time has stopped: June and the doctor are frozen like still photographs—but not quite.

There are three of these halted moments in *AMOLAD*. In the first, Peter and June, who have met on a beach after the fall into the sea that should have killed him, are lounging in a bower of Technicolor rhododendrons when the Conductor appears and magics June and her surroundings into the dreamless sleep of temporal arrest: "She cannot wake up. We are talking in space, but not in time." Towards the end of the film Peter undergoes brain surgery to "cure" his hallucinations; in a scene played mostly for laughs, time is stopped so that he may rise from the operating table and attend his trial. And in between these scenes, this statuesque interval at the ping-pong table. The back-and-forth rallies of Cardiff's camerawork are instantaneously stalled, June with her paddle almost at the table, Frank with arms outstretched as if hoping to catch instead of return the ball. In a curious continuity gaffe, both actors have moved when Peter finds them—June's paddle arm raised high, the doctor's free hand curled in an awkward, squirrelly gesture. It's one of many small

reminders of corporeal reality in a film that could otherwise be all spectacle and allegory.

This is how, in Gay's photograph, we find Livesey in his buttoned-up cardigan and Niven in tweed and cravat. (They are dressed as my late father dressed in the 1940s, and in fact for another four decades, which is perhaps one reason I'm so drawn to this image.) The picture was one of several stills taken to promote the film, and was used again when it was released in the US, late in 1946, as *Stairway to Heaven*. But the version of the photograph here, complete with badly pasted caption, is from a novelization of the film by one Eric Warman, who seems also to have contributed to movie magazines and annuals of the era. This little book also contains production shots, credits and glowing bios of the principals. In his text, Warman has to resort to stilted phrasing—"Not a muscle moved in his face"—but the image is alive with comic as well as metaphysical tension: the bug-eyed Livesey trying hard to maintain an expression of interrupted energy, Niven poised in a moment of agitated amazement. A still photograph made to mimic a mobile image that expresses both movement and stasis, time and no-time. The publicity still is meant to excerpt or summarize the film's action, but here adds another layer of complexity, absurdity, temporal derangement. Warman appends a detail to the scene: "The ball was suspended in mid-air, looking slightly blurred owing to the speed at which it had been travelling when time stopped."

The time-space carry-on in *AMOLAD* was in part indebted to J. W. Dunne's study of precognition and "serial time," *An Experiment With Time* (1927). Dunne contended that past, present and future were in fact aspects of a continuum whose seamless passage could be observed only by more elevated versions of our earthly selves; his

book was an influence on the plays of J. B. Priestley and the fictional conundrums of Jorge Luis Borges. Powell and Pressburger consulted Arthur C. Clarke about how their cosmos should look and behave. In its attitude to time, the film also recalls the impeded lovers and the sleepy, sinister, green-world interludes of Shakespeare. There are references to *The Tempest* and *The Winter's Tale*, and rehearsals for a production of *A Midsummer Night's Dream* are going on in the commandeered manor house where Peter has been put up. Like Bottom in that play, Peter has woken to find himself "translated," no longer quite human. He exists, or persists, between life and death, in a zone of uncertainty, like all those still missing or unrecovered at the end of the war.

An early draft of Pressburger's script included ghostly effects—a curtain flutters, and the dead are with us—that belong instead to David Lean's 1945 film of Noël Coward's play *Blithe Spirit*, with its revenant wives and table-turning séances. The between state of *AMOLAD*, as filmed, is closer to Frank Capra's *It's a Wonderful Life* (1946), which uses the same freeze-frame trick to introduce its leap out of time into the bleak counterfactual of a life unlived. Like Jimmy Stewart, Kim Hunter is frozen in the table-tennis scene into repeated instants of the same image. Livesey on the other hand is actually standing stock-still while Niven darts around him in panic. Even in the photograph, I like to think I can see Livesey wobble a little. "The leaves of the rhododendrons did not stir," writes Warman in his novelization, describing the first stoppage effected by Conductor 71. But if you look very carefully at the movie, you will see that they do stir—the leaves are all trembling. There is no standing still, no heavenly moment outside of time to love and mourn and languish before history starts up again.

A man trapped between this world and the next, drawn by the woman he loves and fears losing: *AMOLAD* is a version of the Orpheus myth. Four years later, in *Orphée*, Jean Cocteau would film that tale with radio broadcasts, an undead protagonist and other-worldly tribunal. But Powell and Pressburger were there first, expressing with amazing lightness of touch a real yearning to bring the war's dead back to life. In keeping with its origin as a work about (or on behalf of) relations between the Allies, the film was screened for British troops still stationed in Europe. When it went on general release in France, the great critic and film theorist André Bazin commended its humour but dismissed its design as so much regrettable "plaster and Plexiglas." A few years later Chris Marker, who was not yet a filmmaker, published his only novel, *Le Coeur net*, which begins with a plane crash. Had Marker seen *AMOLAD* in the aftermath of the war? Was he thinking of its moments of stopped time, and its traffic between dimensions, when he made *La Jetée* in 1962? A film composed almost entirely of still images, which tell the story of a time traveller returning to a moment of his childhood, at Orly airport, which turns out to be the moment of his death. Whenever I look at this photograph I think of Marker, and the flash of inspiration that sees a whole film inside a picture that does not move.

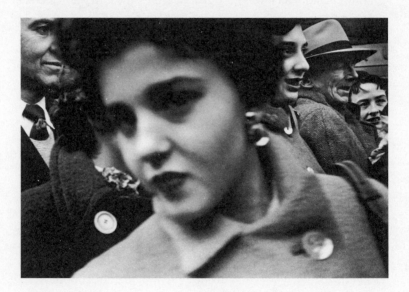

Life Is Good

WILLIAM KLEIN'S *Big Face, Big Buttons, New York 1954–55* is a
ravishing instance of a compositional tendency, not quite a trick, in
his street photographs of the 1950s. (This one is sometimes titled
St. Patrick's Day, Fifth Ave, 1955.) It is partly an effect of his use of
wide-angle lenses that allowed him to get close to the action and
still capture a good deal else. And it's the else that is often the point.
There may be a central or off-centre subject in a Klein photograph,
but at least half the drama unfolds at the edges, where nobody is
quite sure if they are in the frame or why.

Another example, taken on a May Day in Moscow, between 1959
and 1961, is well known because it appears in Barthes's *Camera
Lucida.* (Barthes, predictably, is transfixed by detail: "I *note* a boy's
big cloth cap, another's necktie, an old woman's scarf around her
head, a youth's haircut, etc.") A crowd again and a face at the centre,
just as distrustful as the young woman in *Big Face, Big Buttons*. But
this time she's tiny: an old woman wrapped in thick wool, her eyes
and mouth mere slits beneath the low line of her headscarf or shawl.
Two men standing behind her can see they're being photographed,
and they look straight at the camera. But the younger men who
flank her clearly have no idea they are part of the composition, so
have both turned to look at the old woman: why photograph *her*?
(Barthes ignores, or misses, all of this.)

At times the lateral stretch of a Klein photograph is so pronounced that you suspect he could see three or four pictures at once, as if the city were a comic-book spread of discrete cells or frames. He couldn't simply photograph Parisian lovers on the street in 1968, but instead two similar couples equally absorbed, and then at the extreme right a grumpy man in middle age who turns in our direction. In a park in Moscow in 1959, the three segments into which the image divides are separated by a tree trunk and a pole. At a time when capturing Henri Cartier-Bresson's "decisive moment" was still the ambition of fleet-footed street photographers, Klein makes HCB look like an artist of the nineteenth century: still hooked on picturesque urban anecdote despite the city's acceleration into cinematic blur.

Composition was just the half of it—the texture of Klein's photographs made them hard to look at for the magazine editors and publishers he tried to impress in his native New York in the mid-1950s. He was working for *Vogue*, having spent the best part of a decade in Paris, where he studied at the Sorbonne, trained as a painter under Fernand Léger and switched to photography when his abstract photograms were published by the design magazine *Domus*. In New York, nobody wanted his dark and frantic portraits of the city, their motion-blurred or out-of-focus subjects, the vicious cropping that exploded small portions of his negatives into grainy prominence. Worse, he preferred to overprint the images so they threatened to become slabs of unreadable black. Klein fled back to Paris, where he showed his photographs to Chris Marker, then a young editor at Éditions du Seuil. Marker, it's said, threatened to quit if the house didn't publish Klein, and so his first book appeared in 1956, titled *Life Is Good and Good for You in New York: Trance*

Witness Reveals. Several years ago I met Klein at his apartment in Paris, and he told me that when they first met Marker had a toy ray gun hooked into his belt, as though he really came from the future.

There are six people in the photograph, but only one of them knows it. Among a crowd on Fifth Avenue in 1955, the young woman finds a lens in her face. People are not yet afraid of being photographed by strangers in the street; still, the camera is close for comfort and she leans away to the left, averts her gaze from this guy's impertinent Leica. Or so it seems; in truth it's hard to tell where she's looking—she's quite a blur, and her big dark eyes are further shadowed by overprinting. Between her face and coat and soft bouffant, she occupies perhaps two-thirds of the picture, and she would rather not be there. What she doesn't know is that she's also an absence in the middle of the image; either side of her is a sea of faces, all glaring or grinning towards the right, and all perfectly in focus.

Essay on Affinity VI

"I'LL SIDE with what I can't understand in Brahms's phrase; I'll side with the possible rottenness of an object I might one day love." *I'll side with what I can't understand.* Or can't remember. For a while I also forgot that in his essay "Notes on Affinity" Wayne Koestenbaum describes his ruinous attachment to a phrase in Brahms's Piano Concerto No. 1 in D minor, Op. 15. Here is Koestenbaum, pursuing his affinity into a thicket of parentheses:

> I call the emotion I felt upon hearing that first theme (not an emotion! rather, an awkwardness, a stirring, a hesitation, a fear, a disgust)—I call this uncertainty the birth of an affinity because the sensation brought no intellectual programme in its wake, and it brought no possibility of an argument, no possibility (so I wished to believe) of ideology (as if "ideology" were a toxin I could define, circumscribe and exile from my imagination).

The affinity, says Koestenbaum, is a kind of *crush*, and like a crush it tends to mark one out for the moment as faintly mad. The one who feels an affinity embraces knowingly, eagerly, his or her own madness and stupidity. *Idiocy.* Affinity exiles us from consensus, from community. Koestenbaum again: "I was destroying other pacts, other possibilities of sociability, belonging, conformity, communicability."

Affinity: a means of escaping the community at hand, positing a community to come.

But it's possible to feel suspicious of all this possibility. As Koestenbaum admits, it is not so easy to step outside of ideology—ideology is the limit that we do not like to admit we live inside. One of the contemporary meanings of *affinity* seems to point to exactly this: a type of unacknowledged prejudice. In the language of human resources—a phrase that itself requires some scepticism—"affinity bias" names, ostensibly with the support of studies in neuropsychology, our tendency to reward or prioritize (when hiring or promoting, for example) those for whom we feel an affinity based on gender, race, class, nationality, education background, many other possible factors or criteria. In this context, *affinity* seems a pale stand-in for more exact or forceful language: a way of addressing prejudice or bigotry without saying "prejudice" or "bigotry." The concept (if we can so dignify it) of affinity bias imagines affinity as belonging, equivalence or similitude. But Koestenbaum's idea of affinity—including, I think, his caveat about ideology—is an urge towards something (or someone) unlike us, at least for now. Not an attraction of opposites (the simplistic version of chemical affinity) but a relation of alternatives, of others. But if this is the case, if affinity is something like allyship, what then to do with its undeniable tendency towards identity or union? Could affinity be a condition in which all of this remains in abeyance, in which the question remains open as to what kind of relation the term describes?

A voice intervenes—the voice of the academy, perhaps—and says: *Yes, but what are the politics of all this*? And I want to answer: *As yet to be determined.*

Sufficient Contortion

FOR A DECADE OR SO, until her suicide in 1971, the American photographer Diane Arbus amassed a body of work in which the eccentric, the outcast, the flamboyant, those who'd been judged disabled or perverted, genuine or self-described geniuses, the mad and sometimes even the merely famous—her "freaks," as she liked to say—looked at her camera, looked at us, and seemed fearlessly to admit certain truths about themselves, while declaring their aristocratic distance from you and me. Were we up to the task of returning their gaze and not judging them, or not judging Arbus? It proved difficult even for those who might naturally have been on her side, who approved the avant-garde's fixing its sights—from Jean Genet to Jack Smith, from Antonin Artaud to Andy Warhol—on broken outsiders and their fabulous acts of self-invention or preservation. In an essay on Arbus in the *New York Review of Books* in 1973, Susan Sontag wrote: "The most striking aspect of Arbus's work is that she seems to have enrolled in one of art photography's most vigorous enterprises—concentrating on victims, on the unfortunate—but without the compassionate purpose that such a project is expected to serve." And regarding Arbus's subjects: "Do they know how grotesque they are? It seems as if they don't."

Here are some of the unfortunates. Eddie Carmel, the "Jewish Giant," at home in the Bronx with his parents, who are looking up

at their son with a wonder that must never cease. A young black man and his white, pregnant wife—pompadour and beehive, respectively—sitting in Washington Square Park. Three Russian midget friends in their apartment on 100th Street. A genial nudist couple at the edge of some woods in New Jersey. Many transvestites and "female impersonators," dressed and undressed, backstage or at home. And all the circus freaks and tricksters Arbus met at Hubert's Museum in Times Square: the headless man and woman; fire-eaters and sword-swallowers; Ronald C. Harrison, the Human Pincushion, with his face full of hatpins; the Marked Man, Jack Dracula, whose tattoos include at least three eagles, two of which are on his face. The disabled students at Woodbridge State School, New Jersey, tumbling on the lawn. *Do they know how grotesque they are?* The question sounds more coldhearted than the photographs look—or, perhaps, than they look to us today. If the dominant clichés about Arbus in the 1960s and '70s had it that her work was sensationalist or exploitative—either way, that her pictures were "sick," in the postwar parlance—nowadays she is routinely spoken of as a natural champion of freaks and freakishness; her subjects have started to seem a community of the dispossessed, convened and celebrated by the photographer. But of course no artist is all one attitude, and in the case of Arbus the work seems peculiarly the product of conflicting impulses, interests, and affinities.

How did Arbus become the documenter of Sontag's "grotesque"? When did freaks first trouble and attract her gaze? What kind of artist might she otherwise have been? Among the early works of hers on show at the Hayward Gallery in 2019, there was a single photograph that almost everyone I know who saw the exhibition— *Diane Arbus: In the Beginning*—came away praising. It was taken

in New York in 1956 or 1957, not very long after Arbus had set out on an independent career as an artist. The image shows a skinny young boy who is about to step off the sidewalk and into the street, but first has turned in Arbus's direction and given a delicate, quizzical look. He's wearing a short baseball jacket and dark trousers that rise above dirty white socks. The boy's left foot springs lightly from the pavement, and his right fist is out before him, as if he might be holding something precious. There are cars and a few blurred figures in the distance at the top of the image, but otherwise the boy is alone.

I suppose the picture is striking because in its lightness and sweetness it looked nothing like an Arbus. (There is also the simple fact of its verticality: the image is portrait-oriented, and the boy at its centre a sinuous upright line.) There are many other photographs of children among her early works, and each seems to contain that alien element, the quality of strangeness—let us keep calling it freakishness for now, and figure what that means in a while—that one associates with her later and better-known images. There is *Child Teasing Another, N.Y.C.* (1960), in which a girl is bellowing gleefully in the ear of a little boy, who smirks and shrugs and looks like a fat middle-aged man in his high-waisted trousers. A photograph of a startled baby on the subway, staring from the shadow of her father's hat. (Arbus likely knew about Walker Evans's subway portraits of the 1930s, snapped with a camera hidden between the buttons of his coat; but it was not her style to be surreptitious.) And *Girl with a pointy hood and white schoolbag at the curb, N.Y.C.* (1957): flanked by an awful lot of empty sidewalk, the girl regards the camera along her eyes—she looks like she's been standing there forever, a mute figure out of fairy tale. Then there are the two photographs of adults

bearing sleeping toddlers in their arms—a man on the street, blurred woman in the park—where it is hard not to fancy that the child is dead.

But perhaps even these are not exactly echt Arbus. You could fill an exhibition, or a substantial book, with famous black-and-white photographs of children taken in New York in the first two decades after the Second World War, and in some respects it would be hard to tell the work of one celebrated photographer from another. Who is responsible for a picture (you may well know it) of a young boy pointing his toy revolver at the camera, while a smaller child looks up at him in profile, admiringly? How about a gaggle of kids on a stoop—"the Monster Fan Club"—all wearing crude and grotesque Halloween masks? Or a boy who is laughing wildly from his pram, into which his leaning mother's head has vanished? In each case, the answer might be William Klein or Helen Levitt, maybe Lee Fried-lander or even Robert Frank. There would be certain distinctions in terms of the texture of the image—Klein's are usually more con-trasting and grainier—and its composition. Levitt is more likely to step back, or give the scene a wider angle, to include the place in which children are playing, rather than frame tightly their gestures and expressions. And Arbus? Her children tend to be alone, even when they're not alone. Stranded.

Consider one of Arbus's best-known photographs, from 1962. The boy has short blond hair and ice cream or chocolate smeared around his mouth; he is wearing a shirt covered in heraldic motifs, and loose shorts held up by braces—he's so thin that these have easily fallen down on one side. Grimacing tightly, staring into the camera with a toy grenade gripped in his right hand. And the detail that casts this picture into some region of vertiginous doubt: the boy's

painfully clawed left hand, and an arm that looks twisted round from shoulder or elbow, all of which makes one finally wonder if the awkward rigour of his stance and expression are not the result of a disability. He seems to be on his own in Central Park, and has nothing to do with an indistinct family with pram, way off to the right.

Arbus took seven photographs of the boy with the hand grenade before she got this one. In the first four he poses with his hands on his hips, quarter-turned to the camera, with a lot of foliage behind him—bemused, fragile, not quite present, he has an air not unlike the boy stepping into the street five or six years earlier. In the fifth frame, Arbus must have asked him to approach the drinking fountain on which he's slightly clumsily resting both hands. A young man on a bench in the background turns his head and wonders about the blond boy and the short-haired woman weighed down with her twin-lens camera and its bulky flash attachment. (Some of the starkness with which Arbus's subjects are shot may be attributed to the fact she was using a flash even outdoors in sunlight.) But nothing is really happening in this picture, not yet. By the sixth and seventh, something is up: the kid's hands are on his hips again but this time in a gesture of mock frustration, as if Arbus has let him know he's not giving her what she wants. Or she simply wants more, and he's really getting fed up. And then it happens: the grimace, the locked stance, the grenade which he has been holding all along, but now wishes us to know about. It hardly matters that a woman with two small dogs, who has been approaching in the background for a couple of shots, has now, compositionally speaking, attached herself to the boy's head. Here we are: it's an Arbus. There are three more pictures of the boy on this roll of film, but he's now just larking about

in the dappled light, being entirely unfreakish. There is nothing the matter with his hands or arms.

Look at reproductions of Arbus's contact sheets, as I've done for the boy with the grenade, and you find yourself searching for that atmosphere—is it in her subjects? in her encounters with them? is it purely a matter of style?—that her most famous images seem to possess. One might say it's the same for any artist, once you depart from the canon or core and attend to juvenilia, minor works, drafts, and sketches. It may even be, as Janet Malcolm has argued of Arbus, that some disservice is done to the work of a great photographer— the medium is so much a matter of editing, after all—when negatives unprinted in the artist's lifetime are suddenly revealed to the world. But this is begging the question a bit, because in the first place Arbus's oeuvre has long been notably restricted. Since her death, the artist's daughter Doon and others involved in her estate have jealously guarded the work. Go looking for a book of Arbus's photographs and you will find, for a deceased photographer of her standing, remarkably few—let alone the cheap introductory selection, or the well-illustrated critical study that you might have been hoping for. The Arbus we know, the one who made square, frontal portraits of giants, dwarves, nudists, strippers, callow young couples, and brittle old ladies—she is the Arbus of *Diane Arbus: An Aperture Monograph*, the book of eighty photographs that Doon coedited in 1972, and which along with a touring exhibition really made the artist's name. Is it quite so clear that this is the photographer she always wanted to be?

Arbus was thirty-three when she began taking the photographs featured in the Hayward exhibition. For a decade, she'd been working with her husband, Allan—she had just turned eighteen when

they married—in their joint studio, producing fashion photographs
for magazines such as *Glamour*, *Vogue* and *Seventeen*. Allan took
care of all technical aspects of their shoots, up to the pressing of the
shutter release, but the ideas were mostly hers. The Arbuses were
successful, but hardly in the league of the fashion photographers
they admired, the likes of Irving Penn and Richard Avedon. They
needed the money that magazine commissions brought in—though
Arbus had grown up in a Park Avenue apartment, and her father
was vice president of Russeks department store, family funds do not
seem to have been made available to support flighty artistic ambi-
tions. Allan dreamed of a new career in acting; he eventually gave
up photography, and in the 1970s played a psychiatrist in the TV
series *M*A*S*H*. Their marriage was not yet obviously in trouble—
the couple separated in 1959 and divorced a decade later—but
Diane's sense of emergency was greater than Allan's: she was thor-
oughly worn out with fashion photography. One evening in 1956,
while describing the day's work for *Vogue* to a friend, Arbus broke
down, and said she simply could not take it any longer.

She had been taking her own pictures since the early 1940s: she
photographed herself pregnant in 1945, and her dead grandmother
a decade later. In between were square-format images, made most
likely with a twin-lens Rolleiflex, from the year Diane, Allan and
Doon spent travelling in Europe, starting in the spring of 1951. Some
of these have affinities with her later work, especially those in which
a child (sometimes it is Doon) appears isolated against an empty or
plain background. In other cases—a group of Italian nuns, for exam-
ple, whose habits turn most of the photograph into a sea of black—
they might be any mildly talented photographer's efforts to ape the
work of Cartier-Bresson. From the mid-1950s, her intentions are

different, and less clear. She has switched to 35-mm: rectangular pictures and grainy prints. In 1956 she began to number her negatives, as if she were starting over again. And she looked around for a new teacher, an artist who would point her well beyond her husband's limited ambitions. She found the Austrian-born street photographer Lisette Model, who was teaching at the New School for Social Research. Model, whose famous frame-filling *Coney Island Bather* (c. 1940) is an obvious inspiration for Arbus's photographs of shamelessly outré bodies, demanded that her pupil figure out, and stop fearing, what her true tastes and vision might be. Allan Arbus later recalled: "It was an absolutely magical breakthrough. After three weeks she felt totally freed and able to photograph."

Because her most celebrated photographs contain such singular presences—seem so much concerned with the encounter of artist and subject, to the deliberate and increasing neglect of setting or background—we do not immediately think of Arbus as a photographer of New York. But that is in some essential senses what she set out to become in the mid-1950s. On a blackboard by her bed she wrote lists of the places in the city she wanted to photograph: "pet crematorium, New York Doll Hospital, Horse Show, opening of the Met, Manhattan Hospital for the Insane." She made pictures of New Yorkers—an old couple on a park bench, a young movie-theatre usher weighed down by his cap and uniform—that had begun to show the influence of the pre-war German photographer August Sander. Sander's subjects are avowedly social types—Blacksmith, Bricklayer, Widower, Art Dealer, Explosion Victim—and possess a monumentality that Arbus would eventually perfect in her square photographs. In the late 1950s, however, her characters are still very much part of their surroundings: two glowering girls by a brick wall, the usher

behind a velvet rope, sidling up to the box office. The cinema, in fact, gave Arbus a whole subcategory of her New York photographs: she took several atmospheric shots of movie screens—clouds, kisses, blood-drenched hands, and a man being strangled—and of the rapt audiences who watch them, raked by the projector's beam.

With Model's encouragement, Arbus followed her teacher to Coney Island and photographed New Yorkers at play: some pictures from the early 1960s might easily have been taken by Model twenty years earlier. On the crowded beach, which is out of focus or blurred by heat, a potbellied man in hat, striped silky trunks, socks, and shoes stands and looks, eyes narrowed, straight at Arbus. In an image that's so grainy it suggests Arbus has cropped it out of a much larger photograph, a middle-aged couple are stamping along arguing, both their mouths set tight. And in a very uncharacteristic photograph, an old woman waves at Arbus from the ocean, which is otherwise a grey blank taking up almost the whole image. Much closer to the Arbus we know is a pair of photographs taken at the Coney Island wax museum. In a floral-wallpapered booth stands a hauntingly awkward, suited figure that looks nothing like its original: "James Dean. Killed in an automobile accident Sept 30 1955. The tragic ending of a young great actor. . . ." A girl or young woman is passing by, almost out of shot, no doubt amazed by this spectre with the huge hands and feminine eyebrows. The second wax-museum picture shows a display in which one Pasquale D'Onofrio, "the Torso Slayer," is dismembering his mistress on a bedroom floor and cramming her bloody limbs into a small suitcase, which he will then deposit at a railway station in Brooklyn.

Around the time she took the Coney Island pictures, Arbus had become friends with Joseph Mitchell, the *New Yorker* writer whose

profiles of the eccentric historian manqué Joe Gould (published in 1942 and 1964) are just the most famous examples from a large body of urban prose portraits. Arbus would phone Mitchell frequently; he took to jotting down the subjects they talked about, such as Kafka, Joyce, Walker Evans, and Grimm's Fairy Tales. She had been reading Edith Sitwell's *English Eccentrics* (1933), and was particularly struck by this definition: "Any dumb but pregnant comment on life, any criticism of the world's arrangement, if expressed by only one gesture, and that of sufficient contortion, becomes eccentricity." But Arbus mostly wanted to talk about her developing project to photograph the city's freaks. She wanted his advice on finding and approaching them; she'd been to Hubert's Museum and found that Lady Olga, a "bearded lady" about whom Mitchell had written in 1940, was dead. Others did not wish to be photographed. Mitchell later recalled: "She said she imagined they were a link to a strange, dark world—to an underworld. I said I supposed they were, but hadn't Brassaï done photographs like that of the Parisian underworld in the 1920s and wasn't Weegee doing it now for the *Daily News*?" Arbus insisted that her ambitions were different.

She began to amass images for a series or visual essay about her eccentrics, as well as plans to make portraits of others. *Esquire* was interested, then not. A selection of the photographs eventually appeared in *Harper's Bazaar* in November 1961, under the title "The Full Circle," with a four-thousand-word essay by Arbus. She wrote:

> These are five singular people who appear like metaphors somewhere further out than we do, beckoned, not driven, invented by belief, author and hero of a real dream by which our own courage and cunning are tested and tried; so that we may wonder all over again

what is veritable and inevitable and possible and what it is to become whoever we may be.

There was Jack Dracula, who took considerable persuading before finally allowing himself to be photographed in a bar, shirtless and sullen. There was William Mack, the Sage of the Wilderness, a figure with a biblical aura, who had crammed his tiny apartment with countless incurious curiosities: nine umbrellas, a cowbell, twenty rings, five hammers, thirty-eight cigar butts in a bowl, eleven bracelets, four watches, three earrings, six necklaces, thirty-five empty bottles, a Hopalong Cassidy gun and holster, forty-six rolled-up pieces of string, and many, many more. And Miss Cora Pratt, the Counterfeit Lady, who was the buck-toothed, lacy, wigged invention of a woman called Polly Bushong, whose eccentricity consisted simply and unfathomably in the fact she liked sometimes to go about dressed as Cora.

There is one figure whom Arbus had intended to include in "The Full Circle" but whose image the magazine's editors refused to print. In Arbus's best-known photograph of Stormé DeLarverie, *Miss Stormé de Larverie, the Lady Who Appears to Be a Gentleman*, she's sitting on a park bench smoking, with a half smile. She is wearing a slimly cut tweed suit, stud-collar shirt and tie, wristwatch and pinkie ring, and a pair of highly polished, Cuban-heeled Chelsea boots. Her hair is close-cropped—she's an austere dandy, relaxed and refined. DeLarverie was at the time performing regularly as a singer and the only drag king in the Jewel Box Revue, a racially integrated drag troupe. It is said that on June 28, 1969, her scuffle with police during a raid on the Stonewall Inn, in Greenwich Village, was the start of what became known as the Stonewall Riots.

The rejected photograph of Stormé DeLarverie, whose ambiguity was too much for a magazine that had apparently wanted Arbus's freaks in all their glory, is instructive. One cannot imagine Joseph Mitchell adding her to his picturesque roster of bearded ladies and flea-circus impresarios. Stormé seems to come from a differently freakish future. There are plenty of sexual misfits in Arbus's work, as well as sex workers and strippers—the dominatrix embracing her client; the topless dancer all got up, backstage, apart from her bare breasts; the couples on beds and couches; the occasional appearance of a naked Arbus herself, who later in the 1960s took to frequenting and photographing sex clubs and orgies. But her photographs of drag artists are different, seeming to offer some of the keenest tests of her competing ambitions: to find the most freakish of her contemporaries, in all their difference, and at the same time to give us the ordinary intimacy of her encounters with them. Some of the later work shows these figures much more starkly, it is true: the figure in *Transvestite showing cleavage, N.Y.C.* (1966) fills the frame, with just a bit of moulding and upholstery in the background—we have no idea of her milieu. But in the early work, and sometimes in the contact sheets for sessions that produced the famous later pictures, Arbus's "female impersonators" are people with unkempt beds and messy dressing rooms, are made up lavishly from the neck up but have scrawny boys' backstage bodies, cigarettes always on the go.

One such portrait embodies as well as any Arbus's commitment to her freaks in this first phase of her career, and expresses just how unformed and unpredictable her aesthetic was at this point. *Blonde female impersonator standing by a dressing table, Hempstead L. I.* (1959) is mostly a mess made out of the performer's costumes, which hang out of focus in the foreground; ashtray, mirror, and cosmetics

on the table; primly floral curtains, and a couple of bentwood chairs. And then the subject: awkward, leaning, anxious, she is wearing a corset, a Lana Turner wig, and big black eyelashes. Judged by the conventions of her later photographs, Arbus has simply not got close enough to her subject, failed to clear away some of the visual trash that distracts from her freak. She seems to stumble upon the scene, though it also lacks a sense of surprise or intrusion. In place of all that, the blonde female impersonator is glowing, practically aflame with reflected light from the direction of the dressing-room mirror. Her body is half blown-out, a bright white mass. Although Arbus could probably have saved a lot of detail in the darkroom, she seems to have chosen not to. It is often said that in Arbus's mature photographs her curious, damaged subjects at last admit who and what they are, so have the presence, precision, and solidity of self-knowledge about them. But what if that is all a trick of the light or a matter of framing? In the early work, the freaks are already on fire.

Star Time

EARLY IN JULY 1958, the Japanese photographer Kikuji Kawada, then aged twenty-five and a staff photographer at the weekly magazine *Shukan Shincho*, visited Hiroshima for a cover story to run in the month following. He was there to photograph another photographer, Ken Domon, whose book *Hiroshima* had been published in the spring. Among Domon's subjects: the scarred bodies of survivors of the atomic-bomb attack of August 6, 1945, and the skeletal dome of the city's riverside industrial exhibition hall. When he had finished his assignment, Kawada lingered in the ruins below the Genbaku Dome, where brick and concrete walls were covered with stains composing, as he put it, "an audibly violent whirlpool." Kawada took no photographs of the enigmatic markings, but returned two years later with a 4 x 5" view camera, and began making long exposures in "this terrifying, unknown place."

The book that resulted, *Chizu* (The Map), first published in 1965, is one of the wonders of postwar Japanese photography, as much in Kawada's approach to the form and boundaries of the photobook as his singular address to the atomic history that was then exercising Japanese artists as well as antinuclear activists. The images are coarse-grained, high-contrast evidence of the influence of William Klein and Ed van der Elsken on Kawada and his contemporaries, and a precursor to the even starker imagery and style of the

Provoke photographers later in the decade. Published on the twentieth anniversary of the dropping of the first bomb, *Chizu* went beyond the documentary ambitions of Domon (and the more poised, classical images from Nagasaki made by Shōmei Tōmatsu) into a more abstract and opaque register. In its original run of seven hundred copies—a third of them were destroyed by fire during the Tōdai riots of 1968 and '69—the book was an unfolding mystery. Bound in a black paper chemise, this exquisite artefact had two textual elements: a poetic preface by Kenzaburō Ōe, and a constellation of words and phrases attached to the atomic catastrophe itself, or to its cultural aftermath under Allied occupation. Words like: *Enola Gay, keloid, energy, machine, popcorn, 7-Up, secret.*

In 2021 a new edition of *Chizu* reconstructed the initial conception of the book, by Kawada and designer Kōhei Sugiura, as two discrete volumes to be contained in a slipcase. In addition, the new version also features a third volume, with essays, an interview with the artist, and thumbnail comparisons of the differing layouts. Here we learn, from curator Joshua Chuang, that an original maquette of the two-volume edition was acquired in 2001 by the New York Public Library. What is to be learned by comparing versions? The book as published in 1965 mixed Kawada's photographs from inside the Dome with his studies of wartime relics and artefacts of the decades following. The latter images now form an uninterrupted frieze, each given a full-bleed double spread. There are photographs of abandoned military infrastructure—a curving concrete tunnel with a blaze of light at the end, a looming fortification or gun emplacement—that resemble the ruins of the Nazis' Atlantic Wall, as photographed by Paul Virilio in the same period, and published in his 1975 book *Bunker Archaeology*: "concrete altars built to face

the void of the oceanic horizon." For the most part, Kawada's objects are less monumental. A display of photographs and mementos of kamikaze pilots. Coca-Cola bottles, a crumpled Lucky Strike pack, a pile of bottle tops rendered so obscure in the darkroom that I at first took them for dentures. At the more abstract end: a montage of neon signs and advertisements, white against pure black—a nightmare adaptation of Klein's 1958 film *Broadway by Light*.

In the 1965 edition, some of Kawada's large-format photographs of the stained walls at the Genbaku Dome acted like endpapers, framing the more recognizable images, then interrupting the essayistic ensemble with digressions into a kind of abstract unconscious or atomic sublime. In the variant proposed by the two-volume maquette, we're presented instead with one teeming cloud or shadow after another, a sort of howling static, largely resistant to sense or figuration. Still, the eye searches for mimetic or allegorical intent, and finds the most obvious clues. The book's title is one such; the punctures, contortions, and tonal variations on the walls look like the draft of a blasted mental topography. They call to mind ruined flesh, or how we might imagine the roiling energies at the heart of an atomic explosion. The pictures are punctuated now and then by blank white pages, more reminders of the blinding moment of detonation—or are they rather vacant pauses for reflection amid the vexed relations of wartime history, contemporary commodities, and barely illustrable horror?

Kawada called *Chizu* "an object headed towards the future." The photographs of Hiroshima and Nagasaki that immediately predate his project still belong to a humanist (and for Kawada, sentimental) vision of documentary photography, quite of a piece with the universalizing impulse of the epochal "Family of Man" exhibition,

which toured Japan in 1956 and 1957. Tōmatsu's image of a watch stopped at 11.02 a.m., the time of detonation at Nagasaki; the blind children of Hiroshima in Domon's book—many of Kawada's photographs sit alongside these representations of August 1945 and its legacies. But the photographs taken inside the Dome suggest another domain of historical reckoning. Kawada says: "I think in retrospect the time when I was by myself in that dark space... that was my star time. That was a moment when I found myself shining, like a star in the dark sky." He means, I take it, that it was a signal moment in his career, but it sounds too like a memory of vast, inhuman energies from the past, working their influence on the present.

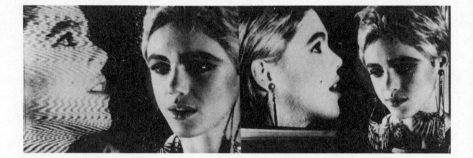

Four Stars

IN THE SUMMER OF 1965, Andy Warhol was loaned by the magazine *Tape Recording* a new Norelco video camera and recorder, with which he proceeded to make nearly a dozen tapes, all now lost or inaccessible—save one, after a fashion. This is not exactly a video work, but rather a film incorporating some of his earliest experiments in the medium. *Outer and Inner Space* is also evidence of Warhol's precedence when it comes to artist's video: it was first shown in January 1966, but was made in August of the previous year, and so predates a video recorded and exhibited by Nam June Paik on 4 October 1965. According to the late Warhol scholar Callie Angell, who oversaw the cataloguing and restoration of his films, Warhol's priority over Paik is beside the point: after its first few screenings, *Outer and Inner Space* was not seen again for thirty years, and so had no obvious influence on the development of video as art.

On two screens showing different footage side by side, Warhol's first "superstar" Edie Sedgwick sits to the right of a video monitor showing her own face in close-up. Two screens, four stars. Video Edie is seen in profile, open-mouthed, gaze elevated, not quite looking at her "real" self. Film Edie is looking out of the frame to our left, where we may imagine Warhol and his assistant Gerard Malanga; the latter sometimes wanders into the shot to attend to the video monitor. Each of Warhol's rolls of 16-mm film lasted thirty-three

minutes, and the videotapes lasted thirty. Throughout, the artist and his crew adjusted the sound levels on the video playback, and on the recording to accompany the film: the result is a sonic mess in which almost nothing Edie says can be made out clearly. (On my last viewing of a version online, a single phrase emerged from the aural murk: "Don't you feel like....") She is talking and laughing and pulling faces from the start, gesturing with her cigarette, using her busy hands to give herself horns and a pointed hat. On two occasions, the version of the video image on the left disintegrates into herringbone lines and the face becomes a cartoon grotesque. In the foreground, perhaps alerted by Warhol, Edie glances round at this monster and laughs, then looks briefly horrified.

Edie's brief tenure as a superstar is well documented: in Jean Stein and George Plimpton's oral history of her short life; in Warhol's *a, A Novel* where she is renamed Taxi; and in the films where the artist is determined to destroy her beauty, her glamour and her brittle self-possession. In Edie, Warhol had found his silver-haired twin: there are elements of narcissism and self-hate in his efforts to obliterate her. He wanted to make a twenty-four-hour portrait of her, to be titled *The Poor Little Rich Girl Saga*. But instead she is scattered across a series of shorter works, among them *Face, Restaurant, Kitchen, Afternoon, Beauty #1* and *Beauty #2*. She stares at Warhol and his Bolex camera in nine of the silent, mostly black-and-white portrait films he called "stillies," which have come to be known as the *Screen Tests*. Frequently in Warhol's films Edie is meant to be a passive object of attention, though her garrulous, quizzical and obviously (even when you cannot hear her) funny character also shows through. Sometimes her humiliation is the point of the film, or is improvised by fellow actors (or near-actors). In *Lupe*, perhaps

her most degraded appearance in Warhol's work, Edie acts, twice, the death by sleeping pills, with her head in the toilet, of the Hollywood starlet Lupe Velez. (The actress had indeed died of an overdose, but the gruesome-comic detail came from Kenneth Anger's book *Hollywood Babylon* and was likely apocryphal.)

In a lecture delivered at the Hermitage Museum in 1998, on the occasion of the renovation and reappearance of *Outer and Inner Space*, Angell said: "It's a painful film, very beautiful, but very painful as well." I would say cruel as well as painful. And yet, if I were pushed to say what is my favourite work of art, at least some of the time I would have to name this film. Of course there is the visual redoubling of Edie: a statement about self-image and stardom that is in no way naive or unknowing. And there is the pitiful, shut-in hysteria of the Factory scene, here lurking out of shot but ever present, ever morbidly diverting. Something escapes all of this: the spectacle of Edie Sedgwick *thinking*. *Outer and Inner Space*: the title implies an easy distinction between the superstar's appearance and her interiority, and provokes us to ask which medium, which image, expresses each: inside or outside. But they are all Edie, whether passive video profile or kinetic presence on film. At a couple of points, the video image on the right-hand screen loses its vertical tracking, so that the subject or sitter is further multiplied: it looks for a moment like a strip of film slipping in the projector's gate. Edie stalls and flickers— will she come back to us?

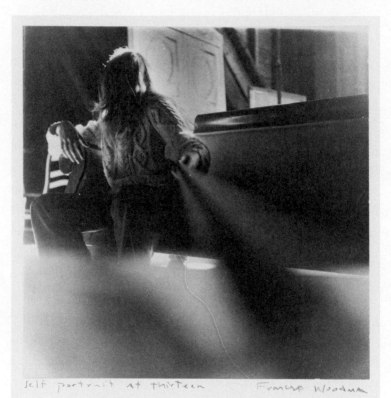

self portrait at thirteen Francesca Woodman

Shinning Up a Doorframe

FRANCESCA WOODMAN knew how to vanish. In 1972, aged thirteen, she photographed herself sitting at the end of a sofa at her home in Boulder, Colorado. The room looks like a studio; her parents were artists, and there's a sliver of easel behind her. A good quarter of the black-and-white image is a grey blur that seems to issue from her half-raised left hand and flood the bottom of the picture like a fog. It is partly made up of the out-of-focus cable release she has used to take the photograph, and the rest is likely a deliberate artefact of the darkroom. The photographer herself is in focus, but she's buried inside a big cable-knit sweater and has turned her head away so that her darkish blonde hair is all we see. There's something monstrous and comic about this faceless head, like the hairball Cousin Itt from *The Addams Family* or the unkempt ghost in Hideo Nakata's film *Ringu*. Woodman's right arm is a blaze of light atop the arm of the sofa, so overexposed that the hand seems to hover unattached: the sole expressive bit of her in a picture that is all veils and avoidance.

So much of Woodman's subsequent imagery and artifice is already there in *Self-portrait at thirteen* that it almost undoes any sense of her development as a photographer. There is the domestic yet mysterious setting, the Gothic ambitions, the use of blurs conjured by various technical means, the open and furtive deployment of her own body. The atmosphere in her photographs is avowedly literary

—tricked up out of Lewis Carroll, Edgar Allan Poe, and Surrealism—as well as knowingly indebted to photographers from Julia Margaret Cameron to Duane Michals. One keeps imagining there's a photographic *Bildung* going on, only to discover that some particularly sophisticated or unsettling image—the artist half buried in lakeside mud or become a hazy whorl inside a mirror—was taken in the first three years of her career. Woodman seems to have arrived fully formed as an artist and simply done her enigmatic, theatrical and sometimes naive thing until she stopped.

That's to say, for only nine years. She was given a camera by her father at thirteen and encouraged to develop her skills. In 1975 she enrolled at the Rhode Island School of Design in Providence. She spent time in Florence and Rome, and in 1980 was an artist-in-residence at the MacDowell Colony in New Hampshire. Much of her best work was made in response to school projects and assignments. She published just one book, a week before she died. At the age of twenty-two, after a period of depression, some apparent setbacks in her career and the end of a relationship, she threw herself from a window in New York. Her suicide is part of the Woodman mythology—it couldn't be otherwise, in light of the fragility she exhibits and the morbidity she courts in the work—but it has not really determined her reputation. Instead of a doomed prodigy, she's long been acknowledged as an artist with a keen sense of photographic history and a subtle take on certain vexing issues of her day: the relation of performance to its photographic record, the extent to which one could play critically with the clichés of femininity, the inherent falsity of photography itself.

The first survey of her work was mounted at Hunter College Art Gallery in New York in 1986. In the exhibition catalogue Abigail

Solomon-Godeau allied Woodman with the feminist body art of the 1970s, and Rosalind Krauss noted how the images shuttled between staginess and tenderness. It's not hard to see why these photographs so excited academic critics in the decade after Woodman's death. Her painterly and photographic references are daring and precise. She poses as a woman out of Vermeer at a table scattered with fruit. She flails before the camera till she's an inhuman blur, invoking Francis Bacon and aspiring, as she puts it herself, to "make something soft wriggle and snake around a hard architectural outline." She crawls half-naked into cupboards in homage to the dandyish self-portraits of Claude Cahun. When Woodman plays dead on the floor, crams herself into a museum vitrine, or binds her legs in tight spirals of tape, you can't help thinking of the photographs Hans Bellmer took of a fetish doll of his own devising in the 1930s. Woodman explores a disused factory in Rome and a bare arm pokes through the wall, like the living candelabra in Cocteau's *La Belle et la bête*.

Then there are the more or less elaborate frames and apertures—allegories of the square-format image she favoured—by which she effects her apparitions and her disappearing acts. Here she is manifesting herself from behind the shutters of a tall window, or apparently trying to climb into a large wood-framed mirror. She hovers or hangs in doorways, gets trapped in a rotting old fireplace, slips behind the wallpaper, vanishes from view as a dilapidated door unhinges itself and seems to levitate in a bare room. The nod to spirit photography becomes more blatant in a series of photographs in which she is seated and black-clad, her hands splayed before her and glowing, or when she opens her mouth and a stream of transparent glass or plastic letters floats out like ectoplasm.

And yet for all their sophistication the strange allure of her photographs surely also derives from Woodman's youth, from the way she seems to know and not know what she is doing. It's possible to read her willowy, blurred nudes amid picturesque ruins as the product of a strictly adolescent aesthetic: culturally hothoused and over-invested in Gothic and Surrealist precursors. There are hints that she was trapped not in these decaying rooms but inside her own self-fashioning—she once wrote to a classmate that she was as sick as anybody of looking at herself. Except that she also played with the iconography of the tragic teen aesthete; she knew that cliché and its lineage too well. (She must, also, have had immense fun concocting these scenes with their paraphernalia of masks and mirrors and a large sinister tortoise.) What she does not seem to have known is just when her treatment of this style itself tipped over into kitsch. Some of her photographs are texturally lovely—she was clearly attached to traditional techniques of printing and retouching—and wholly without tension. Others, such as a late series of Man Ray-ish nudes, resemble too closely the fashion photography that is always stylistically in the wings when looking at her work.

Given her immersion in the past and the claustrophobic world she depicted, it's not clear what kind of artist Woodman might have become. Biographical reports suggest that when she moved to New York in her early twenties she became dispirited at the lack of ready acceptance for her work. She greatly admired the fashion photographer Deborah Turbeville, whose works of the 1970s and '80s—neurasthenic models in Mittel-European grey gardens, Bellmer-like interiors where young women play the inanimate love object—now look, unfairly, like airbrushed versions of Woodman. Maybe Woodman's vision was too hermetic for the fashion world that has none-

theless been in her debt for decades. She had begun experimenting with video, and some of her photographs also point to a more expanded practice; her jagged handwriting adds diaristic captions to the images, treating them more as objects than portals to her Carroll-ish unconscious. Perhaps, fed up with me-decade self-advertisement (however obscurely aestheticized) she might have absconded from her own photographs completely, as she threatens to do in a rare colour print from 1979—shinning up a doorframe and leaving an empty mirror behind her on the floor.

A Mirror'd Be Better

IN MICHAEL ALMEREYDA'S 2005 documentary *William Eggleston in the Real World*, the photographer—aged sixty-six but looking and moving and sounding like an older man—is seen on excursions by car in Kentucky with his son Winston, searching for the special fleeting assembly of composition, colour and mundane subject that makes an Eggleston picture. The artist walks slowly around car lots, stares into storefronts, reckons all the angles on a roadside shack. He sometimes carries his own camera, but only when he's using one of several old Leicas that he keeps in a custom-made briefcase. More often, Winston hefts around a medium-format Mamiya press camera from the 1960s, and hands it over when it looks as though his father is ready to take a shot. (Eggleston is known for making just one exposure of any given subject, but it's not quite true.) On the face of it, the process of taking photographs looks elegant and laconic: like the man, who wears perfect suits and speaks (when he speaks at all) with extreme economy.

Elsewhere in Almereyda's film, we see Eggleston at home in Memphis with his wife, Rosa, playing his own compositions on the piano and explaining his aesthetic and technical interest in guns, which he collects alongside cameras. In most of these scenes he has a drink to hand, and the film adds subtitles when his drawl becomes impossible

to follow. At some point Eggleston decides to pay a visit to Leigh Haizlip, an old girlfriend—there were many during his long marriage to Rosa, who died in 2014—and while he sketches a Kandinsky-like abstract in coloured pencils, the two of them drink their way towards an incoherent exchange about sickness and death. (Haizlip died before the film was released.) The great photographer starts to seem perilously fragile: in voice-over, Almereyda tells us he had recently to be rescued at a hotel far from home, after falling and hurting his leg while adventuring with another woman. Toward the end of the documentary, Eggleston is limping around but still drinking, still taking pictures. Slumped in a diner late at night, he languidly describes a recurring dream: "I'm making the picture, looking at it and thinking it's just beautiful. Beautiful dreams, beautiful pictures. Sometimes I'll remember for a few minutes some of the let's say *highlights* of the dreams. Then after a few minutes one doesn't really remember dreams, even as graphic as these were —what I would call brilliant, beautiful pictures." The filmmaker risks an earnest reply, wondering if reality is not in fact fleeting and dreamlike, the photograph real and permanent. Eggleston ponders the notion for a long while, looks into the middle distance and says with infinite slowness: "You know, that doesn't mean anything to me."

Eggleston's infrequent statements about the nature of his work are bound to be too eagerly interpreted, and his gnomic anecdotes inflated into critical principles. Such is the apparent indifference and laconism of the photographs themselves, so reluctant is the artist usually to help the viewer—"I like the idea of making these things," he will deadpan—that clumsy theories lumber in to occupy the void. For a long time Eggleston's photographs of his native South

were routinely corralled inside the crude rubric of a "snapshot" sensibility. They were in colour, for a start, which seemed in the mid-1970s, when he first became widely known, like a novel choice of medium for an art photographer. In fact, they were part of a decades-long lineage, and their maker had added (or perceived) something more original than colour alone. There was the problem of their composition, which seemed to some haphazard or obvious, like the effort of an amateur. This was not true either, though Eggleston was interested in framing and organizing things and people in ways that foregrounded some accidental or innocent aspect. Then there was the matter of his matter, which looked random and unexceptional. Who takes photographs of such things? Such things as: the inside of a dirty oven, the pale green tiling around a bath, the out-of-focus upper edge of a porch on an overcast day, a barbecue unattended beside a child's bicycle, a scattering of white plastic bottles at a plantation's edge, several dogs on several dirt roads.

If you're familiar with Eggleston's work you will know that I have here chosen to mention some of the blankest, least graspable photographs in his 1976 book *William Eggleston's Guide*. You will know too that there are many pictures in the book that more openly suggest a certain vision of America, more precisely the South, and these days may also be made to fit a nostalgic conception of the 1970s. (Much of the work in *Guide* was actually produced in the late 1960s.) A child lies facedown on the concrete of a golden-lit domestic garage. A brittle blonde woman in a blue dress sits on a low yellow wall beside a thick upright coil of metal chain. A toothless old guy perched on a bed points his revolver at the folded floral quilt. There are people, or fragments of people, in twenty-six of the forty-eight photographs in *Guide*, but only a half-dozen of those

187

put a single figure anywhere near the centre of the picture and so might be thought of as portraits. Eggleston has said time and again that he photographs people, things, and places with the same "democratic" eye, the same concern primarily with colour and composition.

William Eggleston was born in Memphis in 1939 and grew up in Sumner, one of two county seats in Tallahatchie County, Mississippi. (Sumner, whose population has never risen out of the hundreds, is best known for the trial and acquittal there in 1955 of two men accused of the lynching of fourteen-year-old Emmett Till—for the offence of whistling at a white woman.) The family owned a cotton plantation of twelve thousand acres, which William was expected to take over: "It didn't interest me. I thought, there's nothing to do but watch the cotton grow." He recalls that his parents were often absent, so he was effectively brought up by his grandfather and by black servants, some of whom appear in his photographs. His grandfather gave him a camera when he was ten, a box Brownie with which he took his first picture: an already Egglestonian study of a cartwheel and its shadow. In one of the dozens of videos that he shot in the early 1970s, a cousin of Eggleston's laughs at her drunken visitor and says: "Bill was at one time ambitious." He was a talented pianist, but rejected his parent's suggestion that he pursue a concert career. Instead he went to college at Vanderbilt, transferred to the University of Mississippi a year later, but never took exams and never graduated. He claims now to read nothing but technical manuals.

Eggleston began seriously taking photographs when he was at Vanderbilt. Like many artists of his generation, he was impressed and inspired by the work of Henri Cartier-Bresson, whose book *The Decisive Moment* was published in 1952. At times, Eggleston has said, he has been doing nothing but making fake Cartier-Bressons. You can see the influence clearly in certain black-and-white pictures he made in the early 1960s, which have something of the self-enclosed surprise, bordering on glibness, of prime HCB. An older woman in a thick overcoat comes out onto the forecourt of a strip mall and stares in the photographer's direction. Behind her, in the centre of the picture, is a child-sized mechanical elephant with its trunk raised: we don't quite expect her to hop onto the ride, but the implication is there, along with a more sympathetic acknowledgment that her stern demeanour might easily be undone in the company of such a toy. Elsewhere, Eggleston's early experiments in black and white are less knowing and more diaristic, have more in common with the Swiss photographer Robert Frank's book *The Americans*, which came out in France in 1958 and in the United States the following year. Eggleston photographs the interiors of diners and offices, lone workers isolated in the middle of a wide-angle frame, the backs of heads in corridors, a woman at an airport travel-insurance desk turning toward him suddenly and blurring the shot.

The most original of his black-and-white photographs resemble the later colour work in terms of composition. Eggleston must have hunkered or even lain down to capture a German shepherd, and a tiny child behind it, on the slanting driveway of a white house. The photograph is an obvious precursor to his most famous work: an image of a child's tricycle rendered monumental by the extremely

low angle from which it has been looked at. He had already begun cutting off the heads and shoulders of some of his human subjects, or photographing them weirdly stranded by the sides of rural roads, stiff but almost unbalanced, as if the landscape might suddenly tip to one side.

By the mid-1960s, making regular trips to New York, Eggleston had parlayed his inherited wealth and social status into acquaintance with artists and museum and gallery professionals. With his combination of old-fashioned Southern manners, dramatic good looks and hell-raising habits he made friends easily with some of the best American photographers of the time, who were all working in black and white: Diane Arbus, Lee Friedlander, Garry Winogrand. It was another artist from the South, William Christenberry, who first suggested he try working in colour. (Christenberry's photographic studies of decayed buildings in the Southern states have clear affinities with his friend's mature work.) Eggleston started off using colour negative film of the type available at any drugstore, but the quality was not good at that time and he soon switched to Kodak slide film. Its colours were notably warmer than other slide films, and contrast more pronounced. The first colour picture Eggleston considered a success was taken outside a supermarket in Memphis in 1965. A teenage boy wheels a row of shopping carts toward the store entrance, his body stretched out over the carts and his greasy blond forelock leading. It is late afternoon or early evening—the "golden hour" treasured by photographers—and the boy is so aureate with light that his face seems to float free of the background, where an out-of-focus woman in sunglasses is advancing toward him. Shadows are long at this hour: the boy's profile is perfectly doubled on a pink wall. The subject is ordinary, the light and com-

position exquisite. But the picture is notable also for its striking use of colour. The gleaming green bars by which the carts are pushed along must have been among the elements that convinced Eggleston he could do more in colour than he had in black and white.

Two years after that photograph was taken, Eggleston began spending nights at a commercial photo-processing lab, watching other people's snapshots emerge in long streams of jewel-like colour. He was looking for a printing process that would do full justice to the possibilities he had seen broached in his Kodachrome slides. Late in the decade he found what he was looking for with the dye transfer process, which at the time was mostly restricted, by virtue of the labour and costs involved, to use in advertising and editorial photography. Dye transfer involves the production of three negatives— one for each of the primary colours—and corresponding masks that allow control of contrast and highlights. The technique yields prints with vibrant, even expanses of colour; smaller coloured details against neutral grounds look especially vivid. Eggleston has used several printing techniques, but dye transfer is the method with which he's most associated. It is what gave him, for example, the remarkable flat fields of red in the untitled picture often referred to as Red Ceiling. (The photograph appears on the cover of *Radio City*, the second album by the Memphis rock band Big Star. Eggleston may be heard playing piano on their rendition of "Nature Boy.") From a bare light bulb at the centre, three white electrical wires extend, two of them to the edges of the photograph. In the bottom right-hand corner, pinned or pasted to the red wall, is a series of schematic representations of sexual positions. The red ceiling not only dominates—it *is* the picture, a picture of red. You will find this red everywhere in Eggleston, with varying insistence: in a

red-lit photograph of his dentist booze-and-drug buddy T. C. Boring, on the hoods of pristine and decayed automobiles, in a cardigan worn by the photographer's elder son, William, at dusk.

It is less frequently said than it used to be that Eggleston was the first colour photographer to be shown at the Museum of Modern Art in New York—the controversy surrounding his 1976 exhibition there skewed perceptions or memories for a time. The museum's curator of photography, John Szarkowski, was among the friends Eggleston made in New York in the late 1960s: he had put on a one-night slideshow of three colour photographers in 1963, and two years before Eggleston's he would stage an exhibition of forty prints by one of them, Helen Levitt. But colour photography at MoMA had a longer history. Szarkowki's predecessor, Edward Steichen, had shown colour photographs of New York by Saul Leiter in the 1940s. Leiter, who worked mostly for fashion magazines and whose more creative work remained largely forgotten until the early 2000s, was a great photographer whose art was nonetheless on the edge of a tendency Szarkowski pointed to when introducing Eggleston in 1976: an attraction toward the merely abstract or textural. Some of the best photographers of the century, such as Walker Evans and André Kertész, produced colour images near the ends of their lives; but the results even when accomplished tend either to the decorative or to Szarkowki's alternative and equally unsatisfying tendency: they are essentially black-and-white images with colour superadded, quite incidental. Eggleston, so Szarkowski believed, had extended the medium: his colour was intrinsic, just as his com-

position was—but these were still assertively photographs of something, of somewhere.

By the time "Photographs by William Eggleston" opened in May of 1976, and the *Guide* was published with an essay by Szarkowski, the photographer was already well connected and to a small degree recognized. He had published a couple of portfolios of his colour work, been awarded a Guggenheim Fellowship, and appointed (briefly) Lecturer in Visual and Environmental Studies at Harvard. In an exhibition at the university in 1974, he showed some of the static and thoughtful large-format portraits he had been making at nightclubs and bars, and fragments of black-and-white video from similar locations in Memphis and New Orleans. He had not yet settled, it seems, on the style and format for which he was about to be celebrated and widely disparaged.

William Eggleston's Guide remains both the best introduction to his work and evidence of just how provocative the MoMA show seemed at the time. Though the artist has since refused the label of "snapshot" photographer, the book itself invites that comparison with its pebbled black leather-effect cover and gold lettering—just like a domestic photo album of the era. Of course calling it a "guide" takes it in another direction too: this seems to be some kind of survey in forty-eight images of a territory that viewers may have felt they knew, or felt they deserved to be told about a deal more clearly. (Eggleston has nothing but scorn for the idea that he is a Southern artist.) What kind of album, what kind of guide, was this? Alongside images already mentioned was an array of photographs of sometimes affronting vacancy. The tricycle picture is on the cover; inside, the first image shows a basket of various blue flowers hanging from the knocker of a pale grey door. The shadow of the flowers is hard against

the grey, across which vaguer shadows play, most likely of nearby trees. Perhaps the picture speaks of Southern gentility: the scalloped shadow of an awning or sunshade runs along the top of the door. But there is no more, no hint of location, social reality, or indeed much formal ambition beyond a flat, nearly frontal approach to the subject.

At the time, many critics baulked. The *Village Voice* wondered if "some sort of con had been worked"; the *New York Times* declared the exhibition "the most hated show of the year." The same paper's art critic Hilton Kramer wrote that there was "no great formal intelligence at work in these pictures." A common complaint was that the photographs were "centre-built": that is, their main subject was dead in the middle of the composition, as in a typical snapshot, and the periphery was either let go hang or simply extended from this centre. It seemed to such critics that Eggleston had no sense of the whole field, let alone the knowledge that a picture should be constructed from the edges. You can see what they meant, up to a point. In the second picture in the book, the pieces of an unsolved jigsaw puzzle are scattered on a coffee table, and the room around it seems just as haphazardly disposed; a knee juts up from the lower edge. Whether he is photographing a newly built house across a stretch of raw earth, the end-on rufous disc of a water tank at the side of a field, or a little girl coming out of her playhouse in a garden, it seems that Eggleston is only interested in the centre of the picture, and his idea of composition is that all else radiates from there. When the criticism was put to him, he claimed it was true, and further that the arrangement was based on the design of the Confederate flag.

That such an obvious put-on was repeated many times in articles about Eggleston is testament to more than one dispiriting truth,

but certainly to the fact that many critics simply weren't looking hard enough, and didn't yet see that colour was for him an intimate part of composition. The edges of his pictures are often where the clues to this fact lie. Consider the man on the bed with his revolver. He was the sheriff of Morton, Mississippi, and he used to accompany Eggleston as he went looking for things to photograph in the town at night. The sheriff's shirt is a deep plum red; the quilt at the end of his bed has many different reds among its patterned squares. But the points in the picture that hold the whole thing together are over on the right, beside and underneath the bed. A red sliver of magazine on the nightstand, a red handle and rim on the sheriff's chamber pot: these add to a constellation that brings the lateral edges of the picture together, and helps us see that the whole is otherwise composed of blocks and stripes of blue and brown: the empty floor, a thin blue curtain. All of this while we are wondering: why the revolver, and is he sober?

Eggleston's quip about the Confederate flag may also have been directed at critics who wanted easy answers to questions regarding the political content, or lack of such, in his photographs. In this respect the most compelling and ambiguous "portrait" in *Guide* was one that in 1976 was simply titled *Sumner, Mississippi, Cassidy Bayou in Background*. It was taken on the occasion of a family funeral, among trees and dead leaves near the water, and its shows the artist's uncle Adyn Schuyler Sr. front and centre, wearing a dark suit and a red-striped tie, and behind him, just a little further away, a black man in a pristine white jacket. This man is Jasper Staples, whom at

least one later catalogue calls Schuyler's "assistant and driver." He is also, according to Eggleston (who refers to Staples in at least one interview as his "boy"), one of the family employees who helped bring him up and to whom he was closest. The spatial arrangement in which Eggleston has discovered his subjects—he never poses them—is simply astonishing in its formal perfection and unity. (There exists, though I have never seen it, a picture taken just seconds later in which all this coherence disappears.) The two men have adopted precisely the same bodily attitude: hands in pockets, shoulders hunched, gazes directed to some spot off to the left of the frame. They might be as solid and permanent in the landscape as the two pairs of tree trunks behind them to the right. As is often the case, specks of red link different portions of the composition: Schuyler's tie, a red can on the dashboard of the white car beside which they stand, another almost buried in dead leaves in the bottom left corner. But the picture is not all made of unities, and this is where its ambiguity lies. Schuyler is compositionally linked to the car: its door opens as if to meet his shoulder. But Staples is smaller and stranded, has more to do with the dark trees, despite his white uniform. The whole is a study in connection, identification, hierarchy, and disparity, and it is filled with reminders of race and class, however much Eggleston might like us to think of it in purely formal terms. In a catalogue for a show at the Fondation Cartier pour l'Art Contemporain in Paris in 2001, he sequenced this picture among studies of leaves and trees, as if it were after all nothing but an exercise in rendering shape and texture.

In a like manner but a more personal register, Eggleston is apt to disavow any strong emotional content in his photographs of his family. There is an extraordinary photograph of his son William

asleep in bed, blond and tousled, as though guarded by a nearby chair, his pale presence almost menaced by the deep reds and greens with which he is surrounded. (Look at *Guide* and you will see this curious green of the interior walls at the Eggleston plantation house: his grandmother looms out of it at her bedroom door, his nephew is almost swallowed by it when he sits in an armchair.) Eggleston claims the picture has nothing to do with fatherly feeling, but with something "more ambiguous." This is believable, and it seems the artist has been slightly cajoled at times into presenting the relatively few photographs he has taken of his family as if they are in fact "family photographs." There are intimate studies of Rosa in the late 1960s and early '70s: asleep and wrapped in a floral bedspread, breastfeeding one of their children, holding two of them close to her on a lawn as she stands elegantly in a blood-red dress. It is true that Eggleston is a better photographer on the whole when the people he photographs—if he must photograph people—are more distant relatives or local friends and acquaintances. It is hard to think of an image more sympathetic in his whole oeuvre than his picture of the marvellously named Devoe Money sitting on a white metal glider, or swing seat. This wry and fragile-looking older woman is wearing a dress with a complicated pattern in red, brown, and blues. The cushions she's sitting on are covered in red and yellow flowers, the concrete at her feet is strewn with dead leaves. She holds onto her cigarette as if she might disappear amid all this patterned excess.

This is what I mean when I say that Eggleston's portraits are not quite portraits. The sitters are as much excuses for exercises in style as the solid objects or empty vistas around them. Eggleston has nothing against Devoe Money as a subject for his photograph—she was, he recalls, a kind and intelligent family friend, involved in local

theatre—but her character, if that is what it is, emerges almost despite him and his insistence that she is subordinate to his formal ambitions. He must have known that what he had made in this picture was a study in decay: the dead leaves, the rusted glider, the tawdry cushions, and a frail human subject hanging on for dear life in the sunshine. Such a photograph makes one wonder what it was or is like to know Eggleston and be photographed by him, to find oneself submitted to his somewhat cruel gaze. In 1976, on the back of his sudden celebrity, he was commissioned by *Rolling Stone* magazine to photograph Plains, Georgia, the home of presidential candidate Jimmy Carter. Eggleston undertook the task, and made the trip, alongside his then girlfriend, the former Warhol superstar Viva (Janet Hoffmann), whom he photographed seated in the dirt beside a road, with her own Leica in hand. With her sharp beauty intact but all evidence of her Factory glamour vanished, Viva in her sneakers and her yellow shirt is really just a motif to link the red dirt with a mustard-coloured shack on the other side of the road.

Eggleston and Viva were together for some years, and in that time he lived with her at the Chelsea Hotel in New York. With his tailored suits, floppy hair, and horn-rimmed glasses, he must have seemed an exotic addition to the hotel's collection of more down-at-heel bohemians. He got to know, belatedly, Warhol and his milieu, but Eggleston and other Memphis artists had long been attuned to Pop and other developments among artists in New York. One keen reminder of Eggleston's connections to the avant-garde is *Stranded in Canton*, the film he eventually made from thirty hours

of video recorded in 1973 and 1974. Warhol and Nam June Paik had already put the new portable Sony Porta-Pak to artistic use when Eggleston acquired one of the cameras and began to record his current social scene. Ever the tinkerer with his photographic equipment, he added a movie-grade lens and an infrared sensor so he could use the machine at night; it's the latter innovation that gives *Stranded in Canton* its eerie visual texture.

The film begins with one of the most intimate moments in all of Eggleston's work: the appearance of his son William and daughter Andra early in the morning—their father has woken them deliberately—as they blink into the camera still slightly stupefied, rub their eyes and say nothing, while the dawn chorus is heard in the distance. It's a rare moment of calm (of a sort) in a work that is at one level all about drift and blank disarray, arduous states of near-consciousness. These were, said Eggleston later, "the days when everyone liked Quaaludes. *Let's get down.*" Once the children have gone, and excepting a few relatives who appear later on, almost everyone in *Stranded in Canton* is comprehensively out of it, drunk or drugged or otherwise gone on art, sex, music or bizarre performance, most of them rendered in infrared so that their skin is ghostly pale, their eyes dark and dangerous. The film's most disturbing scene is probably not the one where two drunken men, in front of a sidewalk audience, bite the heads off live chickens and drink blood from their gaping necks, all to the carny-barker accompaniment of a friend's commentary.

Eggleston was filming in bars and clubs in downtown Memphis and New Orleans, sometimes in the homes of friends. His cast includes some characters who appear in photographs of the same period. Here again is the dentist T. C. Boring, reminiscing about

the first time, in the late 1950s, that he took Seconal: "I didn't know how to handle drugs then—nobody did." There's a drag artist, Lady Russell Bates-Simpson, trying to torch-sing over a bar's jukebox. Eggleston's then-girlfriend Marcia Hare is there: she is the subject of one of his most ravishing pictures, stretched out on grass, with a Brownie camera in her hand, the red buttons on her dress shining like rubies. Eggleston's artist friend Randall Lyons bares his ass for the camera and screams, "We're in the midst of grammar!"

Stranded in Canton is also a confusing introduction to Eggleston's connections with musicians and the music business in the South. He was a close friend of Big Star's singer Alex Chilton, whom he had known in Memphis since Chilton was a teenage star with the white-soul group The Box Tops in the late 1960s. Chilton is not in the film, but his collaborator Jim Dickinson is: a legendary Memphis figure who played piano on the Rolling Stones's "Angie," produced Big Star's ravaged album *Third* (on which Eggleston also plays), and later worked with Joanna Newsom. Like half the cast of *Stranded in Canton*, Dickinson is dead now. So too the bank robber and rockabilly singer, former Sun recording artist Jerry McGill, who is seen waving a revolver around, shooting holes in the ceiling. And the blues singer Furry Lewis, who essays a stirring version of "Will the Circle Be Unbroken?" One can disappear into a research hole for hours, trying to track the broken, sometimes brilliant individuals with whom Eggleston surrounded himself in the years immediately before his photographic career took flight.

But I mention *Stranded in Canton* for the more obvious reason that it is one of the few places in his work where we got a good view of the artist himself. The photographer appears in repose, having handed the Porta-Pak to someone else. He is the still point in all

this mania: white shirt, glasses and cigarette, looking amusedly at his own camera. But the moment lasts mere seconds. For the most part Eggleston's presence in the film is more ambiguous. He is in control but out of it also—his cousin Mary Elizabeth Wilson laughs and tells him: "Bill, you're a mess—you better go and eat." Sometimes you can hear his low, unmistakable voice off-screen, but you can never catch what he's saying. Toward the end of the film, Eggleston is in a bar, pushing his camera in the faces of a group gathered round a table. An unnamed man turns and faces the photographer, looking like a ghost with his black eyes shining, and says: "You're a posing asshole, Eggleston. A mirror'd be better."

Miraculous!

NOTHING TO SAY, nothing to paint. The earth might be uninhabited. I can't go on, etc. It is too easy, when we think of the writings of Samuel Beckett, to invoke certain frequently cited fragments and conclude that his was at root an aesthetic of silence. In fact, the besetting problem for many or most of Beckett's dramatic and fictional personae is that voices—their own and others', but how to distinguish?—will not let them alone. And no work better stages the invasion of an intimate, alien voice than the short play *Not I*, first performed in 1972. On an otherwise darkened stage the spotlight fades up on a single mouth, engaged in hectic blather. The owner of this mouth displaces her narrative onto a nameless third person, but it is clear she is the woman in question, now in her seventies, who has been "practically speechless . . . all her days."

"A voice comes to one in the dark," Beckett writes at the outset of his short prose work *Company*. The plays and novels are filled with voices that seem at once to flow from inside and outside a character's consciousness—or to come, more vexingly, from the babbling unruly body itself. "It issues from me, it fills me," says the narrator of *The Unnamable*, but "it is not mine, I can't stop it." In *Krapp's Last Tape* the aged protagonist torments himself with recordings of his middle-aged self, who in turn has been listening to the voice of his youth: "Hard to believe I was ever that young

whelp. The voice! And the aspirations!" With the woman in *Not I*, her case has aspects of these others. Her monologue has no discernible beginning or end; it's an interminable "buzzing... so-called... in the ears." Still, she surprises herself with her actual vocalizations, which erupt, "some strange reason," only in winter: "a voice she did not recognize... at first... so long since it had sounded." And further, at such moments she has had "no idea... what she was saying... imagine! No idea what she was saying!"

Beckett had long been interested in the potential reduction of theatrical spectacle to nothing more than a mouth with its unstoppable stream. He had spoken of wanting in *Waiting for Godot* to present merely "a pair of blubbering lips," and the glossolalic speech of Lucky in that play is one precursor for *Not I*. But its immediate occasion, so he recalled, was his viewing in 1971, while on holiday in Malta, of Caravaggio's *Beheading of St. John the Baptist* at St. John's Cathedral in Valletta. (In the play as published and frequently performed, there is a second character of sorts, the Auditor, who stands and listens downstage and is partly based on a figure in this painting: an old woman who before the gruesome sight covers her ears instead of her eyes.) In the vision of a disembodied head, and Beckett's preoccupation with voices out of the void, there is perhaps also a trace of Oscar Wilde's *Salomé*, with its saint banished to an offstage cistern, doomed and speaking still.

When he had finished writing *Not I*, Beckett asked the theatre scholar Ruby Cohn: "Can you stage a mouth?" The technical challenge was considerable, and he was unhappy with the first production, directed in the round by Alan Schneider, with Jessica Tandy in the role of Mouth. Tandy found it impossible to memorize Beckett's text, so read her lines from a teleprompter while standing in a

black box, clinging to a metal bar so that she would not move. "I didn't ever find it fun to do," she said later. The problem was partly one of speed, and when it came to the second production, at the Royal Court, London, in 1973, Beckett urged Billie Whitelaw to approach his words at breakneck pace. Having failed to perform it adequately while reading, or with a prompter feeding her the lines via an earpiece, Whitelaw resolved to learn the monologue by heart. She practised while watching sports on television, matching her performance to an onscreen clock or stopwatch. And Beckett agreed that she ought to speak in her own North Country accent, though the character is meant to be an archetypically Irish "crone" whose voice he said he heard insistently in his head while he was writing. Whitelaw was to perform the play sitting down, strapped in place and with her face masked, black makeup isolating the mouth. There are photographs of Whitelaw on her theatrical throne of agony, mouth open wide and two foam-rubber blocks keeping her head in place—she resembles nothing so much as one of Francis Bacon's screaming popes. If anything, Whitelaw found the ordeal more arduous than Tandy had; after a first run-through the actor collapsed, overcome as much by the words pouring out of her as by disorienting dark and physical effort: "I felt I had no body."

There is a good case for saying that the television version of *Not I*, filmed in black and white by the BBC in 1975, is the definitive performance. It was at one point intended to be broadcast alongside the BBC's earlier production of *Eh Joe*, a play similarly haunted by a disembodied voice—"About one hour's worth of jolly time would be had by all," said Beckett. The TV *Not I* was not broadcast until April of 1977, alongside two plays Beckett wrote for the occasion: *Ghost Trio* and *...but the clouds....* The result is an hour-long

programme to which Beckett gave the title *Shades*. The Auditor has been banished; a decade later Beckett would say that even in stage productions this figure had never been employed to his satisfaction. Whitelaw's mouth dominates the screen, and the full pathos, comedy and horror of the speaking body are inescapable. One wants to look away from this gabbling void, with its lips and teeth and tongue that seem scarcely human. The slurp and clack of articulation, denying articulacy. (The author's friend and editor John Calder reviewed the televised *Not I* for the *Journal of Beckett Studies*, and seemed repelled by the dentist's-eye view. He also, inaccurately, discerned a "hairy chin.") So much is controlled by Beckett's stage directions, only some of which have made it into published versions of the play: the duration of words and screams and laughter, the precise length of a pause when Whitelaw's lips clamp shut. But it is hard not to fixate on the accidents: the dark sheen of the makeup, the foam that gathers at the corners of her mouth, a bubble of spit on the chin. The voice is hers and not hers, a signifying ooze from elsewhere. Whitelaw recalled that when the film was finished she and Beckett watched it together in a darkened room and at the end a single word came from him out of the dark: "Miraculous!"

Like most people I know who love the play nowadays, I first saw *Not I* on YouTube, bookended by Whitelaw's recollections of the Royal Court rehearsals and watching the film with Beckett. After he died in 1989, the BBC showed again all the versions they had made of his work, including plays commissioned by them and written especially for television. I remember as a student at the time—I went to the university attended by James Joyce, not Beckett: we studied, bizarrely it seems to me now, nothing by the latter at all—watching as many of these as I could. The dead grey scenogra-

phy of *Eh Joe*: the anxious methodical movements of Jack MacGow-
ran, the "suppressed venom" (Beckett's phrase) of Siân Phillips's
voice-over. Whitelaw in *Rockaby*, rocking herself off into the void:
"Fuck life." (I had no idea that this had been directed by D. A. Pen-
nebaker, director among much else of documentaries about Bob
Dylan and David Bowie.) And Patrick Magee in *Krapp's Last Tape*,
spooling out his past in riveting close-up. But somehow I missed
Not I: one of those lost moments with a work of art that in retrospect
seems like it would have made all the difference. To what?

To my sense, I suppose, of what an artist was capable of who
refused to choose between the most extreme austerity of means and
nearly unbearable generosity of emotional content. In the theatre,
the play is an immersing experience, though even when most auda-
ciously staged and acted—the Irish actor Lisa Dwan is Whitelaw's
successor here—there is some distraction in the feat itself, in the
fact we have all, audience and actor, got through it. On screen, with
only the isolated mouth to contend with, the piece seems more
minimal and more intimate. The online life of *Not I*, as with so many
works of "difficult" or "experimental" art of the last century, has not
only increased its audience—over four hundred and fifty-four thou-
sand views, when I last looked—but drastically altered the sort of
attention you can pay it. Of course it's true of any monument or
scrap of film that lives now online. But things seem exaggerated with
Not I: it is so blank and so hectic, moving and forbidding, that it
seems to make a great difference to be able to watch it any time and
anywhere, call it up on a slow bus ride, in the middle of a seminar,
for purposes of study or pure rapture. What happens then to the
shock, boredom, confusion or sympathy felt by its first viewers in
1977, very few of whom were able to repeat the experience?

Not I becomes a meditative abyss—not at all abstract, quite the opposite. Easy of course to be distracted by the medium, its marginalia: a YouTube commenter notes a resemblance to the Rolling Stones logo, another to the lipsticked mouth, with its bitten lower lip, that advertised *The Rocky Horror Picture Show* in 1975. Switch to full-screen, try again. Third, maybe fourth viewing: the theatrical gesture, the simple fact of their being only a mouth on stage or screen: this starts to fade. *Can you screen a mouth*? Yes, but it's not the conceit that matters, rather its odd inflections. After you've watched it several times, *Not I* becomes all familiar rhythms, textures audible and visual, heartbreaking repetitions. The stippled flesh of Whitelaw's taut chin as her mouth snaps shut between screams. The tongue crouched like an animal at times, as during the manic laugh interrupting the phrase "a merciful...God." Moments when Whitelaw's accent sounds more insistent—as in "oh long after... sudden flash"—and never fails to make me think of the comedian Victoria Wood. (Maybe *Not I* is not so austerely self-involved, in the end, as I wish it to be.) A slow rictus that grips the mouth when Whitelaw pronounces the name of the place where the woman found herself crying out for the first time since infancy: "Croker's Acres...one evening on the way home...home!... a little mound in Croker's Acres." The blazing white teeth still moving for a second as the whole thing, sound and image, fades to black.

Essay On Affinity VII

AFFINITY INSULTS THE ACADEMY. A shameful memory from my mid-twenties: I am delivering my first or second academic paper to a room packed with professors and graduate students of the English department where I have just arrived to complete a Ph.D. My subject this afternoon is an essay on photography from 1930 by Siegfried Kracauer, and in particular a photograph he describes at the outset, but does not reproduce. It shows a film actress standing in front of the Hotel Excelsior on the Lido, Venice. "Time: the present. The caption calls her demonic: our demonic diva. Still, she does not lack a certain look. The bangs, the seductive position of the head, and the twelve lashes right and left—all these details, diligently recorded by the camera, are in their proper place, a flawless appearance." My shame has two aspects. First I pronounce "Lido" in the British fashion, the first syllable rhyming with "lie," as if the word referred to an outdoor municipal swimming pool. Second, my paper consists of an obvious but laboured effort to link the photograph in Kracauer to certain other photographic moments in fiction, poetry and criticism. I have been thinking about Marcel Proust and his grandmother, about Ezra Pound's "In a Station of the Metro": "The apparition of these faces in the crowd: / Petals on a wet, black bough." I have been reading Walter Benjamin on the mechanical reproduction of faces and bodies. And Roland Barthes

on a photograph of his late mother. Without saying it, I have probably also been thinking about my own dead parents, and photographs of them young, in dingy mid-century rooms or swallowed by sunlight. At the end of my presentation, a junior academic raised his hand and said this was all very well but seemed to consist only of connections. Where were my judgements and distinctions? Where was history—no, *historicity*? This was a quarter of a century ago and more, but still sometimes when I sit down to write I hear, and amplify in my head, this accusing voice. Are you not simply connecting some things to other things? Do you call this criticism? What is wrong with you?

1 meter

0
10
meters

Cosmic View

IN 1956 CHARLES AND RAY EAMES appeared briefly on the NBC television show *Home*—presented by the actor Arlene Francis—and introduced their new lounge chair and ottoman: probably the designers' best-known work. Charles, ushered on first in crew cut and bowtie, submits to Francis's cooing description of his talents, but subtly reminds her that Ray, his wife and creative partner, is waiting in the wings. "She is behind the man, but terribly important," asserts the gowned host.

It's an embarrassing interlude from one of the great collaborations in twentieth-century art and design. Charles had trained as an architect, and Ray as a painter. Their design career began in the 1940s with moulded plywood furniture and early plastic chairs. Based on a philosophy of "learning by doing," born out of a busy and generous studio culture, their work expanded to include buildings, toys and exhibitions. The NBC television spot hints at other ambitions: a decade after their first celebrity, and on the occasion of unveiling a luxurious signature piece, the Eameses are eager to plug the film they have just made about their house in Pacific Palisades, Los Angeles. By the mid-1950s, Charles and Ray were producing films and multimedia presentations that are as much part of their formal and intellectual legacy as their furniture or the elegant glass-walled Eames house itself.

Film and photography had been essential to the couple's work from the start. Charles had taught himself wet-plate photography as a child, was in the habit of documenting his life and work obsessively, and encouraged studio employees to do the same: "I'll do anything to give an excuse to take photographs." He and Ray met at Cranbrook Academy of Art in Michigan, married in 1941, and moved to California in the same year. Before they had set up their studio, Charles got a job in the art department at MGM, where he made friends with Billy Wilder and took countless photographs of Hollywood stage sets. Making films, Charles would say later, was a "terrible, enjoyable bloody business."

Despite their immersion in the West Coast image industry, the Eameses never conceived of the hundred or so films they made as movies per se. "They're just attempts to get across an idea," Charles claimed in an interview with Paul Schrader. The designers seem to have arrived at film as a medium via their experiments with text, slide and graphic presentations. Although they had been making moving images for a few years, in some ways the first Eames "film" is the playfully and seriously titled *Rough Sketch for a Sample Lesson for a Hypothetical Course* (1953): a multimedia lecture about communication and the structures of visual thinking. It included still and moving pictures, text, graphics, music and even smells pumped through the ventilation system. *Rough Sketch* was the first of many such multiscreen projects, combining pedagogy and public spectacle. In 1959 in Moscow Charles and Ray showed *Glimpses of the USA*: a seven-screen portrait of their country. It is supposed to demonstrate geopolitical kinship; there are shots, so a narrator tells us, of "the same stars that shine on Russia each night." But it's also a film, or seven films, in thrall to the patterns produced by city streets

and suburbs seen from the air: an almost abstract counter to the
excessively humanist *Family of Man* exhibition four years earlier—
more a precursor, in its depiction of modern America, to serial pho-
tography of the 1960s, or the New Topographics in the 1970s.
Questions of scale, questions about the place of the human in rela-
tion to present culture and knowledge, had begun to occupy the
Eames Office. In 1964 they designed a complex environment for
the IBM pavilion at the New York World's Fair: an event dedicated
to "Man's Achievement on a Shrinking Globe in an Expanding
Universe."

Although works like *Rough Sketch* and *Glimpses of the USA* were
graphically arresting, they were also, like the Eameses' more con-
ventional single-screen films, essentially illustrations of ideas, or a
single idea in each case. Charles and Ray maintained a regular output
of educational shorts for the likes of IBM, MIT and the Smithsonian
Institution. It was the era of cybernetics and communications theory,
and it seemed that developments in electronic transfer of informa-
tion might pass the design world by if they were not adequately
explained and embodied. As Charles put it: "I had the feeling that
in the world of architecture they were going to get nowhere unless
the process of information was going to come and enter city plan-
ning in general." In 1953 he and Ray made *A Communication Primer*,
which explained current theories of information flow, and in 1966
they completed *An Introduction to Feedback*, demonstrating this key
concept in cybernetics via footage of boats being steered, children
playing and clowns and actors adapting to the vagaries of a live
audience.

As the last example suggests, the Eameses' "idea films" are notably
light and playful. Some examples from the 1950s are unashamedly

lyrical, seemingly at odds with the technological complexity they celebrate, but still rigorously dedicated to new ideas about scale and perception. You can see the lyric tendency clearly in *House: After Five Years of Living*. Charles and Ray had designed their home as part of the Case Study House programme instituted in 1945 by *Arts and Architecture* magazine; the Eames house was eighth in the series of experimental new buildings. The 1955 film shows the two parts of the structure—domestic and professional spaces—already considerably adapted to their eccentric inhabitants. The twin austere boxes, in glass and coloured panels over a steel frame, are merely support for a lot of pastoral detail: flowers and foliage soften the lines of the house, textures of wood and stone make it seem newly primitive—on TV with Ray in 1956, Charles would say the innovative structure has "gotten to be like an old cave for us."

House is full of elegant and meaningful things that can be held in the hand: seashells, toys, a selection of delicate wooden combs. The Eameses took to filming objects on a certain scale: spinning tops, miniature towns and model trains that may seem to exist at some remove from the world of cybernetic systems explained in films from the same period—until, that is, one notices that what the two strands of imagery and thought have in common is a genial but critical optimism, if not outright utopianism. This sense of wonder and adventure is ever present in the Eameses' work. In 1949 Charles compiled a list of useful advice for design students. Alongside predictable instructions to read a lot and be curious and look afresh at the world, he recommends: "Always think of the next larger thing."

That is one way to describe *Powers of Ten*: the best known and most viewed of the Eames films, a study of knowledge and scale, human and technological visualization and the wavering sense of

where exactly you are while looking at the world. In fact it is not really a single film but a constellation of connected works, books and films, not all of which strictly belong to Charles and Ray Eames. The finally achieved film of 1977 is based initially on *Cosmic View: The Universe in 40 Jumps*, a 1957 book by the Dutch educator Kees Boeke. In its first illustration, a girl sits outside her school holding a cat; the book zooms out, step by step, till it reaches the depths of space, then back in again vertiginously to the nucleus of a sodium atom. This is more or less the structure of all subsequent versions, printed or filmed; what differs is first the scene with which the process begins and, more important, the precise structuring principle of the movement itself.

In the early 1960s the Eameses filmed the illustrations from *Cosmic View* and began to experiment with camera setups. In 1968 the National Film Board of Canada released a mostly animated interpretation of Boeke's work: a live-action boy in a boat on the Ottowa River gives way to drawings by Eva Szasz that track backwards to the wastes of space and then down again to the boy's hand, where a mosquito is sucking his blood—we speed towards the nucleus of an atom in the insect's proboscis before returning to the scene on the river. It's a charming film, but lacks the main insight the Eameses now added. Also in 1968, they produced the first black-and-white "sketch" version of *Powers of Ten*. Over eight minutes, in scaled steps based on a factor of 10, the camera appears to move out from a man sleeping on a Miami golf course, and back into a carbon atom in his wrist—time, speed and distance are all indicated in a sort of dashboard to the left of the image. This version was later installed at the National Air and Space Museum in Washington.

In the final 1977 iteration of *Powers of Ten*, a man and woman

are picnicking in a Chicago park. At first we see one square metre of the scene, from one metre away: the man falls asleep on a rug strewn with food, drink, popular science magazines and a copy of J. T. Fraser's 1966 book *The Voices of Time: A Cooperative Survey of Man's Views of Time as Expressed by the Sciences and by the Humanities*. A narrating voice—the physicist Philip Morrison—explains the scale, and the scene begins to expand: 10 metres across, 100, 1km, and so on. The lakeside appears, the nearby Soldier Field football stadium, the city, continent, planet, solar system and eventually the known universe. Even at that distance, we are still, so Morrison tells us, oriented perpendicularly to the square rug on the grass in Chicago. Now we begin to speed back towards the sleeping man, towards a point on his hand and thence via blood cells to a proton of a carbon atom.

The nine-minute version of *Powers of Ten* was assembled from live-action footage, photographs and drawings; most of its 14,000 frames were filmed individually. The movement feels stepped and seamless at the same time: there is less information about timing and distance than in the 1968 version, but the shifts in scale are just as clearly signalled by numbers on screen and Morrison's narration. This makes for a curious viewing experience, every bit as complex in its way as the multiscreen works the Eameses had made for expos and museums. Writing about the first version in *Film Quarterly* in 1970, Schrader pointed out that it was pretty much impossible for the viewer to do just what *Powers of Ten* demanded: that is, to pay attention to both image and calculations at once. The film was a single-channel example of a phenomenon that had occupied the Eameses in most of their film work to date: the sheer profusion of pictures and other stimuli was an argument in itself about the con-

temporary world of imagery and information technology. The films looked and spoke as if this new world were elegantly explicable, but they were structured so as to encourage doubt and difficulty.

Charles Eames died in 1978, Ray a decade later after sedulously cataloguing and preserving their studio and its outputs. In the last years of their life and work together, their non-design projects included films about Newton and Kepler, and a vast touring exhibition about Benjamin Franklin and Thomas Jefferson. They continued to be exercised by relationships between part and whole, detail and ground, history and cosmos. One of the couple's seemingly unlikely friends was Tony Benn. In August 1961, five years before he became minister of technology under Harold Wilson, Benn wrote to Charles, enclosing a limerick that seems to summarise both designers' ambitions, as well as their intellectual and aesthetic interest in space and scale: "A dazzling designer called Eames / so excelled at a myriad schemes / that his rocketing mind / left the world far behind / now in orbit his genius gleams." Benn had neglected to remark, of course, that there were two bright lights in this modern firmament, Charles and Ray.

There Are Eyes Everywhere

"A WOMAN'S CITY, NEW YORK." Thus Elizabeth Hardwick in her novel *Sleepless Nights* (1979), on solitary women seen dragging their baggage—"parasitic growth heavy with suffering"—along city streets or picking their way, black-shawled, back to formerly grand apartments, now decayed. New York at the end of the 1970s is a museum of remnants from mid-century, where certain emblematic figures recall ways of being in public that are now definitively old-fashioned. Helen Levitt had her eye on these women too. Here is one of them, installed with placid dog on the steps of her building, in the shade. It is 1980, and she still has no air-conditioning up there in the dark behind her. In a black dress, stockings to the knee, and her black strapped pumps, she might have been sitting out here since the 1940s.

Levitt's New York photographs are full of tired, vigilant women on steps or stoops. Children too, famously: bursting out of doorways, shinning up drainpipes to mock-fight like classical friezes atop crumbling lintels. She began photographing these kids in the 1930s, becoming a lyric witness of the working-class streets of Spanish Harlem and the Lower East Side. In 1948 she made a short film, *In the Street*, with James Agee and Janice Loeb; among sidewalk games and hydrant fountains, floral sundresses and playful kittens, there are numerous dogs, and the laughing women who love them. In

1980, only the dog looks at us. All three human subjects—or is it four? a mother's outline behind that woman on the right?—have turned aside and stretched out their arms. Toward what?

The averted gaze is a recurring motif in Levitt's work: a woman's head plunged deep in her little boy's pram; a street full of men all looking in the wrong direction, only a child watching the photographer from a window. Some of this is attributable to the *Winkelsucher*: a right-angle viewfinder Levitt stuck on her Leica, allowing her partly to disguise what she was photographing. But the views from behind, the heads lopped off by framing or cropping: they persist over decades, so that one wants them to mean more. Is it too easy to say that in the 1940s they might be looking toward the future? And three of four decades later—a spidery girl almost tucked under a green car, a guy in shorts and not much else at a street crossing—they seem to stare at the dirty, spalled ruins of postwar New York? Even this tiny boy, whose outfit is the only thing attaching us to 1980, seems more curious about the old railings than the street behind him.

Soon, as Levitt lamented in one of her last interviews, there would be hardly any children on the sidewalks of New York for her to photograph. The little boy cannot tell he is almost antique. But the woman in black knows what is passing away, and she's determined to summon the spirit of city streets still, in the sunshine.

Common Martyrs

EARLY IN THE SUMMER of 2020, as the first pandemic lockdown began to ease, I left my apartment and walked to Postman's Park, a small green spot that doubles as the churchyard of St. Botolph's, Aldersgate. In April and May, my partner and I had passed through the park every couple of days, seeking fresh air along a route that felt predictable and not too populous. First, we'd head west, through Smithfield Market, to the grassy square of Lincoln's Inn Fields, where only the homeless now sat together in the sunshine, then south, along empty back streets, to the river. We'd follow it east for a while, before coming north again, via the vacant steps of St. Paul's Cathedral, to arrive among the trees and benches of Postman's Park. Away from news and work and private worry, passing through squares we knew to have been plague pits in centuries past, we thought more clearly about the dead and dying. Sighs, short and infrequent, were exchanged.

There has been a church at the park since the twelfth century. By the 1850s, St. Botolph's burial ground had accumulated so many graves that it rose like a small plateau above the surrounding streets. Gradually, the graves were cleared, headstones stacked in corners, and, by 1900, the whole plot was converted into a park, named after the nearby headquarters of the General Post Office. On a normal weekday in June, the park fills up with lunchtime office workers,

crowding the modest lawns or sitting in the shade near a little pond and fountain. Since lockdown began, the parkgoers had been mostly like us, pedestrians out for their one government-approved bout of daily exercise, or cyclists arriving from further-flung parts of London, seeking out the park's most curious feature. Opposite the southwestern gate sits a wing of St. Bartholomew's Hospital. During our walks, we saw hardly a soul going in or out of its glass atrium, where a sign announced that the hospital had no emergency room.

On the western side of the park, abutting a plain red brick apartment block, there is a wood-framed open loggia, fifty feet long and nine feet tall, with a bench inside and fifty-four glazed ceramic plaques above it. This is the Memorial to Heroic Self-Sacrifice, installed in the early years of the twentieth century to record certain fatal acts of valour in everyday life. The plaques commemorate a fearful, also faintly absurd, litany of shipwrecks, fires, drownings, gassings, and rail or street-traffic disasters. Hang around the memorial long enough, and you will hear first-time visitors mouthing aghast the fate of Elizabeth Coghlam, in 1902: "Died saving her family and house by carrying blazing paraffin to the yard." Or, wondering aloud: "Quicksand is real?" at the awful demise, in the same year, of Arthur Strange and Mark Tomlinson, "who were engulfed in a doomed effort to save two drowning girls."

The memorial was the project of G. F. Watts, a Victorian painter of considerable renown, whose allegorical compositions—*Hope*, *Love and Death*, *Mammon*—earned him the inflated title "England's Michelangelo." In 1887, Watts wrote to the *Times*, proposing that an unusual monument be erected as part of the coming celebration of Queen Victoria's Golden Jubilee. "Among other ways of com-

memorating this 50th year of Her Majesty's reign, it would surely be of national interest to collect a complete record of the stories of heroism in every-day life," he wrote. Watts had been attempting exactly that since the 1860s, and had amassed, mostly from newspaper reports, a list of quotidian heroes. He had in mind at first a vast figure in Hyde Park, but that idea came to nothing—something similar was later erected as *Physical Energy*, in Kensington Gardens. Instead, as the century closed, Watts secured a corner of the new park at St. Botolph's, and set about having tablets made.

There are six police officers and two firemen among the memorialized—the rest are "ordinary" people, ranging in age from eight to sixty-one. Here is Thomas Griffin, who, in 1899, was a young labourer at a sugar refinery in Battersea; following an explosion, he ran into a steam-filled room, thinking a friend was inside, and was scalded to death. Mary Rogers died in the same year; she was a stewardess on board the steam ferry *Stella*, which sank on the crossing from Southampton to Guernsey. Survivors reported that Rogers refused to board a lifeboat, for fear of overcrowding, and raised her arms to Heaven as the water reached her, crying: "Lord, save me!" A local newspaper called her death "Homeric in its majesty." In his letter to the *Times*, Watts singled out the case of Alice Ayres, who, in April of 1885, saved three children from a burning house; she was fatally injured when she jumped from an upper window into the street. Ayres is one of several heroes featured in the memorial who were well known at the time of its construction. Hundreds attended Ayres's funeral, where firemen carried her coffin, and soon her death was the subject of popular poems, children's stories, and a mural by Walter Crane, which depicted Alice on the window ledge with a child in her arms.

Viewers of the 2004 film *Closer*, directed by Mike Nichols and based on Patrick Marber's play of the same name, may recall Jude Law taking Natalie Portman to Postman's Park, where they look at the Memorial to Heroic Self-Sacrifice—it's only at the end of the film, returning to the park, that Law's character, a struggling English writer, realizes where the young American woman he knows as Alice Ayres got her name. Ayres's plaque is also among those photographed by the artist Susan Hiller for her 1981 installation *Monument*, one of several works by the late American-born, London-based artist to reflect on words and loss: on disappearing languages, on city streets named for vanished Jewish communities, on what vanishes when moving between American and British English, thus between versions of how the world is read and made. It was via Hiller's work that I first knew about the park and the monument. She imagined *Monument* in three slightly different versions, but the installation always consists of forty-one photographs of the panels (one for each year of the artist's life to that point) arranged in a diamond pattern. In front of these, a wooden bench, such as you will still find in Postman's Park. Here the gallery visitor can sit and listen, on headphones, to Hiller as she speaks (without ever describing Watt's monument in detail) about the traffic of stories, images and voices between the living and the dead.*

Hiller's voice-over text begins: "You are sitting, as I've imagined you, with your back to the 'monument.' The 'monument' is behind

*A handful of quotations punctuates Hiller's essay (of sorts), from Julia Kristeva, Shirley Ardener, Virginia Woolf, Friedrich Engels—and from Goethe's *Elective Affinities*: "You can think of life after death as a second life which you enter into as a portrait or inscription and in which you remain longer than you do in your actual living life."

you. The 'monument' is in your past. Do the dead speak through us? This is my voice, unrolling in your present, my past. I'm speaking to you from my hereafter, the hear-after." There follows a list of eighteen of the heroic dead, with figures for their time "in the body" and "as a representation." Ernest Benning: 22 years embodied, 98 years inscribed. Amelia Kennedy: 19 years alive, 109 years as a textual remnant. Poor Henry J. Bristow, who "saved his little sister's life by tearing off her flaming clothes but caught fire himself and died of burns and shock": 8 years in his body and 91 as a representation. What is Hiller measuring here? Absence as such, it seems: "Representation is a distancing in time and space." But also something to do with the violent pivot between those two numbers in each case recorded and memorialized. However heartbreaking the narrative, it also partakes of an idea of heroism, says Hiller, and heroism is a very partial idea, which leaves out much arduous experience. "Western industrial society demands from each individual perpetual self-sacrifice, prolonged over a lifetime of effort. This form of self-sacrifice isn't seen as particularly admirable or remarkable, and is not represented as exemplary."

At the time Hiller made her *Monument*, a graffito had been scrawled onto an empty panel in the park: "Strive to be your own hero." Picturesque death was, of course, a staple of the Victorian imagination: there was hardly a dismal reality, whether in the realm of war, disease, industry, or crime, that could not be turned to purest sentiment. But Watts's inscriptions are strikingly laconic. Reading and rereading them during lockdown, I was reminded first of the "news in three lines" that the French anarchist Félix Fénéon wrote, in 1906, for the newspaper *Le Matin*. Fénéon condensed his *faits divers* into nuggets of economic prose, describing murder, accident,

suicide, and strife. There is often an ironic tone in his miniature tales. "Finding his daughter, 19, insufficiently austere, Jallat, watchmaker of Saint-Étienne, killed her. It is true that he has 11 children left." "Nurse Elise Bachmann, whose day off was yesterday, put on a public display of insanity." Watts, by contrast, is mostly a purveyor of plain fact: "George Frederick Simonds of Islington, rushed into a burning house to save an aged widow, and died of his injuries, Dec 1, 1886." Occasionally, though, emotion intrudes, such as when he conveys the last words of Solomon Galaman, age eleven, who had rescued his younger brother from being run over: "Mother I saved him but I could not save myself."

What did Watts mean by "heroism" and "self-sacrifice"? It is hard today not to balk at the latter as applied to Mary Rogers, whose ferry captain was rumoured to have been racing a competitor at lethal speed, or as applied to the four men, working quite without safety equipment, who were overcome by gas in a shaft at a sewage plant in East Ham, in 1895—the local council tried hard to avoid legal responsibility for compensating the dead men's families. What Watts and Fénéon have in common, as storytellers, is the wealth of detail they have left out, but which remains implied. Most obvious: predicaments of class and gender. (All of the dead seem to have been white.) In the *Times*, Watts wrote: "The material prosperity of a nation is not an abiding possession, the deeds of the people are." But heroism and self-sacrifice seem to have meant, for many of the men, women, and children recorded in the memorial, merely succumbing to the risks of their economic station in life.

Among the dead named on the plaques are two doctors, William Lucas and Samuel Rabbeth, both of whom died of diphtheria, which they contracted while administering tracheotomies in the hopes of

restoring their patients' breathing. Lucas, his inscription says, "risked poison for himself rather than lessen any chance of saving a child's life." (That is to say, he sucked infected fluid from the child's neck wound.) On the London Transport bus shelters that my partner and I passed by on our regular lockdown walks, there was a message broadcast in a recurring video: "THANK YOU / to our amazing NHS staff / #thankyouNHS." It was almost a surprise, so many weeks into this horror, to see British health-care workers mentioned in public without the word "heroes" nearby. We had grown used to the headlines and hashtags, joined the weekly public applause, heard the recovering Prime Minister's gratitude to his immigrant nurses— his ashen-faced talk of duty, courage, and devotion. All while doctors and nurses waited, and waited, for adequate protection, widespread testing, free health care for overseas staff, and coherent messages or moral behaviour from politicians and officials. The things a nation may conceal from itself inside an idea of heroism.

By mid-summer the park had begun to fill up again. We still paused some evenings in front of the Memorial to Heroic Self-Sacrifice. Now it reminded me most keenly of the thousand names and brief life stories published on the front page of the *New York Times* in May 2020. But also of the tens of thousands of British dead, some of whose stories would not leave the mind easily. Rajesh Jayaseelan, an Uber driver, age forty-four, died of Covid-19, after spending several days alone in his room, afraid to leave, in case his landlord found out he was ill and evicted him. Donald Suelto, an NHS nurse, age fifty-one, died alone, in his flat, of Covid-19; his family could not locate his body for almost a week. Belly Mujinga, forty-seven, a London Transport worker, was, according to her husband, coughed and spat on at Victoria Station; she died of Covid-19 two weeks

later. It was only later, after staring, time and again, at Watts's mon-
ument, that I noticed the fifty-four plaques are bordered not just by
an empty wall but by a further sixty-six uniform spaces, as yet
unfilled. Watts had planned for a hundred and twenty tributes, but
the majority of them remain blank.

A Twitch Upon the Thread

A MEDITATION ON "DIVINE GRACE," a hymn to the "splendours of the recent past"—this is how Evelyn Waugh described his 1945 novel *Brideshead Revisited*. The grace is more earthbound, the splendours more ravishing in Granada Television's celebrated television adaptation of 1981. In the autumn of that year, a gilt stratum of English life in the 1920s and '30s sauntered across British screens, its principals aching with desire and nostalgia. There is the melancholic narrator Charles Ryder, quickly seduced and slowly disillusioned by aristocratic luxury and ease. His friend and seeming lover, Sebastian Flyte, who is ruined (or is it exalted?) by nostalgia, booze and God. Their louche, stuttering Oxford contemporary, Anthony Blanche, an exotic intimate of Proust, Cocteau, Diaghilev. Sebastian's sister, Julia, for whom the mature Charles eventually leaves his wife. Julia's separated parents, Lord and Lady Marchmain: haunted, unhappy personifications, respectively, of pleasure and piety.

Filmed in Oxford, Venice and Castle Howard, Yorkshire, the eleven episodes of *Brideshead Revisited* were received in 1981 as a high point of heritage television. Also, to some, as a hymn to privilege, snobbery, repression, even union-busting—Charles and pals volunteer to help put down the general strike of 1926—that perfectly suited the early years of acquisitive, prole-scorning Thatcherism.

This equivalence has never quite made sense: Margaret Thatcher's Conservative "revolution" was built on an ideology of petty-bourgeois advancement (and monetarist reality), not on worship of aristocratic lineage, let alone interwar aestheticism. Still, there was a certain rhyme, if only in their floppy hair and cravats, between the male stars of *Brideshead* and the Thatcherite young fogeys being celebrated or despised in the British press in 1981. Early the following year, the show aired in the US, and PBS hired the smoothly sinister conservative William F. Buckley to introduce each episode.

I was a child in Dublin, twelve years old, when *Brideshead* was first shown on British TV, and I knew nothing about its provenance or its politics. In fact, I didn't even watch the show in the autumn of 1981, though I knew it existed. Perhaps I had seen the spare, elegant advertisement that Granada placed in the Sunday newspapers of October 11, without a single image of its cast, but instead a sober illustration of Castle Howard and a quotation from Waugh: "My theme is memory, that winged host that soared about me one grey morning of war-time." Or maybe, at a time when in Dublin we had just two Irish and two British TV channels to choose from, *Brideshead Revisited* was the subject of next-morning drollery at my new high school: I've a distinct memory of a boy in my class announcing with a sneer that "Charles is gay with Sebastian!" This did not seem like the sort of thing my pious parents would allow me to see, and maybe they chose not to watch it themselves because they were unsure how much of the novel's obvious but euphemized gay romance had been kept in, or made more explicit.

Brideshead was broadcast again two years later, on Channel 4, then a new and adventurous addition to the sparsely populated but fertile landscape of British television. This time, I was eager to see

the show; though I hadn't read the novel, it was already connected in my early-teen mind with my growing canon of modern dandyism: from Oscar Wilde through George Sanders in *The Picture of Dorian Gray* (1945), to David Bowie, and the New Romantic poseurs of 1980s British pop. In our one-TV household, on Sunday evenings, I watched *Brideshead* with my parents and my two younger brothers. All I remembered of it, but vividly, for years was the poised, febrile world of the first episode, which is almost all Sebastian and Charles at Oxford and in love. Anthony Andrews and Jeremy Irons, etiolated beauties, outlined against a backdrop of vast advantage and antique grandeur, attended by the lurid modernism of Anthony Blanche, who was played with a rouged, salacious Weimar gusto by Nickolas Grace.

There were occasional reminders of the series in the years following. Some time in the mid or late 1980s, my father bought *Memoirs of an Aesthete*, an autobiography by Harold Acton, an Oxford fop who lurks (among other originals) behind the exaggerated character of Blanche. I read bits of Acton's book, which like *Brideshead* was a strange artefact for a lower-middle-class Irish teenager to have been distracted by, if not exactly obsessed. But I doubt I was alone in having *Brideshead* at the back of my mind, especially as the prospect of university approached—aristocracy as a protective fantasy against academic and social anxiety. The cultural politics of this fantasy are complex, and only partly expressed in the phrase "West Brit," then a common Irish slur on those with anglophile tendencies. My efforts to act the West Brit were in any case crudely embarrassing. In October 1988 I turned up on the Brutalist suburban campus of University College Dublin, to study English Literature, dressed in tweed and corduroy, as if, so I feebly imagined, for a weekend at

some country estate, circa 1925. More likely, I resembled a virginal clerk at mid-century, or looked simply like my own father.

I can't pretend that *Brideshead* was culturally central for me or my friends in our late teens and early twenties. Intellectually, artistically, I was in thrall to French and American avant-gardes that Waugh, at least late in life, would have dismissed as "gibberish" (a word he pronounced in the old style, with a hard "g"). But at some point during my degree I got around to reading the novel, and there was even a period when a friend and I would privately mock any dull scene or person by rolling our eyes and reciting a phrase from Anthony Blanche (who is channelling Walter Pater): *La fatigue du nord!* Later, as a grad student at the more venerable Trinity College Dublin, I met actually posh people, bright young things at their own estimation, who viewed the likes of me with much the same contempt, but expressed without irony.

As I write, I'm halfway through what must be my seventh or eighth viewing of the series. When I first came back to it, about fifteen years ago, I was dismayed by how little is really about the halcyon days of Charles and Sebastian at Oxford and how much is about the importunate demands of Catholicism: on Sebastian, on Julia, on Charles the atheist and the apostate Marchmain. Then I recalled that this is what put me off the novel the first time round: its descent into scolding piety. So I tried watching again a few years later, and started to notice both the comedy and the sadness. John Gielgud in a luscious comic turn as Charles's delicately tormenting father, and Laurence Olivier as the Byronic runaway, Lord Marchmain. (Olivier, who spends much of his onscreen time dying, realized too late that Gielgud had the better role.) Endearing details drew me in—certain joyous bits of business by Gielgud, or just how

bad Irons is sometimes at acting fey—but I also began to discern a long, slow disquisition on lost youth and lost time, on the heaviness and the lightness of middle age.

Some of this is inflated in the novel: Waugh himself dithered, in a later edition, over retaining a wracked monologue in which Julia torments herself about "living in sin." (In the TV series, the scene is a sort of test: Can we believe this woman in her thirties, brilliantly played by Diana Quick, is still ruled by nursery visions of sin and redemption?) Equally overstated, perhaps, is the strictured persona of Lady Marchmain, who kills with icy charm the idyll Charles and Sebastian have made. Even Waugh seems to have thought her a monster, and when I first read the novel I could only agree. In the TV series, her devout conceit is all intact, but Claire Bloom, who plays the part, also radiates intolerable grief: husband fled, brothers killed in the war, children turned against her and against the only consolation she knows, the Church. At fifty-one (the age Bloom was when she played Lady Marchmain) I'm more firmly an atheist than I was at the end of my teens, but now I think Bloom's baffled composure might be the most moving performance in *Brideshead*.

The most outrageous is Nickolas Grace's rendition of Anthony Blanche, who is also the most self-evidently gay character—so obvious, in fact, that his task seems to be to cast Sebastian and Charles as somehow gay and not-gay at the same time. The novel is both blatant and coy about their relationship; Charles describes his enchantment by Sebastian's "epicene beauty," and mentions their "naughtiness high in the catalogue of grave sins." At a nightclub, they are taken for a pair of "fairies," but beside Blanche, with his penchant for policemen and aptitude for enraging the sporty set at Oxford, Charles and Sebastian are distinctly, if elegantly, closeted.

In the TV series, their love consists largely in a kind of meaningful languor: Irons and Andrews stretched, a little drunk, under dappling foliage, or filmed together in dreamy profile against a wall in Venice —like a couple of male models, in pale flannel and linen.

"Languor" is an essential word in the novel; it is, says Charles, the one quality of youth that does not last. It is common now to talk about the slowness of serious television in the 1970s or '80s as coming to us from another age of attention spans and narrative expectations. But even in 1981 some viewers found the rapt, lingering pace of *Brideshead* a touch too stately. It's partly a matter of visual style: long static shots of delicious interiors, the camera lurking at leisure around hushed and painful dinners, waiting in close-up for a childish pout from Andrews or a scandalizing stare from Grace. These all have their pleasures, or longueurs: both of which are more pronounced, for sure, on the seventh or eighth viewing. But there is also a slightly numbing structural solemnity—the sense, over eleven episodes, that a short novel whose Proustian themes are quite compacted or crystallized, has become instead an indolent universe of desire, memory and regret that you could drift around in forever.

As reviewers like Clive James pointed out in 1981, the texture of the show was also to do with language. *Brideshead* repurposed large tracts of Waugh's dialogue and narration: the last added as a perfectly pitched voice-over by Irons, who in his early thirties already had the vocal nuance for the weariness and rue of Charles's middle age. The screenplay was credited to the writer-lawyer John Mortimer—he even wrote a puff piece for the *New York Times* about his approach to adapting Waugh—but in fact his script was never used by the directors, Charles Sturridge and Michael Lindsay-Hogg. Instead, producer Derek Granger and associate producer Martin Thompson

laboured nightly, during production, reproducing almost every scene in the novel. They toned down or excised a lot of snobbery, prejudice and outright racism. Charles's wartime adjutant, Hooper, is no longer quite the portrait of grasping bourgeois vulgarity; Lady Marchmain no longer frets that Julia's fiancé Rex may have "black blood." Most of the anti-Semitic aspersions are gone too, along with Charles's horror of Americans.

What remains? The aspect of *Brideshead* that fascinates me now, once I've got past the adolescent utopia of the first episode, is how much time and attention is given to those long monologues: Julia by the fountain at night, hysterical over her sins; Lord Marchmain on his deathbed, mind speeding back in time to medieval forebears; Marchmain's mistress, Cara, talking regretfully of Sebastian's bouts of nostalgia and drinking. And Blanche, diagnosing in the whole set, including Charles, a cosseting addiction to "simple, creamy English charm." Except perhaps for Blanche, each speaker, framed in close-up, is in his or her own fashion trapped by the past. But they see what Charles cannot: that there is no escaping the past, with its illusions, demands and repetitions.

"My theme is memory..."—*Brideshead Revisited* owes a lot to Proust. Waugh is clear about the debt, even if also a little contemptuous: it's the odious Mr. Samgrass who spends an afternoon with "the incomparable Charlus." It's a short novel, however, stretched in the TV series to become something else: a museum of images and memories—charming, sentimental, and tragic. The series is frequently spoken of as a comforting, reactionary view of a class and country long gone. Maybe, but it's also this: a beautifully lit prison in which the summer of youth is always drawing to a close, nobody can look directly at the present, everything is drenched with the

horror of wars ended and to come, and charm (which is another word for fear) has ruined everything. "Bless you, Charles. There aren't many evenings left to us."

Hope, fear, resignation, regret—how very middle-aged, how very mundane. What happened to grace, whether divine or bodily, inherent or bestowed? It is there, of course, in the hedonism of early episodes and holiness of the last. But it's shadowed by the life in between. So that I wonder now if *Brideshead*—the series first, and then the novel—was always a lesson for me, frustrating and revealing, in how riven and contradictory a work of art could be. I had to read against its grain, turn a story of aristocratic interwar English life into a model for escaping ordinary Irish expectations in the 1980s. Ignore the Catholicism to learn about aestheticism, bundle away Waugh's bigotries—"Modern art is all bosh, isn't it?"—to focus on Anthony Blanche, reciting *The Waste Land* through a megaphone at a crowd of homophobic Oxford louts.

I live in London now, have spent half my life in England, was long ago disabused of any lingering notions about an aristocracy of wealth, heritage, or taste. You will sometimes hear the more outlandishly retro members of the current Conservative party described as plausible, or merely aspirant, figures out of *Brideshead*. Two Prime Ministers in the twenty-first century have been former members of the Bullingdon Club, the boisterous and scornful Oxford dining club that is the scourge of Anthony Blanche, and to which (in the TV series) Sebastian seems to belong. But instead of sorrowed aesthetes it's the minor scolds and boors of *Brideshead* who seem reborn among contemporary Tories: the toady Samgrass, Charles's stuffy cousin Jasper, the eager dimwit Mulcaster. Turn back to the 1981 series, or discover it for the first time, and you find instead a world

of blazing innocence and exhausted experience, wracked with violent nostalgia, touched by kitsch. And populated by characters whose grace or lack of it is beside the point—whose longing, for the future, for the past, for the present, is everything.

Essay on Affinity VIII

HOW TO DESCRIBE the matter or medium of affinity? The connecting tissue between the object and myself, between one image and another? Here is Annie Dillard, in her essay "Seeing":

> A fog that won't burn away drifts and flows across my field of vision. When you see fog move against a backdrop of deep pines, you don't see the fog itself, but streaks of clearness floating across the air in dark shreds. So I see only tatters of clearness through a pervading obscurity. I can't distinguish the fog from the overcast sky; I can't be sure if the light is direct or reflected. Everywhere darkness and the presence of the unseen appalls. We estimate now that only one atom dances alone in every cubic meter of intergalactic space. I blink and squint.

I can't or won't decide if affinity is the fog or the shred of clearness.

The Charismatics

THE PICTURE WAS TAKEN by a press photographer in the late 1980s or early 1990s. The congregation, hundreds strong at least, has come to a prayer meeting held in an exhibition hall on the south side of Dublin. They've come to worship, but also to hope, and some of them are hoping for a miracle, hoping to be cured. Almost all of them are women in middle age, though very likely younger than they look, or look to us now with their complicated glasses and hairdos. Dressed as if for church. Imagine what fear and sadness, what so-far-unspoken troubles they have brought with them on buses out of the suburbs, on train rides up from the country—stories shared today with strangers, before and after, but held in the mind now, offered up in an anonymous shed where many of them have come in the past to stare at hokey designer goods and sample slightly exotic foods during the annual Idea Home Show.

We can assume the women are singing and not speaking in tongues, not all of them, not like this. Their faces compose a selection of mundane ecstasies, such as I know well from certain churches of my childhood. One of the women is less readable—further gone, you might say—though familiar in her way. Sometimes it is hard to comprehend another person's hope, her tremendous perseverance. *How she survived.*

There are seven or eight hands in the photograph, and six of them

are open and raised, held aloft and aslant in a gesture that seems well known, art-historical even. But what does it intend, this hand half raised to heaven? Consider the woman at bottom left, with the face of a Flemish angel. Her oddly foreshortened arm inside its tapered sleeve. Her right hand is raised but she is not pointing; she might be in the middle of a blessing, but the disposition of the fingers is all wrong. (The hand behind her has got it right.) If not a gesture of benediction of deixis—what? Perhaps it is not meant to signify at all, but to receive. It is through their open hands that something will enter, a gift at last bestowed.

I feel as though I know these people well: their bodies, their spirits, their clothes. I recognize the poise of the woman in white, the way she holds herself together, there at the centre. I note another's stoic gaze, looking straight ahead. A third, the youngest, in the back with her blurred face on the edge of tears. I look at them and see only, seek only, one face that I know is not there.

The word "charisma" derives from the Greek *charis*, which means grace, and gives us the verb *charein*, to rejoice. If you follow a devious path through Old German and Old English, you will find that *charein* is related to the verb to yearn, which in turn may surprise you by denoting in Middle English, and in some later Scottish dialects, both a flowing action and its slow stoppage: congealing or coagulating. In its most rigourous theological meaning, charisma is a spiritual gift or talent; early Christians used the word to describe the power of prophecy, the ability to heal the sick and the tendency to speak in tongues. These are gifts of the Holy Spirit, delivered as tongues of fire, in a violent ecstatic infusion of the mortal body. Related terms: *charism* and *charismata*. In time, *charisma* wandered semantically, but not far at first: before it devolved into its present

weak sense of character or personality, the word pointed to a fully supernatural virtue or power. Its historical journey is a little like the one undertaken by *glamour*, which once meant a bewitching or spellbinding charm and now means something more earthly but superficial.

The Charismatic Renewal is a movement inside the Catholic Church that draws on early belief in the gifts or *charismata* of the Holy Spirit: healing, prophecy, glossolalia. Charismatics aspire to a direct communication with Christ, unmediated by liturgy. The movement began in the United States in the mid-1960s, and spread worldwide in the decade following. Traditional Catholics sometimes deplored the turn away from conventional ritual and worship, but the Church (the Papacy included) welcomed a renovation in spirituality, and did not baulk at the boost to church attendance that came with it. Prayer took place in parish churches, in believers' homes, and in meetings or conferences attended by hundreds or thousands of the faithful. Hands were laid on the sick in hope of healing, instances of speaking in tongues were reported, and the ultimate horizon of those meetings was a belief in the real possibility of miracle.

The body and face I'm searching for—they belong to my mother. It is too late: the photograph seems to have been taken some years after she died. But she had been there, perhaps even at the unseen centre of things, hands on her, voices around her raised in prayer. My mother believed in miracles, but I cannot follow her there. One day I will stop writing about this, rehearsing the bare facts for anyone who will listen, attaching her life and her death to half the things I have to say about books and music and art and stray photographic scraps in which as it happens she has no part—trying to match her

story, her case, to other narratives, recondite concepts like *charisma*. To write means to find reasons to tell you about my mother, about my ordinary orphanhood and ordinary grief.

She had been ill for years, as long as I could remember. At first a vicious, intermittent depression, for which she was prescribed many different drugs—and shock therapy: hands on her already, an ecstasy of shame and fear, the wait to see how much of her memory, how much of her, was left on the other side. And then, at what might have been midlife, an obscure diagnosis: the autoimmune disease that would kill her at fifty. It was the kind of disease for which all the usual metaphors were literalized: this thing seized her, tightened its grip and held on. Her body hardened, even air and water hurt her. She turned to prayer—who wouldn't?—and fell in with a local group or chapter of the Charismatic renewal, which thrived during those years in the parish churches of urban and rural Ireland. With a crippled hand she copied out consoling verses from the Bible at her bedside. She exchanged prayers with a countrywide network of the pious and the desperate. She attended small-scale prayer meetings at the church where we worshipped every Sunday at eleven, and at last she joined these women, or women like them, at mass meetings where, she said, the prayed-for person on whom all concentrated their entreaties, their yearnings, would sometimes report that a great heat had come into her body, filling her not with healing force (there were no miracles) but with hope. I do not believe my mother ever felt this heat.

If your knowledge or experience of Catholic worship—private prayers being something else—is drawn from centuries of religious art or from the demonstrativeness of the Mediterranean churches, it may be hard to credit just how furtive and full of shame public

prayer can be for an Irish Catholic. This is what I remember best: bent or buckled figures kneeling before shrines and altars, silently, almost silently, keening their pain into the solid air between them and the statue, relic or tabernacle. An ancient voice muttering its penance—for what unthinkable sins?—outside the confessional. And even at Mass, hundreds of voices raised to nothing more than a diffident hum, embarrassed before their god and each other. At home we prayed most nights in front of a muted television, the picture providing just enough distraction, out of the corners of our eyes, from halting, cracked recitations. It was this reserve that the Charismatics had exploded with their frankness of voice and gesture. I am sure this is why I was afraid of them.

When I was fourteen, maybe fifteen, my mother took me to the parish prayer meeting at the Passionist monastery to which our church was attached. Who knows why she brought me along. It might have been the frightful state of my skin: a childhood case of maddening psoriasis, lately joined by the pustular nightmare of terrible acne. (Some sanctified creep, a friend of my mother's from the prayer group, had already prayed over my spots in our sitting room—imagine.) Or maybe my mother, amid the vile weather of my teenage moods, had sensed in me the stirrings of something like her own depression, clouds gathering before her child was even grown. Whatever the reason, one midweek night I sat beside her in a high narrow room among a dozen of the devout, and at length all eyes turned on me, voices too, and hands were raised invoking the Holy Spirit. I did not feel cared for, loved, healed, infused at last with the gifts of the Holy Spirit. I felt instead the great heat of my total humiliation.

Middle-aged women of the Charismatic Renewal, you scared this boy half to death, and then made him simply furious. I rebelled

against your piety; it was there to be rejected, and it did not only belong to you—it was everywhere. But more than faith and devotion I feared, and then despised, your hope. For where did it get us, and what did it do for her? All the years of panicked, yearning prayer, followed by—what? Her eyelids flickered around noon, one summer's day in 1985. Did she wake before the end? Did she see me?

But there's something less bearable than this misplaced hope. It's the suspicion that here, maybe only here, in this rapt sorority of the unwell and the unhappy that my mother felt cared for. I'm amazed by how they have let themselves go, given in together, each alone, to this moment, this atmosphere of expectation and potential deliverance. You in the overcoat, with your pearls and lapels, your eyes shut and hands out, isolate and embarked on your own inner spiritual migration: this frankly does not look like your kind of thing. I have no doubt pain and fear have brought you here just like the others, but something else too: an unthinkable degree of trust. The woman in pearls looks nothing like my mother, who maintained another sort of image in spite of all: suits and gloves and remnants of darkling country-girl glamour. But it is hard not to wonder: when she stood here five or ten years before the photograph was taken, were these her gestures, this the expression, by which she signalled her attention, her readiness, her desire? With her hands extended thus? In an agony of optimism, waiting and knowing that there was only so much waiting time left? On fire with expectation of another fire, another gift.

For the Simple Reason Is

IT IS GETTING ON TOWARDS AUTUMN, and this is what she must do with her day. Up early, switch off the house alarm, unbolt the doors, and out into the garden with her in slippers, dressing gown, overcoat. Low sun on her flat dusty curls, as she passes along the back of the house, and against the windows, which are shuttered still inside, behind the nets. The birds mad at this hour. Starlings. The young ones from the spring, reared and grown, little hooligans now. She has got a bag of seed out of the shed. From here the feeder looks like a small startled red man, hung from that second stretch of clothesline she had one of the boys put up this time last year. It's empty now, the feeder, light and swinging in the breeze.

Is that why she stops? Because it oughtn't to be empty already? No, that's why she's up and in the garden in the first place. Is it then some detail of the surrounding scene—a pair of breeze blocks tucked into shadow, some irregularity of the fence beyond, the almost leafless tree above—that sends her bustling back inside for her camera? Those roses, perhaps, over on the right there: oddly headless, not a single withered bloom. What has she seen? She has the camera in both hands, but she's stiff as always on her left side and it's still askew when she takes the shot.

What exactly am I supposed to be looking at?

For at least forty years and very likely more, my father's sister

maintained a feud with her next-door neighbours (both sides) that slowly came to dominate her life, a quarrel from which it seemed to the rest of her family she drew a malign sort of energy and out of which, despite the best efforts of all, she could not finally be extricated. She had inherited the problem—I almost wrote *project*—from her parents, who moved into the redbrick suburban Dublin house with their three children (then in teens and twenties) in the late 1940s. Who knows how it all began. My grandfather was a bully and a snob, a former soldier and police sergeant with a greatly inflated sense of his moral and social standing. Some measure of his character may be gleaned from the fact that when he retired early from the police in the 1950s, he got a job as a debt collector—but a debt collector for a chain of toy stores. Imagine the old bastard cycling up your street one fine spring morning, his saddlebag full of confiscated gifts: the ghost of Christmas repossessed. My guess is a man of his sort took easily against some small infringement of a boundary: a box hedge trimmed too far in his direction, a woodpile carelessly edging into his garden, something of that sort. Maybe his children rolled their eyes at the sight of Daddy in the garden at dusk, his Hitchcock silhouette tapered to a pair of bicycle clips, pointing and shouting at the hedge.

Things must have escalated when he gave up work completely, and his natural officiousness was circumscribed by illness and immobility. By the late 1970s, when I was old enough to notice, it seemed he spoke of little else on our Sunday-afternoon visits. *They*—here he would jerk a thumb in either direction—had invariably committed some fresh misdeed, frequently involving their moving by a few inches a section of the rusting cordon of corrugated iron with which he was gradually surrounding his property. He could hear them on

the other side, he said, cursing at him all day long. My father and another sister had escaped, hopped the fence, married—and the sister emigrated to New Zealand. But this second sister, then single and soon to be middle-aged, was trapped inside the precincts of her now widowed father's monomaniac rage. As his health failed, she seemed to elect herself heir to all his spite and fear, and even went to work on her own distinct campaign against life in the suburbs, or simply against life—detailing in countless letters of complaint the almost daily slights and derelictions she suffered at the hands of bus drivers, shop assistants, priests and policemen who failed to help in the matter of the neighbours.

Of course I should like to know what she and her father were really afraid of. To the neighbours and obnoxious functionaries was added a list of wild youth: teddy boys, corner boys, cider boys, *gurriers*. Kids from the local housing scheme. Whether any of them posed a threat is moot. The source of all this anxiety and animus was rather, I think, their mere proximity: a sense that having installed himself in what looked in the 1940s like lower-middle-class security, my grandfather had not come far enough. Fenced away and pensioned off, he still could not stop the down-at-heel city—that is, the recent past—from leaning drunkenly on his privet hedge, or scattering crisp packets on his lawn.

My aunt's case was different, and worse. Her name was Vera—quite a name for a lifelong fantasist. In my first memories of her she is large, vulgar, loud, not always unhappy. She still had a job then, having worked it seems all the sweet counters at all the cinemas in town. She liked to say that as a girl she'd been beautiful, and might have become a model. Packed off in her teens to the care of an uncle in Birmingham, she gorged on clothes and makeup and her temporary

freedom. It might have been this unruliness that got her sent home again, where tuberculosis stole what remained of her youth. I can't say how long she spent at the sanatorium, but the disease, or rather its violent remedy, took away a lung too (the left) so that for the rest of her life she listed visibly to one side.

With her relatively minor debility came, I suppose, a great and lasting shame, or disgust—she could never grow fat enough to fill that hole in her side or disguise where her body had been breached. Her prospects, in the old-fashioned sense, must have faded. In a matter of months, perhaps a year or two, she had been positioned as the daughter who would not get away, but stay at home to be looked after and in time do the looking after. She became an energetic hypochondriac, ever vigilant for a sign that her body was under attack once more. The battle with the neighbours was merely an extension of the vulnerability she already lived with, lived through—a feeling that all her borders, intimate or domestic, were ruinously porous, subject any moment to undignified invasion.

Her personality curdled, she became *an impossible person*. By the time I knew Vera, her residual boisterousness was being swamped by simple aggression and what is called, or was then called, self-pity. At home we learned, my brothers and I, to laugh at her behind her back, treat her as a comic grotesque without a whit of self-awareness. Vera at the front door on Christmas Day: *Do you know what it is, I couldn't look at a turkey*. Vera some hours later, stuffed with turkey and belching freely, rueing her destroyed innards. Vera half pissed and flummoxed in front of the TV: *Who's that? He's got terrible old looking, that fella*. But also, phoning night and day to say *they* were at it again. *Who? Head-the-ball next door and his slut*. Summoning her brother in the small hours to observe by flashlight her trampled

flower beds, a hole in the hedge, the newly rakish angle of a corrugated sheet she had straightened in the daytime. Marshalling her evidence. Making scenes, demanding action, getting angry when my father refused to use contacts in the civil service to ensure something was done. Years later, we discovered she had written to a distant relative among the judiciary in London—the late Sir Brian Dillon, as it happens—and received a bemused, polite and firmly negative reply.

Only once did I ever get a glimpse of how things looked from the other side of the fence. I must have been about twelve years old, and had briefly befriended a son of the family on, for my aunt, the slightly less aggrieving side. One summer afternoon I was invited inside, where the boy introduced me to his mother: "He's a Dillon, but not a mad one." I found I could feel bad for Vera, wish almost to defend her, but I laughed and said nothing.

There was a favourite phrase of hers. *For the simple reason is.* She meant *for the simple reason that*—or more simply, *because.* She spoke it hard and slow, as if you were the stubborn, deluded, mistaken one. She could not sit in her garden, she said, *for the simple reason is they're out there all the time.* Something must be done, *for the simple reason is these nerves will take no more.* But she could not move house after her father died, *for the simple reason is you don't know who you'd end up living beside.* Sometimes she'd stop before she got to the thing itself, letting this phrase hang in the air, as if to say: *can you not see what the simple reason is?* To us the phrase was redundant, overused and idiotic. For her, it was the solid, painful expression of self-evidence.

While I was growing up, it seemed increasingly that she mediated a world bristling with insult and disappointment through things,

through gadgets. Enough stuff to build a barricade. Vera was the first person I knew to own a cassette recorder, a VCR, a colour television. In the mid-1980s, she bought a huge Hitachi boom box, hardly used it, then passed it on to us. When she upgraded her TV, we got the castoff, practically new. She never gave us a camera, so her collection grew, perhaps in hope she'd one day take a pleasing or even competent snapshot. I can see her now with her big white Polaroid One-Step, standing in the sun by an urn full of hydrangeas, growing hot and furious that none of her efforts to frame and fix the world came out looking the way she planned.

After she died we found she'd kept all her cameras. I cannot swear to the model she used to take these photographs in the last decade of her life—it was perhaps a little Canon point-and-shoot she bought in the 1980s. I have in my possession sixty-one of these pictures, plus a few negatives, but I left handfuls more behind me when I helped clean out her home. She photographed the house and environs from numerous angles, paying close attention to all the borders of her property, all points of possible exit and entry, the places where she might be overlooked. Here are the fat hedges flanking the back garden, held up in places by long wooden props where, like her, they have leaned heavily to one side. Views from inside the back door at night, where the camera's flash has lit the jade-green frame but not the scene outside. Blurred or otherwise botched images of door handles, windowsills, opaque expanses of net curtain. An almost abstract arrangement of shadows and edges in concrete, metal and soft wood: somebody, she thinks, has been inside her new garden shed. Snapshots where the flash has bounced off the sitting-room window and swallowed whatever, or whoever, she was trying to catch outside—erased her own reflection too.

She married in her fifties, but her husband died a decade later. (Her brother gone in the meantime, his wife also.) Still, she was not alone—though the boys, her nephews, did not seem to understand what she put up with, day upon day. She needed proof, something to show them when they came around—the younger two, anyway—to trim her hedges and mow the lawn. She was after all the daughter of a policeman, the granddaughter too; it was not beyond her to amass the evidence. It was simply a question of vigilance and speed, recording everything before it was washed away or overgrown. That was the problem: always later, when she pointed in the garden, people saw nothing. And so with her camera she surveyed the frontiers of the place where to her surprise she still found herself. Those boundaries seemed lately to have moved inside the house, in among her pictures and ornaments and the patterns of her carpets, closer than ever before.

I last saw her about two years before she died. Ten years before that my brothers and I, college-aged and orphaned, had sold our family home, and Vera, blaming me, had dramatically disowned and disinherited me. *From now on, I've only the two nephews, do you hear me?* On visits home to Ireland, I would not be drawn into seeing her again. Her age and frailty did not move me. I had learned certain facts about her, about her dealings with my mother when she was sick and even dying, about her attitude to my brothers and me—"children aren't people"—that convinced me she was not only troublesome and afraid but actually wicked, a monster of jealousy and self-regard. Others among the family, including my brothers and my mother's sisters, took pity, found the patience to listen now and then to her tirades, tried to get her to *see someone*. I thought I was the only one who had seen through her, divined her essential

viciousness, which I regarded, I suppose, with the same frustration and certainty she regarded her neighbours. Except of course that I could turn away.

When at last I relented and went to see her, I was quite prepared for the monologue, the blame, the fantasies, the sanctimonious memories of Daddy, whom she must have hated above all. I knew she had lately driven her sister, who'd come back on a visit after thirty years in New Zealand, out of the house for having, so she claimed, gone in search of Vera's will—but also for the crime of treading too heavily on the stair carpet. I knew she was now genuinely ill with diabetes and more, but entirely resistant to the suggestion she might have *psychological problems*. She was consumed in her late seventies by the idea that somebody—it was not even clear she meant the neighbours anymore—was regularly invading her property and cutting her roses. One day my younger brother watched her go into the garden and snip half a dozen blooms herself, then march back in the house with the evidence. *Look, look what the bastards have done.*

She'd recently had CCTV installed, she told me when I arrived. In the small stuffy sitting room, a monitor flickered away in black and white and a camera on the windowsill was pointed at the front garden, its flower beds and neat sprung metal gate. In her living room at the back of the house, an identical apparatus, the screen dominating the dining table and the camera trained on rose bushes, bird feeder, garden shed. Neither camera was attached to a recorder. I felt dizzy at the thought—*she must watch this stuff live.* Could it be true? That in place of her soap operas and old movies with Victor Mature or Dean Martin, she sat down now to squint all day, unseen behind her curtains, at these squarish grey screens, fearing and hop-

ing to see movement from the hedge, a figure dart into view, the crime itself in process? All that was needed was for her neighbours to point a similar camera through a gap in the hedge, and they would have set up between them a perfectly reflexive video loop, capable of staring itself down for another forty years. Perhaps for now she just liked to feel that there was somebody there.

(When she died we discovered Dean Martin, cut from the TV pages of the evening newspaper and taped to the living-room wall, just above the place where Daddy used to sit. Dean Martin: the blithest, laziest, most heedless of stars—her idea of a real man, in the end.)

There are forms of keen, habitual, and even morbid attention to the world around us that don't merely preclude self-examination or disallow self-knowledge, but rather stand in for a close look at our lives and a proper expression of what we find there. If I cannot exactly sympathize with her anxiety and aggression, I understand perfectly her methods and the state of mind necessary to such a protracted act of close looking. For half her time on earth, she never stopped paying this attention, never ceased to examine for clues the shrinking world in which she lived, in which she had, as we say, ended up. For the simple reason is—but there are no simple reasons. Hers was not much of a life, half a life maybe. For sure, she ought to have been rescued from eking it out like this at the last, in anxious trips to the pharmacy to collect her prints and examine the latest evidence, hours and days spent staring at her screens or quiet at her windows, like some haggard self-consuming spectre out of late Beckett.

She thought she had disinherited me, but I am not so sure. I share her tendency to hypochondria: a bout of it every few years, whole weeks and months disappearing in a welter of vigilance and dread.

What else? A history of periodic isolation verging on agoraphobia. A habit of erecting barriers of fragile dignity and forms of anxious attachment—to certain objects, for instance—when I feel myself threatened. And more. Her obsessive and solitary looking, her fretful listening, her poring over pictures and locking the world away so she could address it only in letters of complaint: it all feels quite familiar. You can pursue vigilance and attention into a kind of fugue state, almost hallucinatory, maybe fully so in her case. It's the family curse, you might say, this turning from the world and peering at nothing or next to nothing until it gives something up, some objective correlative. We've all done it; it's how we pass the time: we're quite as mad as she was. I spend my days staring at the screen and hoping something will appear. I call it work, and she called it—what? The way things were.

Afternoon turned to evening as I sat listening to her decades-old complaints. On the table in front of me the screen darkened slowly till a streetlight came on, and headlights streamed in the distance.

Painting the Clouds

Around nine o'clock in the morning on March 15, 1994, the fifty-eight-year-old television dramatist Dennis Potter, recently diagnosed with terminal cancer of the pancreas and liver, arrived at South Bank Studios, London, to give his final interview. Technicians had been working since six to ensure hot studio lights were not too close, because the sick man's body temperature had begun to fluctuate uncomfortably. To conserve Potter's energy, his agent was allowed to drive him into the studio's scenery dock. Cameras rolled straight away. In the footage broadcast three weeks later on Channel 4, Potter is thin, raw and nervous as he approaches his chair—nobody knew how long he could sit and speak—and arranges a few items to keep himself going: cigarettes, black coffee, a glass of champagne, and a hip flask full of liquid morphine. There are some friendly preliminaries about his present headlong writing schedule before the interviewer, Melvyn Bragg, asks: "Are you set now? Shall we?"

The hour-long interview that follows is Potter's last great work: a lyric, mordant, furious and sentimental reflection on death, religion, childhood, politics, England and writing itself. (Like most of his interviews, and some of his writing, it is also not without ego.) Potter was born in 1935 in a mining village in the Forest of Dean, "a heart-shaped place between two rivers," near the Welsh border. His first substantial piece of work for television was a BBC documentary

about his journey from pious, working-class rural life to Oxford, London, journalism, and left-wing politics. (He stood as a Labour candidate in the 1964 general election.) As ever with Potter's work, it was a film about guilt and betrayal. In his mid-twenties, illness struck: psoriatic arthropathy caused his joints to seize and his skin itch, crack, bleed. Potter took it as a sort of visitation or annunciation. He gradually retreated from journalism and politics to write TV plays—plays filled with guilt, betrayal, accidental grace and, in his most famous work, crucifying disease.

Earlier in 1994, Derek Jarman had died, from AIDS. As an orphan in early adulthood, amazed anyone could speak so openly and eloquently about sickness unto death, I paid close attention to the interviews Jarman gave toward the end of his life. Now, suddenly, here was another of my heroes announcing his imminent end. I had been consumed in my late teens by Potter's writing for television. First by *The Singing Detective* (1986), in which Michael Gambon plays a writer who plots metafictional fantasies, and recalls his boyhood in the Forest of Dean, while hospitalized with the same disease as Potter. I watched rapt but also in secret terror: in my teens I had a mild but vexing case of psoriasis and somehow got it in my head that I would end up afflicted just like Potter. In a peculiar spasm of the adolescent brain, I pored over interviews in which he described a life split in half: six months each of writing and illness, every year. Was that my future too? What if I could not write?

I had not quite forgotten about Potter by 1994. After *The Singing Detective*, his earlier work was repeated, reappraised. But the TV series and films he made in the late 1980s and early 1990s—*Track 29* (1988), *Blackeyes* (1989), *Lipstick on Your Collar* (1993)—had been obsessive in all the wrong ways, as if his talent had soured or curdled.

Potter seemed to know this and used his interview with Bragg to remind himself and us how daring and achieved his best work had been. In *Blue Remembered Hills* (1979) he cast adult actors to play children in a twisted reconstruction of his Forest of Dean childhood. In *Pennies from Heaven* (1978) and again in *The Singing Detective*, his characters lip-synched to popular songs of the 1930s—"Painting the Clouds with Sunshine," "The Sweetest Thing," "Down Sunny-side Lane." Potter's formal innovations—also, his darkling views of sex, class, and religion—were made possible by a television culture, especially at the BBC, that was fading fast in the media landscape of the early 1990s. When diagnosed with cancer, Potter named his main tumour Rupert, after Murdoch: "I would shoot the bugger if I could."

All of this TV history is important, but it is not really why Potter's interview seemed so extraordinary at the time, nor why it repays viewing now. Instead, it's the way he talks about his own death that amazed then and impresses today. In places he is merely sardonic. Bragg asks how long he's known about the cancer and Potter replies: "Well, I knew for sure on St. Valentine's Day, like a little gift, a little kiss, from somebody or something." But as they get deeper into the conversation another tone takes over, a thrilled lyricism, urgent, and precise as Potter describes the view that spring from his study in Ross-on-Wye, Herefordshire, as he works on his final script:

> Below my window in Ross, when I'm working in Ross, for example, there at this season, the blossom is out in full now—it's a plum tree, it looks like apple blossom but it's white—and looking at it, instead of saying "Oh, that's nice blossom!" last week looking at it through the window when I'm writing, I see it is the whitest, frothiest,

blossomest blossom that ever could be, and I can see it. Things are both more trivial than they ever were, and more important than they ever were, and the difference between the trivial and the important doesn't seem to matter.

I remember feeling a flush of something like embarrassment when Potter said this—mixed with amazement at his presence of mind. As James Wolcott wrote in a *New Yorker* obituary two months later, in this interview Potter sounded like a psalm. Amid all the reminiscence and score-settling, he grasped that the serious language of pure sentiment—childhood hymns and cheap songs—was his proper valedictory register, and in this passage he is laying it on thick. Potter means every word and at the same time he is performing; there's a frank theatricality about the studio setting, the champagne, the cigarette jammed in his arthritic fist, even the pause for a swig of morphine. The whole hour feels perilous—pain or fatigue might silence him any moment—and perfectly composed.

After its broadcast on April 5, transcripts of the interview were published in the *Independent*, the *New Left Review* and a short book titled *Seeing the Blossom*. There are minor differences between the three versions, but all sound strangely flat on the page, as if to be heard properly his words also need Potter's tender, cracked, near-Welsh accent. The sound of that voice has stuck with me since, and especially the ease with which it moves between deadly crafted invective, sober self-knowledge, and pure emotion. I wasn't yet a writer in 1994, hadn't yet addressed the "referred pain" (as Potter put it) of having chosen at first the wrong vocation. But alongside his frankness, there was a lesson in the dying writer's sheer rigour: up at five every morning to write ten pages before the pain crept in,

frightened only of expiring four pages too soon. At the end of his interview, Potter grabs his cigarettes, pockets his morphine, and turns again to Bragg: "I felt OK, you see. At certain points, I felt I was flying with it."

Essay on Affinity IX

A CONSTANT SUSPICION, unchanged since I was a student: that nothing I write pursues an argument or is built to convince. Instead, I simply get into a mood about the thing I am meant to be writing about, and pursue that mood until it is exhausted or has filled the space it was meant to fill. For a while I plunge into an artist's work and can hardly breathe for its engrossing qualities and the perplex of things to which it attaches. Subjects I've written about during the deranging pandemic years, but not in this book: the prose of Rachel Cusk, Claire-Louse Bennett and Hilary Mantel; the paintings of Allison Katz and Wilhelm Sasnal; exhibitions by Niamh O'Malley and Linder Sterling; the music of Nico, Kate Bush and Klein. So many dream states in which for a time not much else matters but the word, sound or image at hand and what it seems to teach you. Suspension of disbelief: a condition essential to writing about the thing, but which then evanesces when the work is done, and goes—where?

Sometimes I take solace from the fact that other writers, other critics, have had a similar feeling about their work—even if their moods are vastly more impressive or imperious than I could muster. Sontag, in her diaries, claiming to write essays not to persuade but to produce an effect. She says this knowing the aphoristic statement is an example of what it describes: the aesthete's attitude to essayism,

a dandy's approach to criticism, a posture borrowed from Oscar Wilde. In "The Function of Criticism at the Present Time," Matthew Arnold wrote that the task of the critic was "to see the object as in itself it really is." To which solid pronouncement Walter Pater, in the conclusion to *The Renaissance*, adds a veil of in-the-moment apprehension: "In aesthetic criticism the first step towards seeing one's object as it really is, is to know one's own impression as it really is." In turn, in "The Critic as Artist," Wilde pushes Pater's aestheticism as far as it will go: "the primary aim of the critic is to see the object as in itself it really is not.... To the critic the work of art is simply a suggestion for a new work of his own, that need not necessarily bear any obvious resemblance to the thing it criticizes."

We are a long way from the aesthetic controversies of the 1880s and 1890s—even if a radically simplified version of this standoff still seems to play itself out in confected culture wars about art, criticism, politics and education. There is something else in Wilde's audacious, ironic, mock-metaphysical dialogue: a throwaway theory of criticism as *mood*. The term recurs throughout the essay, unexamined but obviously essential: "each mode of criticism is, in its highest development, simply a mood.... When one has found expression for a mood, one has done with it." Mood is in part a way of thinking about the frenetic relay of new artistic styles and movements: Romantics giving way to Realists, ceding to Symbolists; by the tidal rush and recession of moods, Wilde simply intends Modernism, before it had that name. And the task of the critic is to be carried by successive waves, even to travel slightly ahead. But this doesn't quite cover it, because the work of the critic is itself a mood, with its own urgency, its own delirium, its own evanescence when its time has gone.

Affinity is a mood. A temporary emotional state, yes—but also something close to the musical or grammatical meanings. A *mode*, that is, to use another of Wilde's words, with which *mood* has more than one affinity. Webster's dictionary in 1913—my favourite dictionary, as it happens—defines *mood* first of all as "Manner; style; mode; logical form; musical style; manner of action or being. See {mode} which is the preferable form." I like "manner of action or being"—mood or mode of life. The artist Moyra Davey—a contriver and great discerner of affinities, devotee of some of my own patrons such as Benjamin and Barthes—in one of her essays quotes Leonard Cohen: "Mood is all." An art or thought of affinities: too easy to picture it as diagrammatic, composed of lines of correspondence or accord, a conceptual arrangement. In fact, *mood is all*.

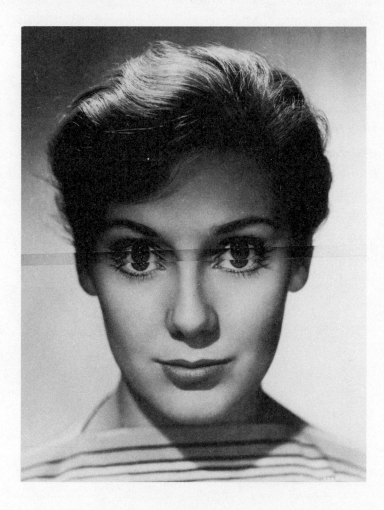

What a Carve Up

THE ENGLISH ARTIST JOHN STEZAKER tells a revelatory tale about the origins of his art. Stezaker was born in Worcester in 1949. When he was thirteen, his family moved to London, and around this time his parents acquired a new slide projector. The teenager was fascinated by this apparatus, and especially the demonstration slide that came with it: a wide-angle photograph of two men overlooking the Thames, with the Palace of Westminster and a lurid sunset behind them. Stezaker swiftly grasped that the projected image might be used to make art, thus obviating the tedium of freehand drawing. But when he took the machine to his bedroom, he found all he could project onto a sheet of paper was a corner of the picture: Big Ben, a few turrets and a stretch of red sky. He tried painting over it in his best approximation of an "expressionist-psychedelic" style, but when he turned off the projector the result was "horrific."

In light of the artist's subsequent romance with the found photograph, this anecdote is almost too apt to be true. By the time he enrolled at the Slade School of Fine Art in the 1960s, his main influences were Gerhard Richter and Sigmar Polke, painters whose use of photographs overlapped with and trumped, in expressive terms, the pop artists of a few years earlier. But Stezaker was a student too at a time when a wholesale critique of the pop-cultural image was

being launched by such thinkers as Guy Debord. The Situationists' scurrilous repurposing of media imagery became an exemplary strategy for Stezaker, alongside his abiding, and then unfashionable, interest in Surrealism. (He remembers William Coldstream showing him Max Ernst's 1934 collage "novel" *Une semaine de bonté* on his first day at the Slade.) Schooled also on the recently translated writings of Walter Benjamin, for whom the conjunction of photograph and caption had altered forever how we looked at images, Stezaker began making work with text and pictures, intent on exposing the mystique of the visual.

It was a move that was very much of its time—other artists in London such as Victor Burgin and Susan Hiller were doing parallel things in different registers—but for Stezaker it was a dead end. He suspected that his subject as an artist was rather the collective fascination with images than the conceptual urge to undermine such. At this point, in the mid-1970s, that sliver of sunset from his adolescence unexpectedly returned. He had since learned that the complete photograph was also a hugely popular postcard, but it was still the skewed portion in the corner that possessed him. And he began to realize, with a mixture of conceptual insight and lingering emotional attachment, that it required little or no artistic intervention beyond his first excision of the haunting fragment. The image itself was the work of art and, although the painstaking subtleties of his style remained to be worked out, the mature Stezaker aesthetic was coming into focus.

Of course, Stezaker was not the first artist to deploy the found photograph, or combine such images without comment. It was a favourite trick of his Surrealist precursors, from Ernst to the pages of Georges Bataille's *Documents*. But it's important to gauge his

careful distance from the tradition of "photomontage"—a term he avoids, in favour of "collage"—of which his work is sometimes a reminder. As Stezaker sees it, the great *monteurs* such as Heartfield or Grosz always worked at some rational remove from the image itself; this was often the critical point of their work: to conjure radical ideas out of pictures that otherwise allured the everyday viewer. With his residual Romanticism and often frank embrace of modern glamour, Stezaker is perhaps closer to Hannah Höch, whose *Album* of 1933 juxtaposes press imagery with ravishing fashion illustrations and fragments of sublime or disturbing nature. In Stezaker's collages, as in Höch's, images sidle up to and seduce one another, shying from overarching arguments or narratives.

That's not to say that there isn't a degree of knowing distance— and a strain, as we'll see, of violence—in Stezaker's work. It is first of all a historical distance. Early on, he began to work with (mostly black-and-white) actors' portraits and film stills from the middle of the twentieth century—images he culled from defunct cinemas and film-industry picture agencies that were then going out of business. (Stezaker once bought the entire contents of one such establishment, though the prints are now so precious and rare that he cannot bring himself to make work out of them.) The film stills are especially peculiar artefacts: posed publicity shots taken during production rather than frames reproduced from the finished film. Like the colourful, scenic postcards with which Stezaker often overlays them, they have an attraction similar to the one Victorian engravings had for the Surrealists. The distance—inflected alike with nostalgia and absurdism—is essential, because one of the projects Stezaker is engaged in is a daring rescue of images from the memory dump of the recent past.

It is hard to say precisely what the artist does with such images. In a sense it's ludicrously simple: he places, for example, one picture on top of another. Consider *Negotiable Space* (1978). The larger "background" image shows a psychoanalyst at his desk, his analysand stretched on a couch, a medicine cabinet in the corner, and a photograph of Freud on the wall. In the centre of the image, and seeming to threaten the foreground, is a colour postcard showing a train emerging from a tunnel, its edge obscuring the face of the patient. The inference seems clear at first: this is a comically "Freudian" emanation from the unconscious of the figure on the couch. Except that this initial schematic response won't exhaust the collage. The crude intrusion of the postcard makes us notice oddities about the film still—a lattice of shadows across the Freud portrait, a surprising expanse of empty floor at the bottom of the picture—as well as curious details by which the two images rhyme: railway tracks aligning with the desk so that it too looks about to charge out of the frame.

There are many works of this type across the decades of Stezaker's career. In the *Trial* series, classical ruins, a picturesque waterfall, and the Bridge of Sighs at St. John's College, Cambridge, all erupt among the anxious monochrome attitudes of a cinematic courtroom scene. In an untitled collage from 2008, a crowd of Hollywood bathing beauties is framed and almost overwhelmed by a sideways-on photograph depicting a complicated sculptural entanglement of Saint George with his dragon. But the signature Stezaker gesture is more frequently the cut and splice of two or more images, doing suggestive violence to both. Here is a young woman (could it be Lauren Bacall?), her face diagonally bisected by roiling floodwaters or—the series is titled *Film Portrait (Disaster)*—obliterated by an image of

282

torn-up trees. Here, in a series called *Third Person*, are lesser stars whose faces are half hidden by anonymous silhouettes, from the depths of which a third image obtrudes: a garish landscape or an eerie flight of birds. In some later works the background picture may also explode through the centre of the interposed image, in a cartoon flash worthy of Roy Lichtenstein.

The mystery of Stezaker's art may be said to reside in these precise and shocking cuts. He has spoken of the moment when he takes a blade to the sleek, fleshy surface of an old bromide print as one of heightened anxiety and tension—having handled and gazed at these images for months or even years, he likes to get the incision over and done with as swiftly as possible. (Much of Stezaker's working life, when he is not corralling his vast archive of source material, is spent watching and waiting for this moment.) Unfinished works in his studio have the look of gaping wounds, something like the suddenly opened slit in Sylvia Plath's "Cut": "a sort of hinge / Of skin, / A flap like a hat, / Dead white." They remind us that historically photographs have been things as much to be touched as looked at, that our fascination with them is at once visual and tactile, almost grisly.

This impression of keen-eyed assault is strongest (and frequently funniest) in Stezaker's cutting and suturing of close-up portraits. Everywhere in his work there are faces made monstrous, comical or weirdly attractive by their carving up and careful wedding with others. In fact one series called *Marriages* shows pairs of men and women— mostly, it seems, they are actors' studio portraits—incongruously conjoined to suggest new faces. A moustached man in a pullover meets a wavy-haired blonde to produce a figure with an oddly raffish cavalier look; a middle-aged woman with a complex hairdo acquires

the aquiline nose of the actor she obscures. For all their strangeness, however, the faces are also exquisitely aligned, the arc of an eyebrow or the thrust of a jaw running on from one image to another, so that the whole is bizarrely credible as a glamorous or grotesque new being. One's eye moves tirelessly, entranced, between the two faces and their Frankenstein offspring.

What is less endearing, and more alarming, about these "married" faces is the extent to which their own eyes have been attacked by Stezaker's scalpel. (There's a reminder here of the founding image of Surrealist oculism: the slitting open of a woman's eye—replaced at the last edited moment by a cow's eye—in Luis Buñuel and Salvador Dalí's 1929 film *Un chien andalou*.) More generally in his work, it's often through the eye that the incision passes: whether vertically (as in the splicing of two faces) or horizontally, as in the series *Love*, where a narrow strip of the same image is inserted along the eye line, so that the subject stares out at us with expanded, blurred and alien orbs. The result is that people in Stezaker's collages seem to suffer a variety of austerely rendered optical afflictions, from a squint or strabismus to full enucleation: in a series simply titled *Blind*, the eyeballs have been razored out along a straight line and the edges of the photograph brought together again.

It is all part of Stezaker's continued investigation of the intimate strangeness of the photographed human face, the way it exposes and veils at the same time the feeling, thinking creature within. (The face, writes Giorgio Agamben, is "the very opening in which [humans] hide and stay hidden.") This line of thought and fascination finds its fullest expression in his *Masks* series. Here there are no cuts, just the judicious placing of colour postcards over monochrome portraits. They are among Stezaker's slyest and most unset-

tling works, because what they intrude into the portraits is a series of gaping holes: chasms and waterfalls that cleave faces in two, yawning caves and sunlit sea arches that tunnel into unknowable interiors. These collages are the more ghastly and comical for once again being perfectly aligned: clumps of rock become noses, the arches of a stone bridge a pair of gawping eyes. *Masks* returns us to another, less nostalgic, story that Stezaker tells about his development as an artist. As a student, he happened upon a photograph in an old medical textbook that showed a woman's face half eaten away by a rodent ulcer—inside and outside had become horribly confused. Stezaker closed that book with the thought that he must never look at it again, but in other ways he has not stopped looking since.

La Prisonnière

AT ELEVEN MINUTES LONG, Tacita Dean's film *Prisoner Pair* is a svelte précis of certain tendencies in the English artist's haunted and haunting body of work. In 2008 Dean was commissioned to make a work in or about the historically conflicted region of Alsace-Lorraine, and she responded with a type of still life: a close-up study of two bottled pears suspended in schnapps and subtly decaying in sunlight. The film's title depends on an obvious pun but also on the name, *poire prisonnière*, given to such novelty liqueurs as are produced in Alsace, parts of Switzerland and the Black Forest. The work is an intimate and almost whimsical portrait of two bodies, two territories, that rhyme with or mirror one another and seethe quietly with life even as they are immured behind glassy frontiers.

Like much of Dean's art, *Prisoner Pair* broaches vast topics—nature, history, decay and the seductions of nostalgia—with apparently modest means: the simple passage of light across the surface of things. If it's not immediately of a piece with her longer films, which often place human faces in resonant landscapes and historically charged architectural settings, that is partly a matter of productive mistiming. Dean had originally hoped to film the harvesting of the pears in Alsace—their buds are bottled on the tree and the fruit grown inside—but, having missed her moment, focused instead

on the textures of the finished product. The result is a film that is all light and flesh and minute drifting particles.

Dean has made other films that look intently at objects and surfaces. Her *Darmstädter Werkblock* (2007) documents the walls and carpets around a permanent installation by Joseph Beuys. *Day for Night* (2009) records objects in the Bologna studio of Giorgio Morandi, the Italian painter of pale and austere still life. *Prisoner Pair* is not so much a consciously painterly move as an expression of the metaphoric potential of its subject. At times the mottled pears resemble aged, maybe dead, flesh, looking as if they're entombed or in suspended animation. (Dean buried the bottles first, so the glass itself seems subject to some dark organic process.) From other angles they look like planets—specifically, the mysterious milky world in Andrei Tarkovsky's 1972 film *Solaris*—that now and then erupt with small puffs of fermentation. Still, in spite of the meanings and references that might attach to these tender, ghostly twins, it is mostly the light you notice as it agitates the fruit inside with its flickering, or burnishes the glass with a golden glow. (There are many golden glows in Dean's films. As Rex Harrison says in Joseph L. Mankiewicz's 1967 film *The Honey Pot*, gold is the colour of time.)

Had Dean managed to film the Alsatian pear harvest, it might have looked like an especially entrancing passage in *Michael Hamburger*, the 2007 film with which she acknowledges *Prisoner Pair* has some affinities. In the earlier work, Dean filmed the poet and translator at his home in Suffolk, a year before he died. (The piece was commissioned in part as a response to W. G. Sebald's *The Rings of Saturn*—in that book, Sebald's narrator travels to the home of his friend Hamburger, whose life, uncannily, he feels he has himself lived.) *Michael Hamburger* is filled with typical Dean motifs—the

textures of old walls and old hands, lingering shots from inside windows, half-open doorways that give onto brightly lit and empty rooms—but it slowly organizes itself around its subject's relationship with his orchard. We see Hamburger naming and caressing the species among his windfalls, recalling an enthusiasm shared with Ted Hughes, plucking apples from his trees while late flowers nod and lazy insects buzz around him in the dog days.

The art critic Jörg Heiser floated the term "romantic conceptualism" to describe what an artist like Dean does, with her knowingly oblique and sometimes subtly frustrating approach to her subject matter and yet too her commitment to the beautiful way she frames it. Her continued use of 16-mm film, instead of the high-definition video that is everywhere now among artists who work with the moving image, is essential to the way her works are made and shown: the whirring, hot projector is often a semi-sculptural presence in the gallery. This too leaves her open to accusations of aesthetic nostalgia, but after three decades of making films Dean is presumably past caring; the rhythms of shooting, processing, laborious sound design and film editing (done by Dean herself on an old Steenbeck at her studio) are part of an artistic practice with a relentless coherence.

Much of her later work seems to be about age, decay, loss and nostalgia in more straightforward ways than her earlier films would openly admit. Or rather, the timescales being canvassed were on the face of it more devious and odd in works made in the early 2000s. Consider a film such as *Fernsehturm* from 2001, filmed at the revolving restaurant atop a 1960s TV tower that she had first visited on a trip to East Berlin in 1986. Like several of the artist's other subjects— Berlin's now-demolished Palace of the Republic, the pre-radar "sound mirrors" at Dungeness, Robert Smithson's drowned and

resurgent sculpture *Spiral Jetty* on the shore of the Great Salt Lake—the tower embodies past and future at the same time. A good deal of Dean's art mines this sense of a future anterior, of technological, utopian or artistic dreams that have gone to ground only to surface again as relics of a time to come that we can no longer imagine.

In one sense, Dean's later meditative film portraits, of which the vegetal memento mori of *Prisoner Pair* is a peculiar relation, express a much simpler chronology of decline or passing. (The same might be said of *Kodak* (2006), a work of frank mourning for which she filmed a Kodak factory in France, using some of the last-manufactured reels of the company's black-and-white 16-mm film.) Dean seemed to be engaged in an aesthetic romance with the image of an artist or storyteller near the end of his life—in an interview with Marina Warner in 2006, she joked that she had developed "a thing about old men." Among the earliest examples was *Boots* (2003), a three-screen film installation that follows the aged character of the title (a Dean family friend, so named for his orthopaedic footwear) around an empty art deco villa in Portugal. Boots tells stories as he goes about what might have gone on in the house, reminisces about his affair with a woman named Blanche, and muses that the placer seems to have drifted off into another time. it turns out that this portrait of melancholy recall is no such thing—the old man is inventing (or maybe half inventing) history as he limps between the sunlit rooms, projecting it into a time that never was.

Boots had been preceded the year before by *Mario Merz*, a study of the Italian artist sitting beneath a tree in summer heat and contemplating his own mortality. (Merz did in fact die not long after the film was made.) In 2004 Dean made *The Uncles*, in which two of her elderly uncles recalled their fathers: Basil Dean and Michael

Balcon of Ealing Studios. And in 2005 she completed *Presentation Sisters* at a convent in Cork: a muted collective portrait of the few nuns left and the domestic rituals with which they filled the days. But the best of these portrait films are surely the two works Dean made with Merce Cunningham in the last years of the choreographer's life. The first, *Merce Cunningham performs STILLNESS (in three movements) to John Cage's composition 4'33" with Trevor Carlson, New York City, 28 April 2007 (six performances; six films)*, is a still life of sorts. It shows the frail but poised Cunningham seated in a chair in a dance rehearsal space, performing static interpretations of Cage's famously silent work.

The second, *Craneway Event* (2009), is among Dean's most dynamic and spatially ambitious films. It records three days of rehearsals by Cunningham's dance company at a disused Ford assembly plant in Richmond, California. (Cunningham had originally asked Dean to document the resulting performance, but she preferred the unpredictable rehearsal and its lack of music.) Of course, this is a film about movement: the fourteen dancers careering between three sprung stages, the way a pelican flexes its wings in San Francisco Bay, the stately passage of ships past the building's huge windows. But at the centre of all this energy is the still point of Cunningham himself: aged eighty-nine, conserving his energy and restricted to his wheelchair, but entirely focused on the dancers and the possibilities of the space. Dean's portrait of him is all about timing, about Cunningham's knowing when to give himself up to fatigue, when to urge his young dancers to work as hard as he does or to trundle himself out of shot when he gets bored.

It's into this lineage of portraiture, strangely, that we ought to fit *Prisoner Pair*. Because quite apart from the dazzling array of textures

and light effects that Dean manages to tease from a macro lens and a couple of muddy schnapps bottles in a London garden in summer, and bearing in mind the pears' ripe and fleshy reminder of vulnerable bodies, this is a film about concentration (ours and the artist's) and about survival. The trapped pears are fragile living things consigned to a sweet and potent afterlife, caught behind glass like museum specimens but still redolent of all the time between their budding and their maturity. In that sense they resemble Dean's aged portrait subjects, but also in this: watching them, the greatest mystery for the viewer is how the artist has managed to imprison them in the first place and turn greying flesh into filmic gold.

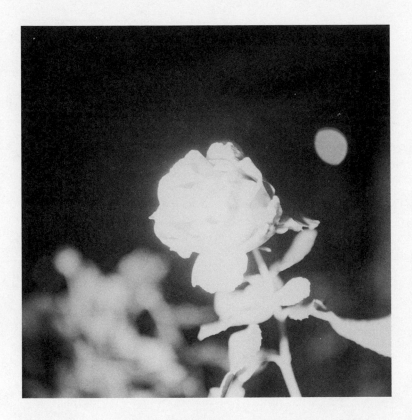

They Are All Gone into the World of Light

THE WORLD RARELY LOOKS so calmed or precious as it does through the viewfinder of a medium-format twin-lens reflex camera: the camera of Doisneau, Capa, Arbus—and Japanese photographer Rinko Kawauchi. The striking transformation that happens before you have even pressed the shutter button is partly a matter of bodily attitude: to compose a photograph you have to look away from your subject and down at the image on a matte glass focusing screen. Colours seem at once jewel-like and muted. Although you may be about to take the picture in black and white, it seems your attention has already modified the thing you are looking at. Then there is the square format of viewfinder and photograph, which can lend to the finished product a monumental quality, with subject or sitter placed solidly in the centre.

In a self-portrait by Kawauchi, she is peering into the flip-top hood of her Rollei, hair falling over her face and here and there picked out in perfect focus. As with many of Kawauchi's pictures, everything seems on the edge of succumbing to an excess of light, or subsiding into blur. A rose whited out in the foreground, while all else turns a rich shade of pink. A glowing figure of the Virgin Mary, plugged into a power outlet and irradiating the scene: three

cables snake out of the same socket and beyond the borders of the image. In *Illuminance*, perhaps the most entrancing of Kawauchi's books, the sequence of images begins and ends with photographs of a solar eclipse. Always in her work the threat of obscurity, flaring or fading. I'm reminded of Annie Dillard writing about the world-unmaking oddity of an eclipse:

At once this disk of sky slid over the sun like a lid. The sky snapped over the sun like a lens cover. The hatch in the brain slammed. Abruptly it was dark night, on the land and in the sky. In the night sky was a tiny ring of light. The hole where the sun belongs is very small. A thin ring of light marked its place. There was no sound. The eyes dried, the arteries drained, the lungs hushed. There was no world.

I first came across Kawauchi's work in the early 2000s, and straight away spent more than I could afford on imported editions of her books. I loved the intensity of her focus on frail bodies, whether human or animal, and the way everything else, objects of places or mere atmospheres, starts to seem corporeal too—but also hardly there at all. Kawauchi carefully removes from the sequencing of her books any reference to place: "It is like cooking; you carefully skim the broth to make it clear or sift the flour to make it fine." A type of anonymous intimacy marks much of her early work: we feel we are in the orbit of immediate family, but a great deal of context is absent. A domestic photography, dedicated to an infinity of small things, impossibly tender and exposed. Paired on the page with a small porcelain doll's head: a wounded melon like a caved-in skull. On a brightly lit pavement, a pigeon lies dead: the tiny drop of blood that

leaks from its head looks like bright red paint. The frailty of animals doubles that of humans: two feet pushed into sand (are they the artists?) match-cut across the page to a pair of tiny turtles, fragile and also sand-bound.

Vulnerability is one of Kawauchi's more obvious themes, nowhere more so than in the portraits of family in her 2005 book *Cui Cui*. Births and deaths, hands held, tables laden for celebration or ceremony, gardens, shrines and hospital beds—amid all this, the artist's grandparents together and alone, around the time of her grandfather's death. It's among the most expressly autobiographical sequences in Kawauchi's work. More usually, vulnerability is a matter of detail, and it need not necessarily be a body that expresses it. Among her small miracles of exact and isolated focus are various delicate filaments and membranes. A thin stream of water from a water pistol, a length of thread held taut and horizontal in a girl's hands, a single hair as it brushes against eyelashes—all of these might easily be broken or disturbed. A pincushion like a baby's soft cranium.

Kawauchi's photographs teem with such things. She has spoken of being attracted to herds or flocks—there are birds everywhere in her work—and it seems that these gatherings or agglomerations simply multiply instances of individual rawness or fragility. A signature motif is the mouth of a fish (carp, mostly) as it breaks the surface of a pond, gapes at the air and rolls its wild, panicked eye. Kawauchi photographs a mass of these mouths: bright and rubbery, darkling inside, voracious. Less alarming: a scattering of tadpoles like errant commas, countless droplets of dew caught in a spider's web, photographs filled to the edges with chrysanthemums or plastic bags.

You might expect the monumental tendency of the square image to work against Kawauchi's commitment to intimacy and frailty,

setting her subjects so solidly at the centre. But she takes advantage of this bias to place in the middle of certain photographs—precisely nothing. Or rather, a recurring and familiar gulf, a near-circular hole into which the picture is falling. Her photographs are full of vortices. Sometimes it's simply a matter of circular form; in *Cui Cui*, a plain round light fitting on a left-hand page rhymes with a gas burner on the right. More energetic or elemental: the spiral surge of water in a top-loading washing machine, set alongside a swirl of cloud with a blue centre. It's never only a matter of form: this starkest of compositional arrangements also gives us the howling void of her baby's open mouth, an egg cracked to reveal the feathered thing inside, a candle flame, a small glass dish of strawberries and cream, a blaze of light between trees that threatens to take everything away.

Essay on Affinity X

A PARTIAL LIST (or imaginary collage) of images that are not mentioned and do not appear in this book, but will not leave the mind. ☛An Edwardian postcard showing in sepia a young woman in a nightdress, her partially bare arms raised above her head and her long thick hair let loose. On the reverse, this legend in neat blue script: "She would make a bad wife for an old man." I found the postcard at a market stall in Dublin thirty years ago. For a long time it migrated as a bookmark among the notebooks in which I was trying to imagine what it would be like to be a writer. There is no other handwriting, no indication who this woman was, where the photograph was taken or who wrote that smirking sentence about a turn-of-century pin-up. She is lost now somewhere in my library, stuck carelessly in a book I cannot find, but I promised long ago that one day I would put her in a book of mine. ☛ David Bowie in the video for his 1979 single "DJ," pushing his way grinning through a real, impromptu crowd on a London street and seeming, as he gets free into the foreground, to settle his features into an expression derived from the languid allure of Elvis, Brando, Bacall, Jagger—and Bowie. ☛ The cover photograph of an album of blues standards released jointly in 1966 by the record company RCA and the pharmaceutical corporation Merck. *Symposium in Blues* was a marketing device for Merck's new antidepressant Elavil. The sleeve notes posit

a connection between the pain of the blues and depressive symptoms of low mood, anxiety, insomnia, guilt and so on. Nothing is said about the particular historical, that is, racial circumstances that may have occasioned the plaint that is the blues in the first place. "The blues ain't nothing but a black crepe veil, ready to wear." On the cover: a young, white, blonde woman, head resting on one hand—does she, or does the designer of this curious artefact, know that she repeats a melancholy motif at least as old as Dürer? ☞ Tortured variant on the melancholic's gestural array: Irm Hermann as Marlene in Rainer Werner Fassbinder's 1972 film *The Bitter Tears of Petra von Kant*. Ghost-pale in her black dress and helmet of red hair, Marlene the implausible but compelling and silent masochist watches jealously as her fashion-designer boss accumulates lovers and familial dramas. Marlene lowers her head and raises her right hand against a glass partition: tortured mime, agony in semaphore. ☞ Jacques Henri Lartigue, aged no more than ten, photographs, some time between 1902 and 1904, his cat Zizi, who is leaping vertically, all legs extended, to catch a ball. ☞ Denis Lavant dancing at the end of Claire Denis's *Beau Travail* (1999)—of course. ☞ A tomb sculpture by Nicholas Stone of the poet John Donne, modelled after a picture of same (by unknown hand, and later lost) composed while he was in fact dying, in pious readiness for the end. And which sculpture, installed in St. Paul's Cathedral—it survived the Great Fire of 1666—I still have not seen, though it's not ten minutes' walk from where I'm writing. ☞ In the opening credit sequence of the early-2000s TV show *Six Feet Under*, briefly: a framed photograph of a woman in a large old-fashioned hat, which every time (third viewing now of the whole series) reminds me of the profile or silhouette of the monster in *Alien*. ☞ For his 1974 series *Infinito*, the

Italian photographer Luigi Ghirri pointed his camera at the sky every day for a year. A doomed serial project with photographic and painterly antecedents both sublime and banal. How do you frame "the sky" after Tiepolo, Canaletto, Constable and Stieglitz? And yet despite their ironies how thrilling are Ghirri's grids of the resulting snapshots: the balmy typology of clouds, occasional aeroplanes, varieties of infinite blue, the mundane miracle of looking. ☞ In the pages of *Virtue's Catholic Encyclopaedia*, a small black-and-white image of a Victorian or Edwardian actress playing Lady Macbeth: distraught, gesticulating, her pale gown darkly streaked. Quite the most troubling image in my childhood—who was this woman and why was she covered in blood? ☞ After Lady Macbeth, the most disturbing image from my childhood was the unseen one attaching to a card my mother placed in my bedroom when I was about ten years old. A lavishly tasteless holographic picture of a bust of the Irish saint—he had been canonized only a few years earlier—Oliver Plunkett, who was hanged, drawn and quartered at Tyburn in 1681. On the reverse of the card was a short account of his execution, concluding in a singularly grotesque detail: *his bowels taken out and burned before his eyes.* The image with which I would sometimes torture myself before going to sleep. Around this time, like many Irish schoolchildren, I was taken to St. Peter's Church in the town of Drogheda, to see the martyr's preserved head. ☞ One of several photographs, film frames or video grabs showing the "topless cellist" Charlotte Moorman in performance. She affronted John Cage with her knockabout interpretations of his already experimental compositions; she submitted (happily, it seems) to many physical indignities as a collaborator of the artist Nam June Paik: playing her instrument not only topless but with various of Paik's electronic

gizmos (such as bras fitted with flashing lights, or TV screens) attached, or stepping in and out of a barrel of water mid-performance. When she was diagnosed in middle age with terminal breast cancer, she invited her friends to watch her perform a version of Yoko Ono's *Cut Piece*, in which the audience was invited to scissor the clothes off Moorman's ailing body. ☛ Numerous grainy handheld shots of Germaine Greer in D. A. Pennebaker and Chris Hegedus's 1979 film *Town Bloody Hall*, which documents a debate about feminism staged in New York eight years earlier. The antagonists: Jill Johnston, Diana Trilling, Jacqueline Ceballos, Norman Mailer and Greer. (And in the subsequent Q&A: Betty Friedan, Cynthia Ozick, Elizabeth Hardwick and Susan Sontag.) Greer was at that time (and for many years after) an eloquent, furious, heroic and funny presence—the dark star of this film in her feather boa. In fact, everyone in *Town Bloody Hall* is eloquent, whether demotic or elevated, including the misogynist Mailer, who thought he was there to finally vanquish the libbers. In the days before the event, Greer informed the New York media that she intended to seduce Mailer and "carry him like a wounded child across the wasted world." ☛ The sight of celluloid burning or dissolving at the end of Monte Hellman's surpassingly blank, entropic road movie *Two-Lane Blacktop* (1971). The film consuming itself, whiting out much in the way the central characters (they are barely characters) have committed to the emptiness of speed and chase. No sequence—not even the blackout ending of Ingmar Bergman's *Persona*, to which Hellman here pays homage— seems to me more self-aware or more lost in the wonder of cinematic movement. ☛ The ravishing (and in fact ravaged) emptiness of pure white church interiors in certain Dutch paintings, especially *The Interior of the Grote Kerk at Haarlem*, painted around 1636 by Pieter

Saenredam, in which amid the stark columns and exaggerated angles, a tiny dog worries the pew where his master sits. ☞ A Polaroid by Andrei Tarkovsky showing his wife, Larissa, attended by their dog Dakus, standing by a fence, most likely at their holiday home in Myasnoy, Russia, in the early 1980s. Trees in the distance, a hint of mist (or is it the medium's fading colours?) in the top left corner, the golden earth raked by long shadows. Sometimes I think Tarkovsky's Polaroids may be the most sheerly beautiful photographs I know. ☞ A series of abstract line drawings made by Francis Picabia to accompany in 1924 the publication of seven Dada manifestos by Tristan Tzara. When I was about sixteen I found a translation of this book in my local library, and in the months that followed used to try and copy, in the margins of school textbooks, the curving and zigzag lines that here and there suggest bodies. They were, and perhaps still are, the only things I could ever draw, aside from a passable rendition of the head and shoulders, but not the body, of Betty Boop. ☞ In one of Derek Jarman's Super 8 films of the late 1970s, in which hieratic, masked figures disport themselves round a bonfire: the sudden appearance, in ghostly Monroe drag, of the future (fleeting) pop star Marilyn. ☞ In a book I own about strange weather and anomalous precipitation, a line drawing of a bemused young man around whom are falling ragged flattish snowflakes the size of dinner plates. ☞ The flight of pigeons from the palace. ☞

Illustrations

WHAT PITIFUL BUNGLING SCRIBBLES AND SCRAWLS
Robert Hooke, *Micrographia: or some physiological descriptions of minute bodies made by magnifying glasses. With observations and inquiries thereupon*, 1665. Credit: Wellcome Collection.

THIRD PERSON
Louis Daguerre, *Vue du boulevard du Temple*, 1838.

RESOLVING
John Herschel, *Results of astronomical observations made during the years 1834, 5, 6, 7, 8, at the Cape of Good Hope*, 1847.

VAGUENESSES
Julia Margaret Cameron, *Julia Jackson*, 1867. Copyright © Victoria and Albert Museum, London.

ESSAY ON AFFINITY III
Étienne-François Geoffroy l'Aîné, "Table des differents rapports observés en chimie entre differentes substances," from *Mémoires de l'Academie Royale des Sciences*, 1718.

A BRIGHT STELLATE OBJECT, A SMALL ANGLED SPHERE
Hubert Airy, visualization of scintillating scotoma, 1870, reproduced in P. W. Latham's *On Nervous or Sick-Headache* (1873).

BEAUTIFUL SCENIC EFFECTS ARE PRODUCED
Harry C. Ellis (attributed to), *Loïe Fuller enroulée dans son voile*, c. 1900–1928. Silver print. Paris, Musée d'Orsay. Copyright © 2022. RMN-Grand Palais / Dist. Photo SCALA, Florence.

ILLUSTRATIONS

Dada Serious
Hannah Höch, *Cut with the Kitchen Knife Dada Through the Last Weimar Beer Belly Cultural Epoch of Germany*, 1919. Photo: bpk / Nationalgalerie, SMB / Jörg P. Anders.

Discordia Concors
Aby Warburg, *The Mnemosyne Atlas*, Panel 6, 1929. Copyright © The Warburg Institute.

Preposterous Anthropomorphism
Jean Painlevé, *Female Sea Horse*, 1936. Courtesy of Archives Jean Painlevé, Paris.

L'autre Moi
Claude Cahun and Marcel Moore, *Keepsake* (from a series of 4), c. 1925. Courtesy of the Jersey Heritage Collections.

Voracious Oddity
Dora Maar, *Le Simulateur*, 1936. Copyright © ADAGP, Paris and DACS, London, 2022.

On Not Getting the Credit
Berenice Abbott, *Portrait of Eileen Gray in Paris*, 1926. Copyright © Berenice Abbott/Getty Images. Interior of E-1027, reproduced from e1027.org.

The Leaves of the Rhododendrons Did Not Stir
Michael Powell and Emeric Pressburger, *A Matter of Life and Death*, 1946. Production still by Eric Gay, reproduced from *A Matter of Life and Death: The Book of the Film*, by Eric Warman (London World Film Publications, 1946).

Life Is Good
William Klein, *Big Face, Big Buttons, New York*, 1954–55. Copyright © William Klein.

Star Time
Kikuji Kawada, *Chizu* (maquette version), 2021. Courtesy of PGI. Copyright © Kikuji Kawada.

Four Stars
Andy Warhol, still from *Outer and Inner Space*, 1965. 16 mm, black and white,

sound, 66 minutes (33 minutes in double screen). Copyright © The Andy Warhol Museum, Pittsburgh, PA, a museum of Carnegie Institute. All rights reserved. Film still courtesy The Andy Warhol Museum.

SHINNING UP A DOORFRAME
Francesca Woodman, *Self-portrait at 13, Boulder, Colorado*, 1972. Copyright © 2022 Woodman Family Foundation / Artists Rights Society (ARS), New York.

A MIRROR'D BE BETTER
William Eggleston, still from *Stranded in Canton* (1973). Copyright © Eggleston Artistic Trust. Courtesy of Eggleston Artistic Trust and David Zwirner.

MIRACULOUS!
Samuel Beckett, still from *Not I*, BBC (1977).

COSMIC VIEW
Ray and Charles Eames, still from *Powers of Ten* (1977). Courtesy of the Eames Office.

THERE ARE EYES EVERYWHERE
Helen Levitt, *N.Y.*, 1972. Courtesy of Galerie Thomas Zander, Cologne. Copyright © Film Documents LLC.

COMMON MARTYRS
Susan Hiller, *Monument* (detail), 1980–81. 41 photographs, color, on paper, bench, tape player, headphone and audio. Dimensions variable. Courtesy of Susan Hiller and Lisson Gallery. Copyright © Estate of Susan Hiller.

A TWITCH UPON THE THREAD
Brideshead Revisited, 1981. Still from a television series. Anthony Blanche and Charles Ryder (Nickolas Grace and Jeremy Irons). Photograph by TV Times via Getty Images.

THE CHARISMATICS
Delegates singing at the Silver Jubilee Charismatic Renewal Conference at the RDS, c. 1980s or '90s. Photograph: Paddy Whelan (*Irish Times*).

FOR THE SIMPLE REASON IS
Photos by Vera Merriman, courtesy of the author.

WHAT A CARVE UP
John Stezaker, *Love XI*, 2006. Courtesy of John Stezaker and The Approach, London. Copyright © John Stezaker.

LA PRISONNIÈRE
Tacita Dean, *Prisoner Pair*, 2008. Courtesy of the Tacita Dean, Frith Street Gallery, London, and Marian Goodman Gallery, Paris. Copyright © Tacita Dean.

THEY ARE ALL GONE INTO THE WORLD OF LIGHT
Rinko Kawauchi, *Untitled*, from the series "Illuminance," 2009. Copyright © Rinko Kawauchi.

Readings

Peter Adam, *Eileen Gray: Her Life and Work* (London: Thames & Hudson, 2019).

Diane Arbus, *Diane Arbus: An Aperture Monograph* (New York: Aperture, 2011).

Samuel Beckett, *Not I* (London: Faber, 1973).

Mary Ann Caws, *Dora Maar* (London: Thames & Hudson, 2000).

Thomas De Quincey, *Works*, ed. Grevel Lindop (Manchester: Pickering & Chatto, 2000).

Georges Didi-Huberman, *Phasmes: essais sur l'apparition* (Paris: Les Éditions de Minuit, 1998).

Charles and Ray Eames, *Powers of Ten: A Flipbook* (New York: W. H. Freeman, 1998).

William Eggleston, *William Eggleston's Guide* (New York: Museum of Modern Art, 2002).

Loie Fuller, *Fifteen Years of a Dancer's Life* (Boston: Small, Maynard & Co. Publishers, 1913).

William H. Gass, *On Being Blue* (Manchester: Carcanet, 1979).

Johann Wolfgang von Goethe, *Elective Affinities*, trans. R. J. Hollingdale (London: Penguin, 2005).

Hannah Höch, *Album* (Berlin: Hatje Cantz, 2004).

Robert Hooke, *Micrographia*, ed. R. T. Gunther (New York: Dover, 1961).

Marie Jager and Jonathan Watkins, eds., *Jean Painlevé* (Birmingham: Ikon Gallery, 2017).

Kikuji Kawada, *Chizu (Maquette Edition)* (London and New York: MACK and New York Public Library, 2021).

Rinko Kawauchi, *Illuminance* (New York: Aperture, 2021).

Frank Kermode, "Poet and Dancer before Diaghilev," *Puzzles and Epiphanies: Essays and Reviews 1958–1961* (London: Routledge & Kegan Paul, 1962).

Wayne Koestenbaum, *My 1980s & Other Essays* (New York: Farrar, Straus and Giroux, 2013).

Stéphane Mallarmé, "Another Study of Dance: The Fundamentals of Ballet," *Divagations*, trans. Barbara Johnson (Cambridge, MA: Belknap Press of Harvard University Press, 2007).

Alexander Nagel and Christopher S. Wood, *Anachronic Renaissance* (New York: Zone Books, 2010).

Maggie Nelson, *Bluets* (Seattle: Wave Books, 2009).

Dennis Potter, *Seeing the Blossom* (London: Faber, 1994).

Jennifer L. Shaw, *Exist Otherwise: The Life and Works of Claude Cahun* (London: Reaktion, 2017).

Isabelle Stengers, "Affinity," in Michel Delon, ed., *Encyclopedia of the Enlightenment* (London: Routledge, 2001).

John Stezaker, *Crossing Over* (London: Ridinghouse, 2014).

Aby Warburg, *Bilderatlas Mnemosyne: The Original* (Berlin: Hatje Cantz, 2020).

Eric Warman, *A Matter of Life and Death* (London: World Film Publications, 1946).

Oscar Wilde, *The Critic as Artist* (New York: David Zwirner, 2019).

Francesca Woodman and George Woodman, *Francesca Woodman's Notebook* (Milan: Silvana Editoriale, 2018).

Virginia Woolf, Julia Margaret Cameron, and Roger Fry, *Julia Margaret Cameron* (Los Angeles: J. Paul Getty Museum, 2018).

Acknowledgments

MANY OF THESE AFFINITIES were first explored in the pages of *Artforum*, *Cabinet*, *The Dublin Review*, *frieze*, *The Guardian*, *London Review of Books*, *The New Yorker*, *Tolka*, and *The White Review*. Thanks to my editors at those publications.

I'm grateful to the artists who spoke to me about their work: Tacita Dean, Susan Hiller, William Klein, and John Stezaker. Exchanges with other artists contributed over many years to an idea of affinity condensing in my mind—among them Gerard Byrne, Sophie Calle, Tom Dale, Enrico David, Patrick Keiller, Helen Marten, Jeremy Millar, Niamh O'Malley, and Eva Rothschild. And Chris Marker: "We all know that Irishmen have strange connections with the untold and the untouchable."

At a time when writing seemed either impossible or beside the point, several people sustained this book with their conversation and kindness—including Katherine Angel, Michael Bracewell, Dorothy Derbyshire, Grace Derbyshire, Matthew Derbyshire, Orit Gat, Donna Huddleston, Mary Hurrell, Olivia Laing, Roger Malbert, Christian Marclay, Ian Patterson, Lisa Robertson, Pauline de Souza, Matthew Sperling, and Lydia Yee.

ACKNOWLEDGMENTS

Thanks to my editors Jacques Testard and Susan Barba, to Charlotte Jackson for picture research and rights, and to all their colleagues at Fitzcarraldo Editions and New York Review Books. The book was also made possible by a generous grant from Arts Council England.

And thanks most of all to Emily LaBarge who, seeing further and more clearly as always, first pointed out that the loose trilogy this book completes (on essays, sentences, and images) was really all about affinity.

BRIAN DILLON was born in Dublin in 1969. His books include *Suppose a Sentence*, *Essayism*, *The Great Explosion* (short-listed for the Ondaatje Prize), *Objects in This Mirror: Essays*, *I Am Sitting in a Room*, *Sanctuary*, *Tormented Hope: Nine Hypochondriac Lives* (short-listed for the Wellcome Book Prize), and *In the Dark Room*, which won the Irish Book Award for nonfiction. His writing has appeared in *The Guardian*, *The New York Times*, *London Review of Books*, *The New Yorker*, *The New York Review of Books*, *frieze*, and *Artforum*. He has curated exhibitions for the Tate and Hayward galleries. He lives in London.